CONTEMPORARY PAINTING IN POLAND

CONTEMPORARY PAINTING IN POLAND

RICHARD NOYCE

CRAFTSMAN HOUSE

G+B ARTS INTERNATIONAL

LOT Polish Airlines has been very fortunate throughout its 65 year history to be
in a position to encourage Polish art and it is with great delight that we support
Contemporary Painting in Poland. As an airline which is not afraid to change with
the times, LOT is proud to introduce to you some contemporary Polish artists who
have captured some of these changes on canvas.

CONTENTS

ACKNOWLEDGMENTS

The writing of this book has been aided greatly by the willing assistance of many people in Poland, Great Britain and Australia. I am particularly indebted to Jaromir Jedlinski, Director of the Muzeum Sztuki in Lodz, to Pawel Chawinski in Krakow, to Wieslaw Borowski of the Foksal Gallery and to Milada Slizinska of the Centre for Contemporary Art at Ujazdowski Castle, both in Warsaw, all of whose friendship and co-operation over many years has made a growing understanding of the complexities of Polish art possible. In Krakow I received much useful assistance in contacting artists and galleries from Jan Motyka. During my visits to Poland over the years I have been fortunate in having the assistance of Robert Morawski of Warsaw as my guide and interpreter. In London the willing involvement of Dr Hanna Mausch, Director of the Polish Cultural Institute, and her Deputy, Aleksandra Czapiewska, and the considerable help of Andrzej Rode, the UK and Ireland General Manager for LOT Polish Airlines, helped me in many valuable ways to achieve the creation of this book.

I wish to acknowledge with thanks the faith put in the venture by the featured artists themselves, and their help in providing information and photographic material as well as hospitality in their studios. Without the generous assistance of the Directors and staff of the many galleries concerned the task would have been less straightforward: in this respect thanks are due to Miroslawa Arens in Warsaw, and to Jacek Stawski, Marta Tarabula, Andrzej Starmach and Dominik Rostworowski in Krakow, as well as to Kasia Kubaty and Agnieszka Gregorczyk, my guides and interpreters in that beautiful city. I am also indebted to Barbara Jaroszynska-Stern and to Michal and Dorota Praszalowicz, all of Krakow, for their assistance in obtaining material relating to the late Jonasz Stern. In Sydney the professional co-operation of Nevill Drury and his colleagues at Craftsman House has been invaluable in the production of this book.

Finally I wish to thank Fiona McHugh and my son Joseph without whose tolerance and good-humoured support the work of researching and writing this book would have been less pleasurable and considerably more difficult.

PREFACE

It may at first seem unusual to find a book on Contemporary Polish Painting written by an Englishman, and the genesis of this book may require some explanation. I first came into close contact with the contemporary arts of Poland in 1972 through my active involvement in the installation of the major Edinburgh Festival exhibition, "Atelier '72" at The Richard Demarco Gallery, which introduced over forty Polish artists and also Tadeusz Kantor's "Cricot[2]" Theatre to Britain. In the years since then, stimulated by the experience of that memorable festival, I have maintained a close interest in Polish art and visited Poland twice during the 1980's to meet artists in many places and to select work for an exhibition as well spending time in that country in 1994 during the research for this book. My contacts and experience have led me to a profound sense of belief in the importance of the art and events in Poland since 1972. The opportunity to write this book, which seeks to describe a view of what has happened in the world of painting in Poland in the past two decades, was therefore irresistable.

The book does not seek to give a definitive art historical view: that remains for future writers to decide. Rather it is a personal view based on over twenty years' experience of an aspect of World art that deserves wider recognition and which it is hoped will be seen to have relevance in Europe and beyond. The selection of artists is likewise a personal one, aiming to give an overview of the achievements of artists whose work has seized my interest and which I consider to have an importance, either in recent historical terms or in terms of the directions in which Polish painting seems to me to be heading. It was not possible to include the work of all the artists whose work was considered and some regrettable omissions have been inevitable. Nonetheless I believe that the selection of work in this book will prove the vitality and excellence of contemporary painting in Poland and I hope it will stimulate others to explore the diversity and richness of that country's art for themselves.

INTRODUCTION

Poland's unique identity as a nation has historical roots reaching back through more than a thousand years of history, during the course of which periods of relative peace have been interspersed with periods of violent upheaval. Located in northern Europe between Germany and Russia, hemmed in to the south by the Tatra and Bieszczady ranges of the Carpathian mountains and to the north by the Baltic, Poland has for centuries straddled the crossroads of history. At times the country has been something of a paradox, having a fierce national identity but shifting and disputed boundaries, a nation without fixed territory. For all this however the Poles have developed an idiosyncratic culture owing its nature in part only to the influence from the four quarters. Within the boundaries of present-day Poland can be found architectural and cultural influences ranging from the Germanic in Silesia in the south-west to the Russian Orthodox along the north-eastern border, and from the Hanseatic influences of the Baltic coast to the alpine influences of the southern mountains. The country is still largely agricultural, with small areas of true forest wilderness remaining, but increasingly, and especially since the end of the Second World War, there are areas of heavy industrialisation with all the attendant problems of pollution. Nonetheless the country still retains much of its old character with a wealth of cultural heritage that is directly connected to the mainstream of European history but which is still too little recognised outside the country.

The years following 1945, in the course of which Poland became a satellite of the former USSR, separated like other Eastern European countries from the rapid economic development of Western Europe, fragmented but did not destroy the evolution of a unique visual arts culture. Indeed certain developments, particularly those in experimental theatre and the graphic arts, were unmatched anywhere else in Europe, and in the case of the graphic arts, practised by many painters as an integral part of their work, remain so. Throughout its history Poland has been a country that has had to withstand some of the worst horrors that have ever faced a European nation and yet the strength of national identity and a fierce pride have not only enabled much to survive but have also allowed the emergence of an artistic style that is distinctly and

recognisably Polish. The country was not immune to the deprivations of post-1945 communism — as in other parts of Eastern Europe the shortages of good quality art materials, the scarcity of international art books and magazines and the limitations on foreign travel led to a sense of growing isolation from developments in the visual arts in the West. In some ways this was a malign influence, causing an understandable sense of resentment among the country's artists, but at the same time that isolation can be seen to have encouraged a peculiarly Polish solution to the problem of artistic self-expression with very limited materials, and through this to the development of a strength that may yet be seen to be of great value now that the old order has gone and Poland is once more able to participate fully in European and world culture.

It is necessary, as with any nation, to consider Poland's cultural development in the light of political and social events, but with a particular focus that acknowledges the unique circumstances of the country. In order to understand some of the complexities of the current state of Polish painting it is also necessary to have an understanding of the historical background over the last century, which, in Poland as elsewhere in Europe, saw a period of tremendous changes, not only in the arts but also in the social background from which those changes sprung. When Jan Matejko, the greatest history painter in 19th century Poland, was at the height of his powers in the mid-1800s, the country was partitioned, the Polish language was outlawed in schools and in the law courts and the dream of nationhood had receded into a deep-seated and persistent longing. Matejko's great and perennially popular painting on an epic scale, *The Battle of Grunwald* (in the collection of the National Museum of Warsaw), recalled the heroism of the past and at the same time encapsulated the longings of that artist's generation for a return to what was perceived by many as being a golden age. Jacek Malczewski, the Symbolist painter in whose lifetime (1854–1929) Poland was to be transformed for the first time in centuries from a partitioned and subjugated state into a free democracy, developed a style of painting that still speaks eloquently of a people's yearning for freedom, and that forms a bridge between the academicism of Matejko and the work of the 1920s avant-garde.

The turmoil of the events of Malczewski's lifetime, not just in Poland but throughout Europe, led to the context in which the theories of Wladyslaw Strzeminski and his contemporaries could evolve. Released from the bonds of subjugation to foreign overlords, free for the first time for centuries to develop a distinctly national culture, artists in Poland played an important role in the European avant-garde experiments in the years between the two World Wars. The influence of these artists can still be seen in the work of a number of present-day artists and was to be a major determining factor in the re-assertion of Polish artistic identity.

In the 19th century, due partly to the three successive partitions of their country, many Polish artists had developed close cultural ties with other European countries, sometimes in exile, sometimes with a relatively free interchange across the shifting borders. While Polish independence remained a dream artists remained able to keep in contact with developments elsewhere if perhaps without influencing them to a great extent. At the turn of the century the Polish Symbolists, including Wyspianski and Wojtkiewicz as well as Malczewski, adopted a visual language of symbolism and mysticism to express their ideas and to delineate the urge for the regaining of a national identity, building on the work of Matejko. As new influences largely from Germany and predominantly in the form of Expressionism, came to be felt, these too were incorporated with Symbolism into a sometimes grim vision of what art could achieve. However, news of innovations elsewhere came to the art community, and as early as 1909 the Futurist Manifesto of Marinetti was published in the Krakow journal Swiat. In the years preceding World War I it was Expressionism, as well as other new movements, that provided the main stimulus for the early avant-garde. After 1918, with new vigour being injected as a result of Polish independence, younger artists in particular espoused the multiple disciplines of Futurism, Cubism and Expressionism through the group Formisci (Formists) which was active between 1919 and 1921, and produced a journal bearing the group's name which was published in Krakow. The group included Stanislaw Ignacy Witkiewicz (also known as Witkacy) whose work embraced many formats including his idiosyncratic versions of Surrealism and Dada.

In 1923 the 'Exhibition of New Art' in Vilna marked a turning point for the avant-garde and the subsequent group Blok (active 1924–26) launched a new direction based on Constructivism which mobilised a variety of talents, architectural as well as artistic, notably those of Strzeminski and Henryk Stazewski. The group's journal Blok published theoretical essays by members as well as by foreign artists such as Malevich and Schwitters. The conflicting theories within the group led to its decline and in 1925 the artists left to reassemble in the group Praesens (active 1926–39). This group too aimed at integrating art, design and architecture, and was involved in the design and realisation of pavilions for national expositions and at the 'Machine Age Exposition' in New York in 1927, which showed work by group members in a specially designed environment. Active in the writing of theoretical papers as well as in the making of art, the members engaged in dialogue with artists elsewhere in Europe, notably Moholy-Nagy and Mondrian. Through the activities of Blok and Praesens the emerging new avant-garde linked their work with developments elsewhere, laying the foundations for a new Polish style very much in tune with wider attitudes. It is worth noting that prominent among such links was the involvement of Polish artists in international groups such as Cercle et Carré and Abstraction/Création.

Praesens continued as an architectural group much concerned with the problems of the new technology and architecture until 1939, but in 1929 Strzeminski, Stazewski and Katarzyna Kobro left to form a.r. (revolutionary artists) being joined by two experimental poets. This group was to form the platform for Strzeminski's theory of Unism, which sought to create a means for linking the developments in art with those in society and for combining theory, material and form into a homogenous organic unity which still has a profound importance for many contemporary artists, even if the means used to express their ideas appear to have little relationship with the original theory. Within the group Stazewski developed the ideas of Constructivism which were to absorb him for his long career until his death in 1988, and Kobro developed her spatial concepts for sculpture which presented a wholly coherent relationship with the paintings of Strzeminski. Equally important was the group's

influence on the formation in 1932 of the 'International Collection of Modern Art' which was shown to the public for the first time in the Town Hall of Lodz in 1932. This collection, containing work by leading world avant-garde artists of the time including Arp, Leger, Ernst, Picasso and Vantongerloo as well as all the artists of the burgeoning Polish avant-garde, formed the basis for the Muzeum Sztuki (Art Museum) in Lodz, which is still a major focal collection of avant-garde art and the generator of a growing relationship with Museums elsewhere in the world.

The members of a.r. engaged in active dialogue with artists in many places until about 1936 when, as in common with other such groups elsewhere in Europe, there was a degree of suppression by conservative forces as World War II approached. Forced underground during the German occupation the group nonetheless continued its work in apartments and cellars, and became a major influence on developments by a new generation, who linked the principles of avant-garde visual art with those of experimental theatre, notably in the first Cricot Theatre which attracted the active involvement of artists of the calibre of Maria Jarema and Jonasz Stern. Following 1945 the work of these artists and many others, encouraged by the continuing involvement of Strzeminski (by this time a Professor at the Art School in Lodz) and Stazewski, was to become the backbone of much that developed through the 1950s and 1960s, and indeed it continues to be so.

During the 1930s, amid the proliferation of groups and styles, there emerged a polarisation between two main tendencies, one concerned more with rationalism and order, the other with experiments in abstraction. The first, characterised by the paintings of the Colourists (otherwise known as the Kapists after the Komitet Paryski or Committee of Paris which originated in the Krakow Academy of Art under Jozef Pankiewicz), owed allegiance to the post-Impressionists, in particular to Pierre Bonnard. They viewed painting as an act of autonomous creativity based on the values of pure composition and colour and members of the group achieved major positions in the art academies and with this achievement an influence that persists despite all the subsequent changes that have come about. While their work achieved

much initially it eventually came to be seen as rather elitist, lapsing into academicism and out of touch with broader social and cultural developments. The other main tendency was characterised by the succession of groups from the Formists to a.r. who saw their work and the deeper role of art as being intimately involved with the whole development of society, where art became the means for describing and questioning the conditions in which it developed. It is the second tendency that has proved to be the most influential on developments in recent years.

The period of the Second World War was particularly traumatic for Poland and the suffering of the country was all the greater, following as it did the first period for many years in which self-determination had brought a positively beneficial effect. The avant-garde was not however destroyed and, particularly in the southern city of Krakow, kept alive many of the pre-war ideals during the Nazi occupation: for example, the experimental Cricot Theatre of Tadeusz Kantor and others who had been active in the first Krakow Group maintained the flow of creativity as well as they could under extremely difficult circumstances as an artistic underground. Painters of course managed to continue painting and developing ideas, if without the possibilities for exhibition that existed before 1939, but much activity took place behind locked doors in small rooms in the city, utilising makeshift theatre as a means for the exploration of ideas. The destruction of many towns and cities during the war, the despoiling of much of the countryside, the grim legacy of the Holocaust and the handing over by the Allies of power to the Soviet Union following the Potsdam and Yalta Conferences, viewed by many Poles as a betrayal, left a bitter taste. Post-War Communism wrought its pervasive influence over almost all aspects of Polish life — cultural life included — and the avant-garde faced a situation of new difficulties.

In the first few chaotic years after 1945, as the process of recovery and reconstruction brought about a redefinition of the country within changed boundaries and with major enforced population shifts, there was for a short time a state of pluralism without clear direction in the arts which resulted in 'The First Modern Art Exhibition' in Krakow in 1948. For the first time the work of the Colourists and the

avant-garde could be seen in conjunction. But the relative liberalism of the exhibition did not last for long and in 1949, as the full force of Stalinism descended on the country, a new national art policy based on Soviet Socialist Realism came into being. Based on the ideological and propagandist function of 'socialist content in a national form' the policy was to remain central until 1956, and defined the only officially acceptable form, with endless portraits of brave leaders and of the noble proletariat engaged in building the new Poland. The immediate effect was to polarise artists into those who accepted and participated in the policy and those who did not who were, effectively, 'silenced'. The Ministry of Culture and Arts put new principles into practice in 1956 which introduced a more liberal climate that lasted until the end of the decade. Selected artists were permitted to travel abroad, exhibitions allowed greater freedom of expression and critical debate and showings of art from Mexico, France, Belgium and elsewhere (including a Henry Moore exhibition in 1959) introduced a dimension of international dialogue that had long been missing. In addition Polish art (albeit from a select few artists) was shown abroad, for example at Expo '58 in Bruxelles. Thus, while matters were far from ideal, there was once again some limited form of international exchange of ideas which in particular helped those artists who saw their work as being relevant more widely than on a merely national scale.

With Warsaw devastated during the war and not yet rebuilt as a place where art could develop, Krakow continued as the main centre of culture in the country. Immediately after the war, largely on the initiative of Tadeusz Kantor, the Grupa Mlodych Plastykow (Group of Young Artists) was formed, involving such artists as Tadeusz Brzozowski and Jadwiga Maziarska, as well as Maria Jarema and Jonasz Stern. They considered that art had an independent reality and that abstract art in particular was synonymous with freedom. In 1957, building on this group's considerable achievements, the Grupa Krakowska (Krakow Group) was reactivated and a year later they settled in their base in the vaulted brick cellars beneath the Krzysztofory Palace. The Krzysztofory Gallery became a showplace for their art, a meeting place for wide-ranging discussions and debate and very soon the venue for

exhibitions of work by the international avant-garde. Because of the involvement of many Krakow artists in Kantor's Cricot[2] Theatre the Gallery also provided a base for that group's subsequent development throughout the 1960s, giving further impetus for a concentration of activity that was to mobilise much development elsewhere in the country during that decade.

While extensive travel and international collaboration was still not possible events elsewhere in the world continued to influence Polish artists. In several locations, Osieki and Zielona Gora amongst them, symposia of artists from a range of media became annual events, leading to much experimentation with forms, including happenings and mixed-media events. In common with other parts of the world traditional painting and sculpture took on a less immediate relevance for the avant-garde. Jerzy Beres, a Krakow artist, developed his sculpture into public events, often including his own naked participation, questioning the whole notion of artistic creativity in challenging ways. Other artists developed conceptual theories in their work, linked closely to similar work being carried out elsewhere in Eastern Europe and by the international group Fluxus. In retrospect this period may be seen to have been something of a dead end but it did function very importantly as a motor for a radical reconsideration of the nature of art and brought a degree of prominence to a small number of artists who continue working, if in ways greatly different from those in earlier years.

In Spring 1965 the Foksal Gallery opened in Warsaw and soon became a gallery whose influence and importance extended, as it still does, on an international scale, with a record of exhibitions that reads as a chronicle of the Polish and international avant-garde over the past thirty years. The foundation of this gallery did much to help reassert the importance of new art in Warsaw, and it became, together with the Krzysztofory Gallery and the Art Museum in Lodz, one of the three major focal points through which contacts in many countries have been established and nurtured. Lodz, the pre-war centre of the textile industry and a former centre of the Jewish intellectual tradition that was all but wiped out during the war, has lost much of its

former glory but remains a major centre for artistic development. Due largely to the already established influence of the Art Museum and its policy of active co-operation with galleries elsewhere, Lodz gained international prestige as a centre of art. The Lodz Film School produced a succession of influential directors, among them Andrzej Wajda in the 1950s and Roman Polanski in the 1960s, whose films achieved wide recognition on a scale previously unknown. Work in experimental film also continued, involving artists such as Jozef Robakowski, Andrzej Lachowicz and Natalia LL, who also maintained international connections.

In the 1970s Polish art was characterised by an intensification of the social aspirations in art, a seeking of ways to utilise art as a means for questioning the status quo and for proposing alternative visions of reality. Through the three main centres of avant-garde art there was much interchange of ideas with sympathetic artists elsewhere, sometimes utilising forms that could be transmitted by post when travel was restricted — if sculpture and paintings were difficult to transport there was no such restriction on ideas and documentation. In 1972 the first major manifestation in Britain of Polish avant-garde art (on a scale not yet surpassed) created much interest at the Edinburgh International Festival. In conjunction with the Museum of Art in Lodz and under the mercurial influence of its eponymous director, The Richard Demarco Gallery staged 'Atelier '72' which showed work by thirty-nine visual artists, theatre performances by the artist Jozef Szajna, audio-visual music performances by Boguslaw Schffer, work by eight film-makers from the Studio of Film Forms in Lodz and the first performances in Britain of the Cricot[2] Theatre which caused a sensation. Seen as a whole the manifestation demonstrated beyond question the vitality of Polish contemporary art at that time, helping the re-assertion of its importance in a positive manner.

While the avant-garde arts in Poland came to greater prominence during the 1970s the social and political fabric of the country had started to crumble. The years of Stalinism had sown the seeds of dissent and successive protests had been harshly repressed: student protests in 1968 ended in violence, workers' protests against food

price rises in 1970–71 and again in 1976 brought an angry confrontation between the people and government militia, engendering a state of unease that would not go away. But in 1978 an unforeseen event of international importance helped to set in motion a process of change that has resulted in the redefinition of Europe. Cardinal Karol Wojtyla, Archbishop of Krakow, was elected as Pope John Paul II and his triumphant visit to Poland, drawing the largest crowds ever seen in the country, helped Poles to believe once more in their right to self-determination. The final fall of Communism was to come ten years later, but these years, for all the hardships they brought, brought about a widespread re-assertion not only of the notion of independent Polish nationhood but also that of a national cultural identity.

To a greater extent than ever before the social and political situation in the 1980s was allied to extensive changes in the position of art in the country. The social turbulence of 1980 and the subsequent legal registration of the independent trade union Solidarnosc (Solidarity) in November of that year demonstrated that the old order was facing a massive challenge and these extraordinary events caught the imagination of the world's media, making the names and faces of the principal participants familiar well beyond the country's borders. From the outset Solidarity was a very different protest movement, because for the first time in the long history of dissent in the country there was an alliance of workers, students, intellectuals and the Catholic Church which was eventually to prove unbeatable. For all that the Communist government had tried to impose totalitarian control over the country the Church had retained its power in what had long been a stronghold of Catholicism, and once allied to this power Solidarity achieved a powerful grip on the entire nation that even the extremities of the period of Martial Law in 1981–83 could not shift. Deeply disturbing on an international scale those and subsequent years undoubtedly were, and reviled as he was by the majority of Poles at the time, it may yet be seen that the actions of General Jaruzelski, the Communist Party leader, averted the very real possibility of a Soviet invasion, and helped to pave the way for a new Poland and, ultimately, to contribute to the downfall of Communism throughout Eastern

Europe.

Artists during those difficult years, unless they were old style 'apparatchiks', allied themselves to a greater or lesser extent with Solidarity and the consequent effect proved to be a turning-point in Polish art-history. The old artists' unions (which had in any case been viewed with suspicion by many artists) were in disarray and the state-run institutions were boycotted. It was a time of scepticism and plurality in which the old theories of the social relevance of art were put very much to the test. Unwilling, or unable, to show their work in conventional state-run gallery system of the time artists chose instead to exhibit in the unofficial but relatively safe surroundings of the churches, and in so doing entered into a dialogue not only with art-lovers and with churchgoers but indeed with the Catholic Church itself. Whether they were believers or non-believers many artists found it possible to express themselves in powerful ways. It is significant that a number of artists whose work achieved prominence chose to return to figuration and the older painterly traditions. It was of course a largely tactical liaison, beneficial to artists and the Church alike, but the work of artists such as Zbylut Grzywacz and Leszek Sobocki in the 1980s heralded a return to the power of realist painting, echoing in some ways the aspirations of Malczewski at the beginning of the century, and the demonstration of a national yearning for freedom in a form that was comprehensible to many. The dialogue that resulted in many places where artists and the church co-operated enabled a broad questioning of the place of art in conjunction with the energetic debates on the nature of the country's future.

In the crypt of the Church of the Holy Cross in Warsaw for example, in an initiative led by prominent members of Solidarity such as Professor Janusz Bogucki, artists showed their work in a series of exhibitions and events that involved many people of a broad range of persuasions. Unlike the atmosphere of the old state galleries, with all the echoes of totalitarian control remaining, churches were seen as being 'spiritually clean' places where artists, intellectuals and any other interested people could meet and explore the coming closer of art to Man's spiritual needs,

encouraging the search for the spiritual within and at the same time the ways in which this could be demonstrated to others. In the ferment of the early years of the 1980s much of the art that was shown in churches created controversy, sometimes because the overtly religious nature of the work ran counter to the former ideas of art's necessary independence, sometimes (as in the showing of abstract works by Koji Kamoji) because the work was obviously so opposite in form to the traditional notion of sacred or spiritual art. Out of this time however there came a much freer situation in which younger artists in particular felt able once more to return to the idea of 'art as art' instead of it being a didactic vehicle favouring or questioning one or another attitude or the status quo.

The 1980s was a time of far-reaching changes throughout Eastern Europe as the totalitarian regimes that resulted from two World Wars ceased to maintain any real credibility in a wider Europe that was itself having to change as a result of wider international economic and political influences. As the decade came to its end, bringing the final dismantling of Communism, Poland found itself having to deal with the harsh realities of the free market economy, and the need to compete on a broader stage in order to reassert itself as a European country with a presence and culture that belongs in the mainstream and not on the fringes. Artists, like everyone else, had to come to terms with this new situation, one in which the cushioning effect of the dependent socialist state (however distasteful the results of that effect were) was no longer there. Instead it was necessary to deal with a very different world, and within a country that had radically changed.

However, as far as artists were concerned, matters were not as bad as they might have been. The extensive 20th century tradition of the avant-garde in Poland gave a firm basis from which to proceed, one that had a relevance that extended beyond the country's borders. Cultural influences from elsewhere, often channelled through Germany, the near-neighbour and old enemy, brought about an alignment for many younger artists with neo-Expressionism and the Neue Wilde. Groups of young artists such as Gruppa (which included amongst others Wlodzimierz Pawlak and Jaroslaw

Modzelewski) and Kolo Klipsa found a ready identification with work being produced in Germany. A style looser and less restrained than that of Grzywacz and Sobocki, which characterised the start of the decade, began to emerge. This expressionist trend was far from imitation of developments elsewhere because the roots from which these young artists worked ran deeper, with a uniquely Polish signature based on the art philosophies developed during the course of the century. Poland has long had a formal tradition of art criticism and theoretical philosophy which has underpinned much of the effort of artists, even if at times the theory and critical stance became impenetrable to all but the intellectuals and artists who followed it. Nonetheless that late 1980s brought about the beginnings of a new freedom in the visual arts, producing much work that was readily acceptable in Germany and the Netherlands where Polish artists have gained a growing recognition.

In parallel with the developments of neo-Expressionism came a growing involvement in the public art scene of artists who, basing their work on well-established roots that reached back to the 1960s, used installation, performance and site-specific landscape art as the means for exploration and expression. The work of Krakow artists such as Marek Chlanda, whose use of drawing has developed into a unique form of sculptural installation, and Pawel Chawinski, who has worked in the natural environment, firstly at Florynka in the hills outside the city and more recently at remote locations in Scotland and Ireland, offered new propositions, which have a formal basis in drawing but a deeper means for considering art's role in defining and questioning reality. This tendency involved other artists as well, such as Joanna Przybyla from Poznan and Miroslaw Balka from Warsaw, who have extended the concepts of sculpture in ways that are gaining a growing international recognition. There are similar developments in many other parts of the World but the Polish contribution, based as it is on an identifiable national art tradition, has much to offer.

Equally there is much of value to consider in the work of other artists currently in their mid-thirties who are developing new concepts based on the depiction of the human figure, including a significant proportion of women artists who are using

painting as a means for reconsidering the ways in which the figure can be utilised to explore relationships within social developments. Among the artists in this category are Bozena Burzym-Chawinska, Hanna Michalska, Alina Raczkiewicz-Bec and Dorota Martini (all from Krakow) and Jadwiga Sawicka from Przemysl. While the methods they use are significantly individual there is a traceable common thread which combines a root in formal academic training and a feminist viewpoint that together offer new possibilities for development.

The art academies in Poland, where the majority of artists received their initial training, have played, and continue to play, an important part in the development of ideas and artistic trends as well as in art education itself. The four main academies, in Warsaw, Krakow, Poznan and Gdansk, each have a unique identity and have played their role in the definition of individual local traditions. While many art colleges in the West were abandoning the older traditional methods of art education, preferring to allow for an `anything goes' philosophy, the Polish academies stayed true to the notions of a basis of drawing from the cast and figure and working subsequently in a studio system, under the guidance of a practising artist. The result, far from creating an ossified adherence to past styles and attitudes, has been a lively, provocative even, evolutionary process which produces artists working in a very wide variety of ways connected however loosely to a traditional approach with considerable emphasis on the figurative. It is evident from the work of many young artists that while there is a considerable opening out of the Polish art world to the ideas and concepts of artists in other countries (itself not necessarily a bad thing), there is also a close identification with the history of Polish art. This has long been one of the strengths of Polish culture and still is — there is a recognisable historical development and an identity which is essentially Polish. How much this will change now that the borders are open and a freer interchange of ideas is possible cannot yet be judged, but it is to be hoped that the strength and individuality of Polish art will not be drowned in an international levelling out which fails to recognise the importance of national idiosyncrasies.

In the past ten years there has been a growth in the relationship between Polish

art institutions and galleries elsewhere. The exhibitions arrranged have been much more in the form of a dialogue and interchange than simply being exhibitions demonstrating national achievements. In 1985 the Moderna Museet in Stockholm, on the initiative of Olle Granath who visited Warsaw and Lodz in 1982, organised the exhibition 'Dialogue' which showed the work of seven Polish artists ranging from the old master Henryk Stazewski to the newly graduated Leon Tarasewicz, each artist being given the opportunity to invite an artist of his choice to show their work alongside his own. The result was a ground-breaking and truly international exhibition of art from Poland, France, Britain, Sweden and the USA. At the Van Reekum Museum in Apeldoorn, the Netherlands, in 1989 the Art Museum of Lodz showed a major exhibition, 'Vision and Unity', of the work of Strzeminski and nine contemporary Polish artists all influenced in their own ways by that leader of the mid-century avant-garde in Poland. The Lodz Museum was also instrumental in setting up in 1992 a major exchange of works, 'Collection, Documentation, Actuality' between its own collection and that of the Musée d'Art Contemporain in Lyons and l'Espace Lyonnais d'Art Contemporain. These and other such collaborations had the result of establishing Polish contemporary art in an international context and in the comprehensive publications that accompanied each exhibition have helped the establishment of a valuable resource of contemporary art history.

Within Poland also the developing situation, particularly in the last five years, has brought changes in the way in which art is shown to the public. While the extensive network of official BWA (Bureau of Art Exhibitions) galleries continues to show the work of Polish artists in a regular series of exhibitions and the National Museums in the main cities continue to stage major exhibitions (including the extraordinary 1994 'Ars Erotica' exhibition at the National Museum in Warsaw, an exhibition that would have been unthinkable even five years ago), it is in the area of the private commercial galleries that there has been the greatest development. With the coming of the free market economy there have been major changes in the country, particularly in the cities where franchised American fast-food outlets proliferate, as do up-market

restaurants and shops selling expensive Western products, and where luxury hotels and services cater for the growing needs of an economy that seeks actively to develop joint ventures with international businesses. It is of course arguable that such changes bring with them new dangers and that the economic imperatives may not always act in the best interests of the people of the country. But, so far as the visual arts are concerned the growing number of commercial galleries can be seen as being very positive.

It is evident that there is a new sense of optimism in Poland that was missing ten years ago, and the resignation to the grey realities of that time have been replaced by a sense of purpose which bodes well for the future. In Warsaw, and particularly in Krakow, there are new commercial galleries that are operating in very much the same way as galleries elsewhere in the west, building a stable of artists. some established, others newly emerging, and marketing their work not only locally and nationally, but increasingly in conjunction with galleries elsewhere and at Art Fairs. This raising of art's profile is likely to have a growing importance for artists, giving them cause to reconsider their attitude to the role of their work in relationship to the international art world. As the economy of the country grows it is probable that the number of new galleries will increase and become even more positive in their approach.

The old certainties, limited though they were, no longer hold true. Poland, whether or not its people like all aspects of the transition, will continue to emerge and play a growing role in the World and with this emergence will come many changes affecting the way in which art is made and shown. There is no doubt that the resources upon which Polish artists have long drawn and which have proved their richness in the past, will remain a valuable source of inspiration and potential for future development. Given the right opportunities, and provided that commercialism does not swamp creativity, Poland's artists will continue to prove that their work has increasing interest, deserving to be recognised for the worth it undoubtedly has.

ANDRZEJ BEDNARCZYK

The paintings and graphic works of Andrzej Bednarczyk create a world of strange contradictions where precious materials, hand-made papers and traditional art materials are allied to base materials and images that can appear banal. The success of his works is enabled by his masterly balancing of the two extremes, creating works that have an integrity and startling originality.

Bednarczyk was born in Lesna in 1960, studied Graphics from 1981–83 and Painting from 1983–86 at the Academy of Fine Arts in Krakow, graduating from the studio of Zbigniew Grzybowski. He currently works as an assistant in the Painting Department at the Academy, as well as pursuing his work as a painter. He was awarded Scholarships by the Ministry of Culture and Art in 1987 and 1988, followed by a grant in 1992 from the Pollock-Krasner Foundation in New York which was instrumental in allowing him to develop his present programme of work. As well as painting his creative activities have included theatre design, performance, participation in juries for International graphic art competitions and in 1994 the publication of a book of poetry, *The Stones of God*. In 1993 he made a journey of exploration to Siberia which has been influenced his work through his experience of that vast place and its ancient culture.

The paintings he made shortly after graduation, in his characteristic mixture of techniques on canvas that owe as much to his graphic training as his painting, utilise flows of thin or near monochrome colour over delicately worked textures and traces of graphic signs. The titles of these paintings, which contain clues to the meaning behind the work, were painted along one side in handwriting and have a poetic nature, for example, *Glory to the Outsiders of the Sea because they were the Ones to look at the Foundations of the Earth*. This serious playfulness is an element to which he has returned in recent work and is indicative of a manner of working which is not immediately apparent but requires decoding. In this sense Bednarczyk's work could be termed 'post-modernist' but this cliché is too trite if applied on its own. Instead it would be better to term his work 'poetic' for, although the images can stand on their own, the resonances that come through the addition of words reveal a sensibility

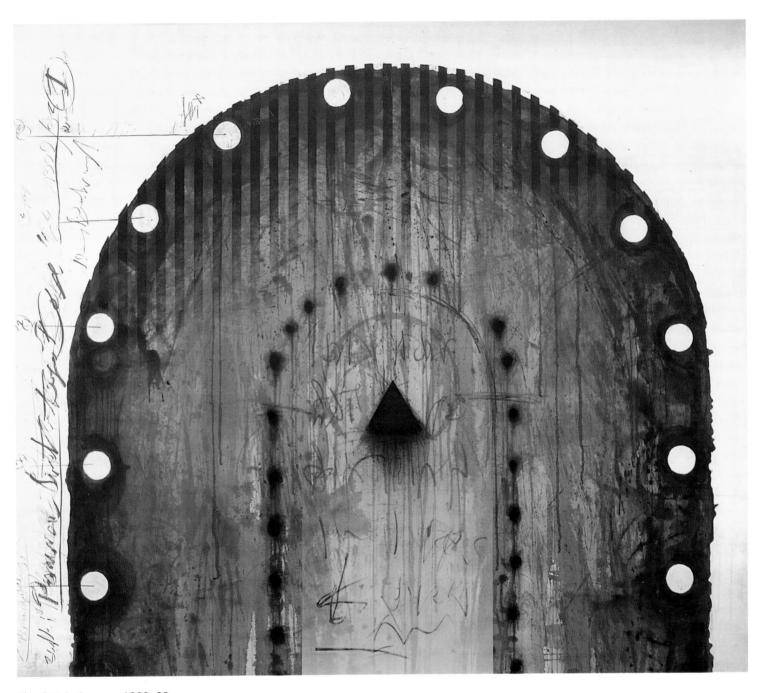

The Gate's Armour, 1992–93,
Gouache, pastel, print, gold on canvas and
board, 139 x 160 cm,
Courtesy Stawski Gallery, Krakow

that is akin to that of the poet.

The award of the Pollock-Krasner grant enabled the artist to realise a developing ambition, that of incorporating pure gold into his work. He had previously used gold leaf as part of his repertoire, using the material for its symbolic spiritual value and its ability to act as a counterpoint to the grey-brown tones of his paint. With the aid of the grant he was able to develop the application of 18 carat sheet gold on a substrate of clay which has resulted in a series of works of extraordinary presence. The atmosphere of his 1994 paintings is not simply more spiritual but contains something of the essence of medieval miniatures albeit on a much larger scale. The physical weight of the paintings is matched by an emotional charge that comes from the extreme contrast of thin paint on smooth canvas and the warm glow of the gold, and from the interplay of implied depths within the surface. The sense of delighted involvement with materials is continued in his graphic work, and, in a recent 'book' of many large pages, Bednarczyk demonstrates a rare virtuosity in the handling of heavy textured papers, inks, colour and gold leaf, with holes in the papers revealing a passage through the succeeding images, rewarding, as do his paintings, repeated viewings and contemplation.

Even if you hide yourself behind the last stone I will find again the softness of your carpets, 1989,
Individual technique on canvas,
110 x 130 cm

Between Body, Spirit and Soul, 1993,
Mixed media on paper, 50 x 35 cm

TADEUSZ BRZOZOWSKI

Tadeusz Brzozowski was born in Lvov (now in the Ukraine Republic) in 1918, lived first in Krakow and then in the Tatra Mountains town of Zakopane where he spent most of the rest of his life. He died suddenly in 1987 on a visit to Rome and was buried in Zakopane, his funeral being attended by one of the largest gatherings ever seen of representatives of the Polish art world, marking the deep regard in which he was held as a painter, illustrator, teacher and stage designer. Highly respected internationally as an artist, with many one-man exhibitions and representation in over 300 group exhibitions world-wide, he also achieved great success as a teacher whose influence on those he taught in Krakow, Zakopane and Poznan between 1945 and 1981 cannot be overestimated.

Brzozowski studied at the Academy of Fine Arts in Krakow from 1936–39 and again in 1945; in 1940–42 he continued his studies at the Krakow Kunstgewerbeschule which was effectively the pre-war Academy operating underground. During this period he was also a major participant in the underground activities of the Cricot Theatre for whom he designed masks as well as acting in Kantor's productions. In the first decade after the war the Cricot Theatre was the most important driving force in Polish art and the re-emergence of the Krakow group, in which Brzozowski was very active, did much to revitalise the avant-garde in Poland. Brzozowski's emergence as a painter of importance dates back to this period during which he survived the restrictive climate imposed by the Communist government by painting polychromes in several churches and becoming involved in the conservation of works of art, an interest which continued to absorb him for many years after.

His painting came to public notice through an exhibition of work by Krakow artists in 1955, and through his first one-man exhibition in Warsaw in 1956, which established him as a major figure. In the following years he showed widely and with success, as well as designing monumental tapestries and stage sets, interests that he was to return to on other occasions. While his international reputation increased, as did his foreign travels throughout Europe, South America and the USA (where he spent 7 months in 1971), he did not lose his connections with Zakopane. The blend

Razura, 1982,
Oil on canvas, 183 x 133 cm,
Photograph: Marek Gardulski
Collection: Museum of Contemporary
Art, Radom

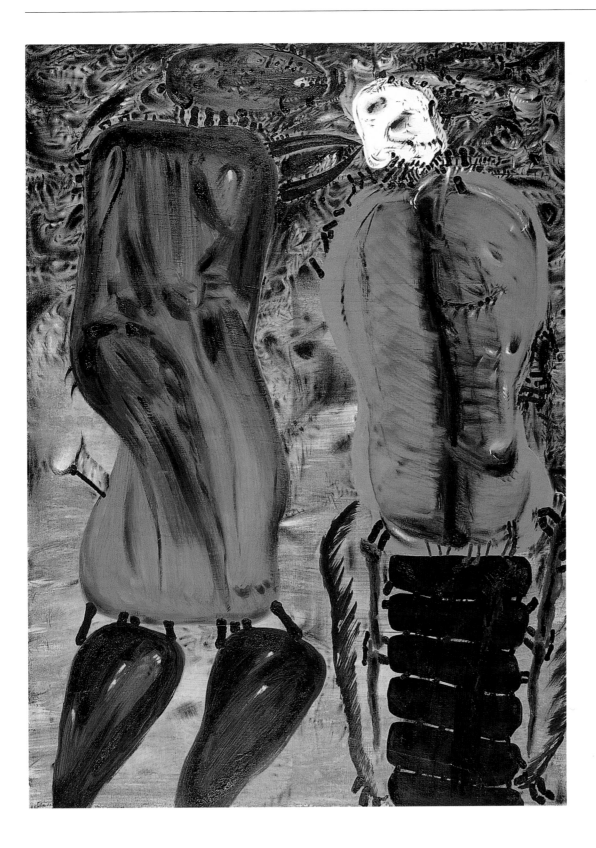

of a strong provincial home base and a wide knowledge of international art developments gave his work both a strength and a potent individuality. Brzozowski's formative years gave him a strong awareness both of the old traditions of his country, where the art of living well was matched by an equally important art of dying well and ancestral roots were honoured passionately, and of the vigour of the emerging avant-garde. This dual awareness, coupled with a firm basis in drawing, which he pursued as a parallel autonomous activity, formed the cornerstone of his art.

The main characteristic of Brzozowski's mature painting and drawing is that it is organic and visceral, full of movement and colour, with an underlying sense of the comical nature of Man's self-importance. He used line provocatively and with panache to create bizarre confrontations resembling military pomposity or animal couplings. At the same time he was able to create images that hold the attention through their lyricism while challenging the imagination with their magical mystery. His deep-seated humanity and the generous friendship with which he treated those with whom he came into contact run through his art where the joy of living is celebrated and the horror of death is denied with a haunting exuberance, the influence of which continues to inspire many younger artists. He has been described, fittingly, by the critic Anna Markowska as, '… a juggler frolicking with Majesty.'

Szwestra, 1979,
Oil on canvas, 136 x 140.5 cm,
Photograph: Zdzislaw Slomski
Collection: Museum of Contemporary Art, Radom

Egzercyrki Kres, 1982/82,
Ink, pen, brush, paper, 51 x 73 cm,
Photograph: Zdzislaw Slomski
Collection of the artist's family

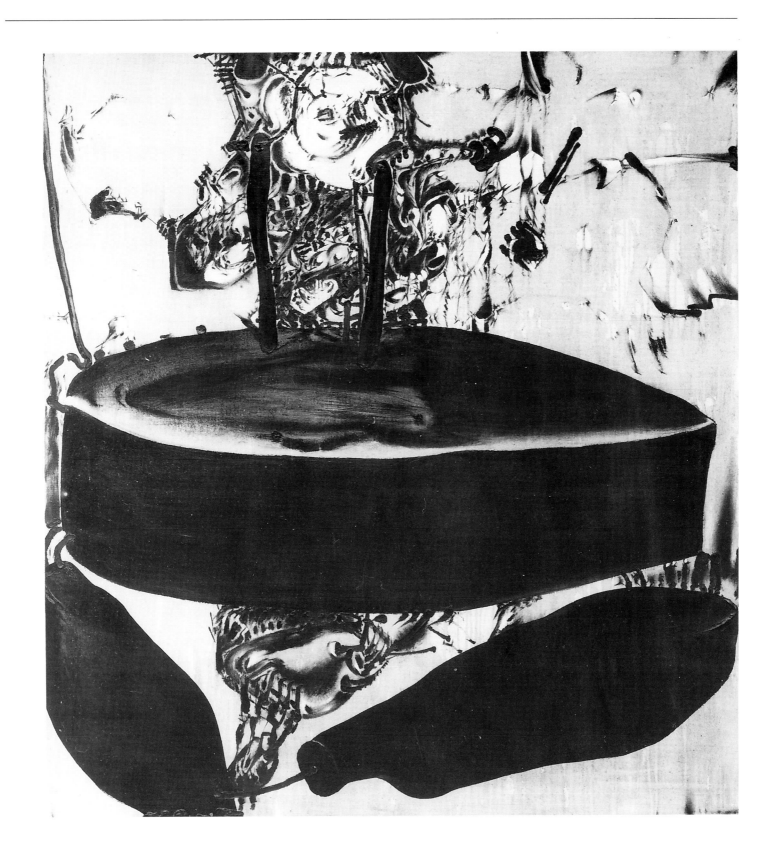

BOZENA BURZYM-CHAWINSKA

Bozena Burzym-Chawinska was born in Krakow in 1954 and studied painting at the State Higher School of Art and Design in Poznan from 1975 to 1980, graduating with an M.A. from the studios of Professor Tadeusz Brzozowski and Jacek Waltos. She lives in Krakow and is actively engaged in painting and drawing. Her work is essentially concerned with the human figure, not simply as a genre or traditional theme for the artist, but as the symbol of her fascination with the process of internal transformation and self-creation. While the gender and number of figures in her work changes from painting to painting she considers that, '… the crowd being drawn is essentially a result of the transformation that a single person undergoes … frozen within the frame of a picture, in various stages of his or her journey.' (Notes, 1994)

The resulting works have the nature of theatre about them, the figure and its variants become the participants in a drama that is essentially interior and private, even though its manifestation in her paintings becomes public. In this there is a sense of the paradox of human identity, an awareness of the relationship between the inner and outer lives that we all lead, and the complex reality that comes about through social interaction. Burzym-Chawinska is an observer, not only of the changes within herself but also, acutely so, of those that she perceives in others. The quality of pure line, evident in her drawings, is also very apparent in her painting, and this, combined with her fluent use of paint and carefully balanced colour, gives her work an individual and recognisable signature. She frequently uses multiple images, some fully resolved, others transient, indicating an awareness of the nature of movement which comes from her earlier involvement with dance. The results are frequently lyrical but this aspect is always offset by a harder edge and a questioning of the roles her figures play.

Burzym-Chawinska's ideas often result in a series of paintings which gives the opportunity to observe the process of transformation. In *Morning/Noon/Evening* (1992), for example, the sense of drama is heighted by her bold use of colour: in the first painting a nude female figure loosely drawn in reds stands against an area of

Presence — Absence II, 1994,
Oil on canvas, 120 x 120 cm,
Collection of the artist

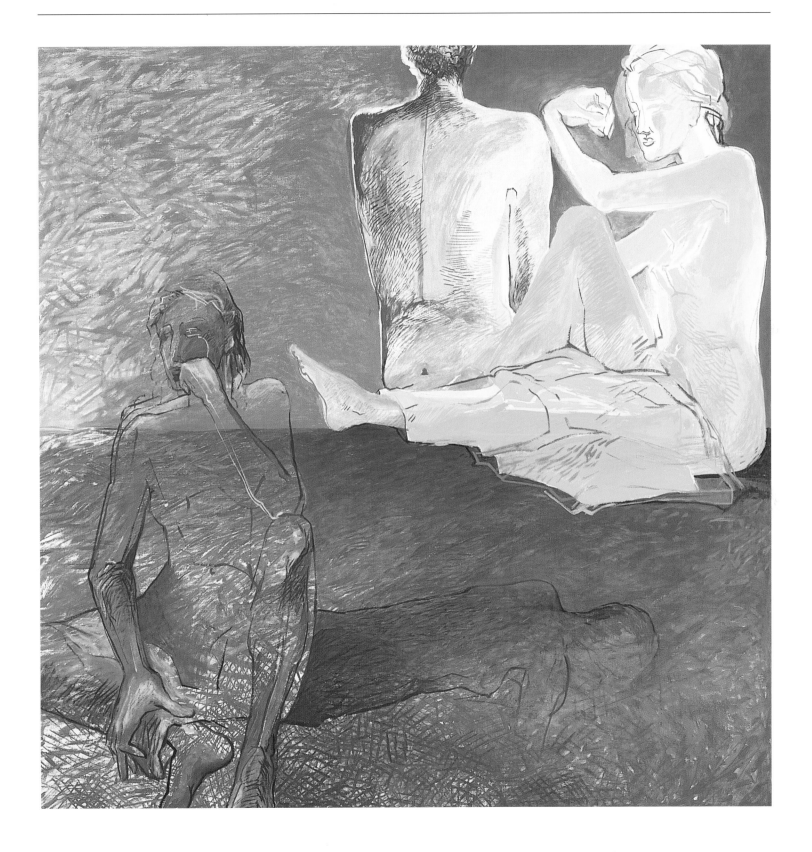

bold viridian across which falls the shadow of a slender tree; in the second a semi-clad couple, male and female sit back to back on a red cloth to either side of the tree against a blue distance which could perhaps be sea; in the third the couple walk across a wide russet area with a deepening viridian background and the shadow of the tree falls across their path. The story remains a mystery, the identity of the figures may change, but there is nonetheless the possibility of the observer of these paintings identifying with the images that are presented.

Presence – Absence II (1994) is a deeply reflective pair of paintings which deal, literally and metaphorically, with the tensions that come from togetherness and separation, and the spaces between people that come from both physical and psychological distances. With a palette restricted to blues and yellows and a confident delicacy of line Burzym-Chawinska has established a powerful statement of a universal truth within relationships. The clarity of her vision, coupled with her mastery of the medium, marks her as an artist whose sensibilities are well-suited to expressing the changes that are coming about not only in her country but also in the wider theatre of the human condition.

Monologue, 1992,
Oil on canvas, 80 x 100 cm

From the series 'Where do we come from, Where
do we go'. Installation: *Process of Change
(Entering the Drawing)*,
The BWA Gallery 'Arsenal', Bialystok, 1992/93

PAWEL CHAWINSKI

Pawel Chawinski was born in Krakow in 1955 and studied painting under the guidance of Professor Tadeusz Brzozowski at the State Higher School of Art and Design in Poznan, graduating with a M.A. in Painting. He subsequently worked as an Assistant Lecturer in the Painting Department at the Academy of Fine Arts in Krakow from 1975–89 since which time he has devoted himself full-time to his art.

In the early 1980s his work was almost exclusively concerned with pure painting and drawing, developing his own techniques within the traditional canon. His paintings of that period were portraits (including a notable portrait of Brzozowski), and portrayals of people packed into the trams that circle the old city of Krakow and link it to the concrete suburbs. He captured in these paintings, and in the fine pencil portraits of friends and colleagues, the tensions of the early 1980s in Poland and these works remain as a testament to those uncertain times. Between 1983 and '84 he stopped working, realizing that the means he was using for expression were no longer in tune with his developing philosophy, and he began a lengthy period of re-assessment of his motives and means. His return to the making of art began through a thorough exploration of the region around the village of Florynka in the foothills of the Beskid Sadecky hills in South-Eastern Poland. During a series of walks he photographed the structures made by the local farmers, stacks of logs, haystacks wrapped in tarpaulin and so forth, calling the series, 'My not Mine Sculptures'. Through this work he began rediscovering in his own terms the interactions between nature, man and art.

While staying in the country he also constructed sculpture using the flat stones of the river bed and made drawings on other stones using as his material the variety of coloured stones and clays in the region, works that had a life-span determined by the fall of rain and flow of the river. Some of these works he later reconstructed in his studio and in gallery installations, and in doing so found his own means for expressing the links between art and the environment. While this work can be seen to relate to the Land Art being produced elsewhere in the period it nonetheless has a

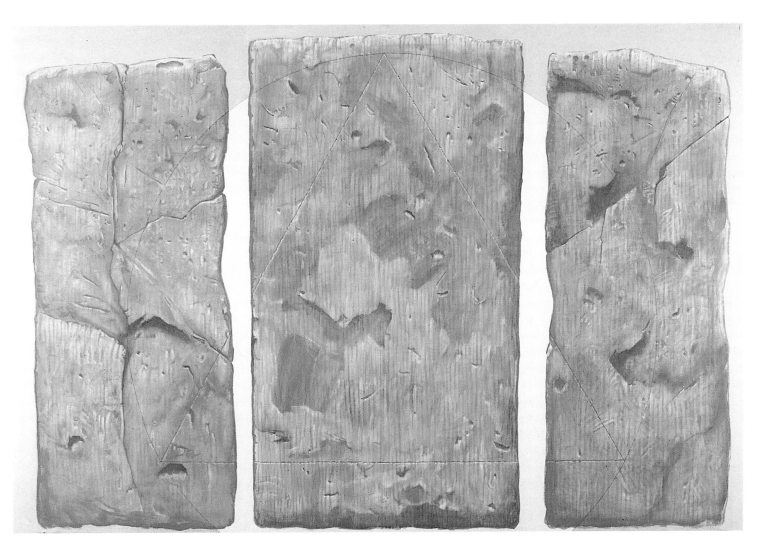

Vocatus atque non vocatus, Deus aderit, 1990,
Gesso, egg tempera and clay on canvas,
160 x 240 cm,
Collection of the artist

distinctive quality, based on his personal experience of the paradox of Krakow, in that one of the architectural gems of Europe is victim to the dreadful effects of pollution from the Communist era steel works at Nowa Huta.

Since then his work has taken various directions, ranging from the re-creation of stones in gallery spaces using mixtures of natural materials to recent paintings using natural clay as the main constituent of the medium. *Vocatus Atque ...* is such a work, based on the text, attributed to the Delphic Oracle, that Carl Jung carved above the doorway of his house. The full text can be translated as, 'Invoked or not invoked, the god will be present' and this is an apt text for the whole of Chawinski's recent work. His involvement in workshops in Scotland and Ireland has brought a new dimension to his art, and the serendipity of one location, in which he found the three basic geometrical white stones incorporated in his site-specific sculpture, *My Library*, provided a potent link for much of his recent output. While not exclusively painting Chawinski's art is derived primarily from drawing and the means he uses can be traced back to Man's earliest creative expression. It is an appropriate contribution to the art being made in this time.

Seven Stones and the Piece of Driftwood, 1990, Cliche Verre, 48 x 58 cm

My Library, 22 May 1992,
Stones on rock, length approx. 350cm,
Talmine Bay, Sutherland, Scotland.
From the series 'Sculpting with Scotland'

TOMASZ CIECIERSKI

Tomasz Ciecierski was born in Krakow in 1945 and studied at the Academy of Fine Arts in Warsaw, graduating in 1971 from the studio of Krystyna Lada-Studnicka. He was a lecturer at the Academy from 1972–85, a period which included two stays, in 1981 and 1983, as artist in residence at the Stedlijk Museum in Amsterdam. He spent 1985–86 at the Atelierhaus in Worpswede and in 1990–91 was awarded a research grant which allowed him to spend the year at the Museum of Contemporary Art in Nimes. He therefore began his professional career in advance of the coming of the Neue Wilde movement to Poland and before the events of the 1980s. Thus his work can be seen to provide a distinct alternative attitude to those that have tended to dominate Polish painting in the past two decades, and the uniqueness of his painting offers an important contribution to the current rich diversity of art in Poland.

Ciecierski's central preoccupation is the role of Time, Space and Memory in art, of the way his experience of the world in which he lives is modified through the layers of memory to enable a synthesis of his visual sensations. His paintings allow a partial insight into this complexity and give the viewer the opportunity to consider how this insight may complement his or her own experience. However total a visual experience may be Ciecierski believes that the process of recollection through memory acts as a filter so that the different aspects of that experience are given varying emphasis, subject to alteration and modification over a period of time.

Drawing is an integral part of Ciecierski's approach to painting, as well as an end in itself. In the drawings of the late 1970s silhouettes of figures are combined in ranks or massed together to suggest frantic movement. By the 1980s the figures have become more geometric, and presented in series as a larger work of up to twenty separate drawings suggesting a mysterious narrative. The paintings of this period run in parallel to the drawings, gaining in image density and incorporating the beginnings of themes that are developed in the work of the past decade. In the mid-1980s Ciecierski began to develop one of the themes which occurred as early as 1978 (in *Hot Night*) — that of the small landscape, similar to a tourist postcard,

Untitled, 1994,
Oil on canvas, 126 x 86 x 12 cm,
Photograph: J. Sabara
Collection of the artist

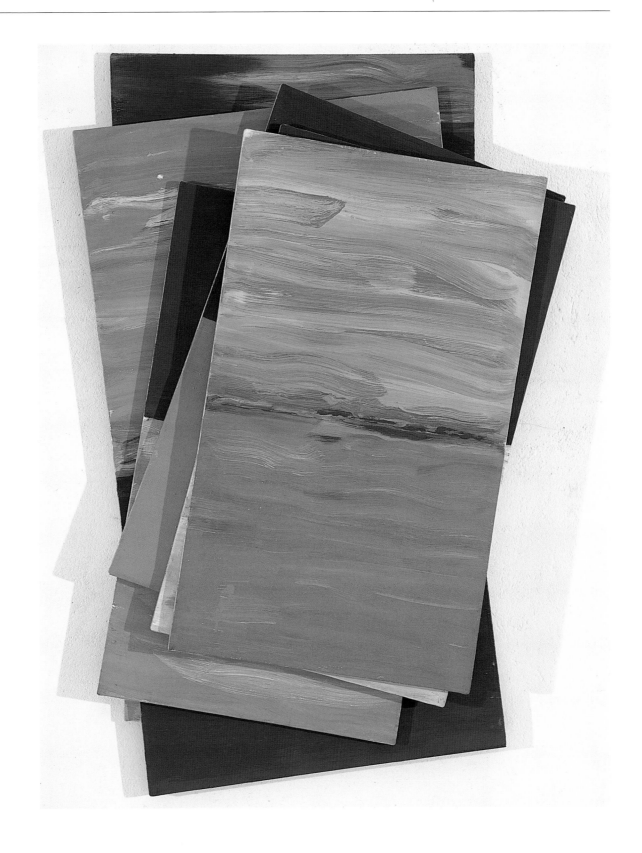

incorporated as part of the painting. In paintings such as *Déjà Vue* (1986) a large central canvas is surrounded by numerous smaller canvases, the central panel relating to his earlier work but the surrounding canvases adding a series of landscape images, all with a simple division into land, sea and sky. The sense of recalled memory and stories told becomes more evident.

From 1990 onward Ciecierski began to combine small canvases by placing them partially on top of each other, each part containing an image suggestive of landscape, but with an increasing tendency towards looseness combined with a wider range of colour. It is clear that a single painting did not suffice to express 'the idea recollected in tranquillity', and that only through multiple images could a satisfactory result be obtained. Yet this also was only a step along the way towards his recent work in which triangular canvases with a unifying colour — blue or red — are joined to create a flat painting in which the tensions between the constituent elements are more apparent, the narrative even more mysterious. Ciecierski appears to be moving away from the figuration of his earlier work and towards abstraction, but yet remains resolutely in control of his idiosyncratic technique.

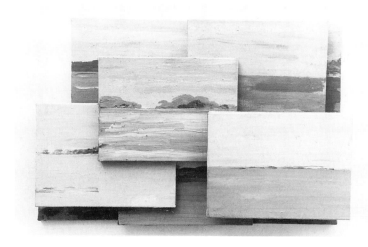

Untitled, 1991,
Oil on canvas, 49 x 74 cm,
Photograph: Jeanne Davy
Collection of the artist

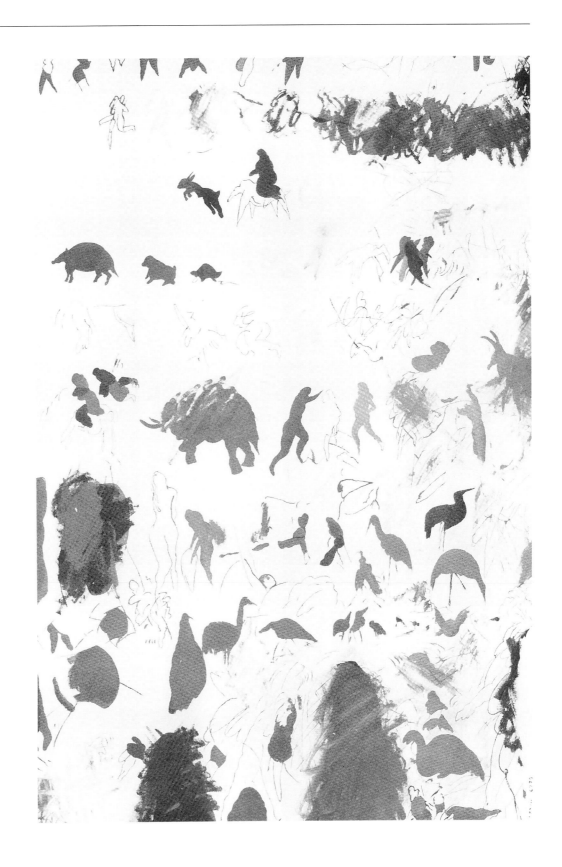

Paradise, 1979,
Oil on canvas, 200 x 180 cm,
Photograph: courtesy the artist

MARTA DESKUR

Marta Deskur was born in Krakow in 1962 and studied there from 1980-82 at the School of Fine Arts during which time she also worked at the Teatr Stu. In 1983 she went to Aix-en-Provence, studying at the School of Fine Arts until her graduation with a Diplome National Superieur d'Expression Plastique in 1988. She was an exchange student at the School of Visual Arts in Bristol, England, during 1986 and taught drawing at the School of Fine Arts in Aix-en-Provence from 1989-90. In 1992 she was artist in residence at the School of Design at Altos de Chavon in the Dominican Republic. She is now based in Krakow, where her work encompasses painting and installation. Her experience of studying and working outside Poland as well as within has given her work a universality which transcends a purely Polish approach to the development of her understanding of the aesthetics of painting.

There is an essential spirituality in the work of Deskur which is concerned primarily with line, form and carefully considered use of colour. By restricting herself to the use of simple means of expression she does not however lack a deeply underlying seriousness of intent, neither does she allow the possibility of the observer dismissing her work as being merely decorative. Instead she makes works which engage the observer as participant in a meditation on the nature of light.

The 'paint' used in her recent work is, unusually, natural pigment blended with acrylic medium applied to long, narrow canvas panels combined in sequences to create large paintings which have an austere stillness which requires contemplation. Her understanding of the nature of her chosen medium produces areas of colour having subtle variations in tone and texture, which combined with a certain lack of tension in the canvas results in a surface which modulates the light that falls upon it. This effect is apparent in each of the constituent panels and in their combination into the large final works. In a note about these works she writes that, '...the vertical form is that which unites the passing of time with progression' . She adds that, '...the work becomes an intermediary, allowing those that are involved with it to open a space of intuition and mystery in the direction of God who is the only Perfection.'

Hematyty 3, 1993,
Natural pigments, acrylic on canvas,
120 x 80 cm,
Photograph: Courtesy Zderzak Gallery
Collection of the artist

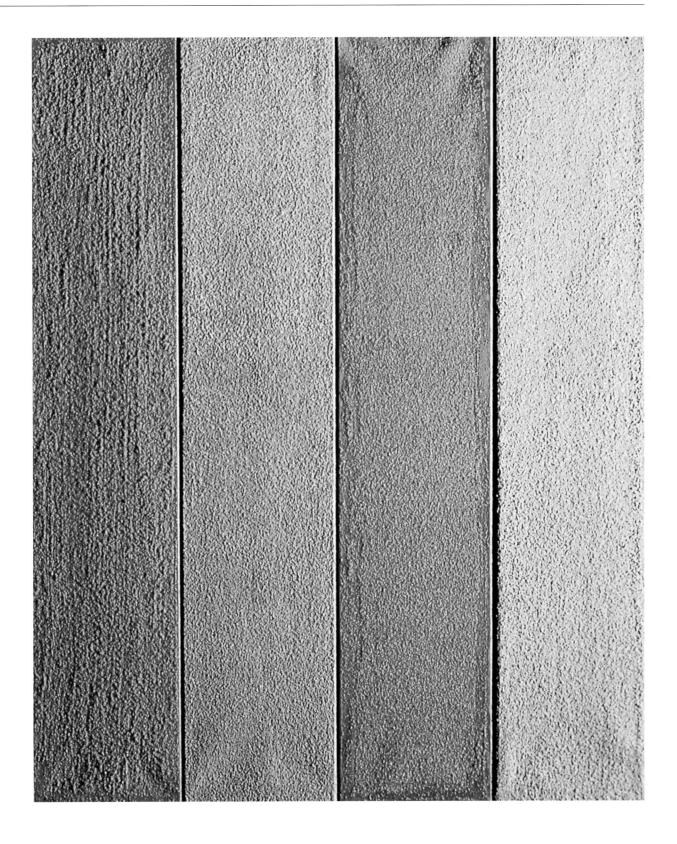

She includes a quotation from St. Thomas Aquinas, 'All that comes from outside enters into composition with the essence.'

Progressing from paintings to installation has allowed Deskur to extend her philosophy of painting into the third dimension, and through the temporary nature of such works allowing for the incorporation of the real element of time. In 'Modus' at the Zderzak Gallery in Krakow from December 1993 to January 1994 she created a three-dimensional network of saturated blue lines varying in tone which intersected to create geometric shapes on the white walls and ceiling of the room. She intended that these lines should create the sensation of ascetic simplicity, reaching towards the unlimited possibilities of metamorphosis, which were hinted at in the reflections of the lines in the polished floor and the windows of the room. Marta Deskur is aware of the paradox of temporality, taking it as a symptom of the manner in which we experience both light and art. The photographs of installations remain as a trace of memory whereas the essential quality of light is eternal. In these works, as in her paintings, she addresses a basic need for the artist and for those who participate in her work, that of approaching, tentatively, an understanding of the pure light of the universe.

Blue Room, 1993,
Pigments, fluorescent light,
Construction/Installation, Lodz,
Photograph: courtesy Zderzak Gallery

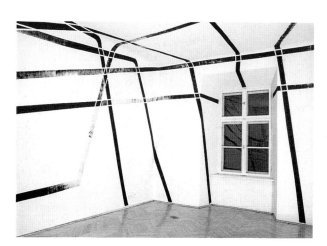

Modus 01.12.93 – 04.01.94 , 1993/94,
Painted installation, Zderzak Gallery, Krakow
Photograph: courtesy Zderzak Gallery

JAN DOBKOWSKI

Jan Dobkowski has created his own universe in his work, one which is at the same time quite irrational and yet perfectly logical, imbued with humour and yet at the same time deeply serious. He was born in Lomza in 1942 and from 1956–61 attended the High School of Fine Arts in Warsaw, then from 1962–68 the Academy of Fine Arts in that city where he studied firstly with Juliusz Studnicki and then with Jan Cybis. In 1972 he was granted a Scholarship by the Kosciusko Foundation in New York which enabled him to spend nine months in the USA, and he has since then travelled widely in Egypt, Europe, South America and Scandinavia, journeys which have informed his sense of art in relationship to human civilisation and the natural world, as well as giving him a different perspective on the development of his own country. His activities as an artist have encompassed painting and drawing and have resulted in a large number of exhibitions in many parts of the world.

The universe he creates is unique, readily identifiable as his alone and yet relating to the world in which we all live. Using, as he always has done, the elements of colour and line he invents (or interprets) a familiar set of responses to the human predicament of dualities — life/death, male/female, nature/spirit, substance/ether and light/darkness. His work is both child-like in the open-eyed sense of astonishment at the world around him and yet at the same time profoundly philosophical and true to a finely-honed awareness of the persisting importance of myth and spirituality. In his early work he used plexiglass cut into flat inter-locking shapes which echoed his paintings of the time — repeated suggestions of breasts and limbs evolving in delirious delight, organic, erotic and unashamedly speaking of physical pleasure. In these works the colour range was limited but saturated, provoking an immediate response to the contrasts of red and green, blue and red, yellow and blue. The apparent simplicity of line and colour concealed a deep awareness of their symbolic power, and this aspect of his work has continued with his development over the years.

Dobkowski's drawings and paintings have developed since the 1960s to contain greater complexity but still show his sophisticated skills as a draughtsman and his

Between Light and Shadow, 1992,
Acrylic on canvas, 197 x 441 cm,
Photograph: Jerzy Michalski
Collection of the artist

control of colour. His sea-journey to Latin America in 1986–87 resulted in a masterly series of small watercolours, 'Ocean', with subtle variations of hue, building up simplified figures and Ark-like boats, placed against the meeting of sky and water. Running through the images are variations of a motif that resembles floating seaweed, linking the elements together and indicating the flow of currents, while at the same time symbolising the cyclic nature of existence. Contrasting with this series are the drawings he produced in the difficult days of the early 1980s in which dense repetitions of curving and straight lines build up to form rhythmic structures in which small areas of light emerge from the encroaching greyness of the lines. These drawings are very different from those made in 1986–87 in the series 'Genesis' in which he returns to some of the earlier themes of sinuous female figures but with a greater subtlety that comes from the manner in which the forms emerge from a uniformly striated background of evenly spaced lines. The emergence of the figures symbolises the exultant bursting of life from a formless void, a theme which he continues in his recent work. In paintings brimming with life emerging joyfully from fertile fields of colour Dobkowski affirms the vitality of existence with power and great good humour.

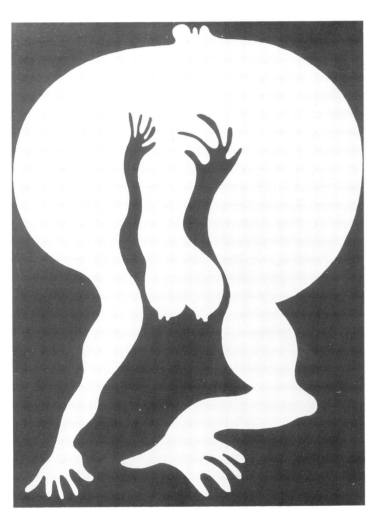

Abundance of Delight, 1969,
Oil on canvas, 200 x 150 cm,
Collection of the artist

From the cycle 'Ocean', 1988,
Acrylic on canvas, 197 x 147 cm,
Photograph: Andrzej Rybczynski
Collection of the artist

EDWARD DWURNIK

E dward Dwurnik was born in Radzymin in 1943 and studied painting and graphic art at the Academy of Fine Arts in Warsaw from 1963–70. He lives and works in Warsaw and has proved to be one of the most prolific and successful painters of his generation, with a noteworthy series of exhibitions throughout Europe. The evolution of his work marks him as a highly individual artist who has succeeded as few others have in describing a vision of the social realities of Poland throughout the last two decades. The sense of outrage that he feels is evident in his paintings and drawings which have an immediacy that cannot be ignored, and at the same time there is the sense of the impotence of the individual to act against the awesome power of social and political turmoil. His art seeks to comment, often forcibly, on injustice and barbarity but admits that it probably has little chance of effecting radical change.

In some respects, particularly in the series 'The Way to the East' (1989–91), he can be likened to Goya whose grim vision of *The Disasters of War* has lost none of its potency over the years, reminding each succeeding generation of the essential inhumanity and bestiality of conflict. In the case of this series of paintings the subject matter is the atrocities carried out by the KGB against Polish Army Officers, culminating in the horrors of Katyn Forest. There is a deep humanity in Dwurnik's work, however caustic his angry comments may be, and one senses that he identifies closely with the ordinary people of his country, yet at the same time being aware that he sets himself aside, in the role of onlooker and commentator. His work is diametrically opposite to Socialist Realism even if the range of subject matter is often very similar, but his workers are not shown as heroes, simply as victims struggling for existence in a harsh environment where the weight of history is palpable and the future is uncertain. The landscape in his paintings is far from being a bucolic setting for a pastoral idyll, instead there is mud, snow and unremitting hard labour.

Dwurnik's paintings and drawings are made in cycles, each exploring a different aspect of the Polish situation. A series of paintings of towns shows the buildings crowded together, the streets teeming with people engaged in the simple act of

Blue Cycle no. 1797, 1992
Oil on canvas, 150 x 210 cm,
Collection of the artist

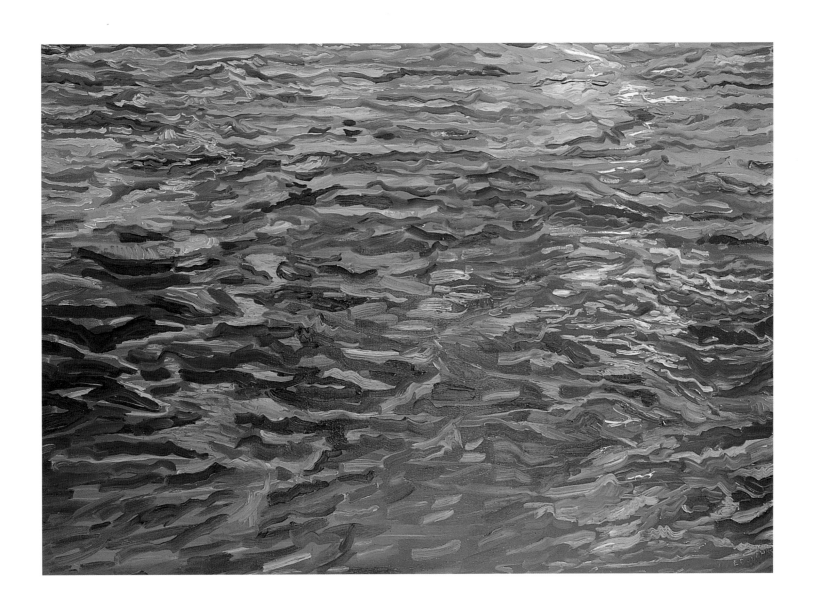

survival. In these works the artist detaches himself choosing to paint from an elevated viewpoint, yet is clearly closely aware of the minutiae of the daily struggle. In another series, 'Workers' is a painting of 1984 which shows two sturdy agricultural workers straining to pull the Ursus tractor to which they are yoked. Seen on a superficial level the painting is about the hardness of labour, but the knowledge that in that year Poland suffered a severe shortage of fuel that hit agriculture particularly hard, and also that the Ursus tractor factory was one of the main seedbeds of Solidarity, adds further implications.

In 1992 Dwurnik began working on 'The Blue Cycle' which marked a new and intriguing direction. In this series there is nothing but the sea, painted thickly in blues and greens, devoid of any spatial references, without coastline or horizon, and without the human presence so typical of his earlier work. The times change and as his country emerges to find its place in the new Europe it is certain that this artist will find ways to describe Poland's evolution that will confirm further his position as a major European artist.

From the cycle 'Workers',
Hope (No. 1191), 1986,
Oil and acrylic on canvas, 210 x 150 cm,
Collection of the artist

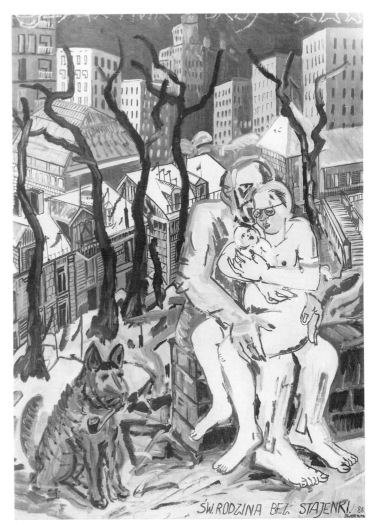

From the cycle 'Workers',
The Holy Family without a Stable (No. 1183), 1986,
Oil on canvas, 210 x 150 cm,
Collection of the artist

STANISLAW FIJALKOWSKI

During a long and distinguished career Stanislaw Fijalkowski has pursued a highly individual path, developing a style which has remained remarkably unaltered throughout the past three decades and which is immediately recognisable as his own. He was born in Zdolbunow, now in the Ukraine Republic, and studied at the State Higher School of Fine Arts in Lodz under the guidance of Wladyslaw Strzeminski, Stefan Wegner and Ludwig Tyrowitz, graduating in 1951. He has worked at the same institution since then, becoming a full Professor in 1983, and his career as an educationalist is as distinguished as that as a painter and printmaker.

There is a magical quality about Fijalkowski's work, one that defies categorisation, although he has at various times been termed by some a Surrealist, by others as an abstract artist, by others still as a master of metaphor. While certain correspondences can be traced in all these fields his work defies pigeon-holing, remaining consistently his own — further definition is not necessary and would prevent the depth of understanding required to enter his silent, magical world. He has written that, for him, '… painting is a technique to achieve concentration, perhaps close to Yoga. It serves to bring the picture of the World and one's inner life into harmony.' This statement, made for the catalogue for 'Poland Painting' in Epsom in 1986, provides the clue through which his mysterious world may be experienced. It is necessary to enter into a state of complicity with the works, to participate in a cool and clear vision of unity between the maker, the object and the observer. His work cannot be understood through the titles alone — these are in any case sometimes elliptical in nature and provide little more than a clue — but only through contemplation, with the work becoming the mediator between the artist's vision and the viewer's participation.

Fijalkowski has been honoured throughout Europe for his work as a painter and also as a printmaker, and his work in this latter medium, mostly in the form of linocut or woodcut, has a particular resonance. As with his painting his technique in these traditional forms is faultless, his sympathy for the materials he uses and a profound

Epitaph for my Mother, 1991, Acrylic on canvas, 70 x 60 cm, Collection of the artist

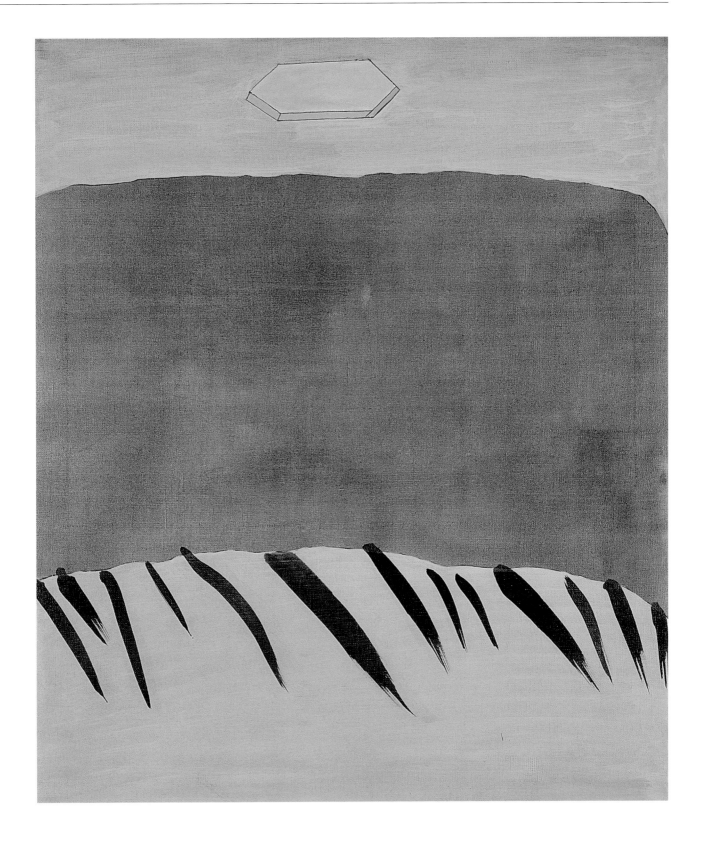

understanding of the control required have made him an acknowledged master. The stillness of his work does not, however, indicate that he has reached a point of stasis. While his work is greatly different from that of some of his younger contemporaries for whom the questioning of situations requires energetic expression, Fijalkowski instead employs gentler means. His paintings are usually in subdued hues, often approaching monochromes, but with a subtlety of palette that is entirely congruent with his use of line and form. Likewise the symbolism he uses is not immediately fathomable, but this is understandable when one considers that his inspiration is from such abstruse texts as the Talmud.

In a major series of works in the series, 'Autostrada' (or 'Highways') he is not presenting a literal view of roads as such, they are not merely the highways built by Man to enable his commerce and travel. Instead they are symbolic of the highways of the mind, the means for linking ideas, and express a poignant view of 20th century Man, doomed to wander through a modern world in which the deeper values of civilization are seldom considered. While his paintings and prints use techniques that are very much to do with the skills of the hand and eye, he has also recently begun to use a powerful computer and sophisticated graphics programs to express his ideas. That these works are instantly recognisable as Fijalkowski's is a tribute to his integrity and skill as an artist, and to his continuing exploration of the potential of art.

Talmudistic Study XVII, 1979,
Linocut, 43 x 33 cm,
Collection of the artist

November 10th 1993, 1993,
Ink on paper, 77 x 57 cm,
Collection of the artist

STEFAN GIEROWSKI

Stefan Gierowski was born in Czestochowa in 1925 and studied painting under Karol Frycz at the Krakow Academy of Fine Arts, graduating in 1948, together with Art History under Wojslaw Mole at the Jagiellonian University in the same city. In 1949 he moved to Warsaw in which city he has lived and worked ever since. His work as an artist following an uncompromising personal programme of development has been complimented by a distinguished career as a teacher at the Warsaw Academy of Fine Arts and active involvement in the promotion of artistic professionalism through the Union of Polish Artists.

In the four and a half decades since Gierowski graduated Poland has seen many far-reaching changes in its political and social life and consequently much change in the arts, both in terms of their nature and in their perception within the country. This artist has however not been diverted by shifting fashions from his chosen course since the mid-1950s. As with many young artists the first period following graduation was for Gierowski a time of experimenting with different styles, culminating in 1953–56 with a style based loosely on expressionism. Following his successful first solo exhibition at the gallery of the Club of the Polish Architects' Association in 1955 he began consolidating his earlier work, concentrating on the exploration of the notions of space through painting. At the same time he chose to avoid misunderstandings by giving all his subsequent paintings the title *Obraz* (*Picture*) followed by successive Roman numerals. In the following years until 1974 he explored various aspects of the problem of depicting space, both explicitly within the painting and implicitly beyond it through suggestion, using an essentially abstract language of colour and form. In his notes on the nature of painting Gierowski refers to the importance of the physical presence of the painting rather than theoretical explanations and judgements, stating that, 'Paintings left on their own … must defend themselves', and that painting awakens, '… energies and hidden areas of sensitivity — remainders of instinct which react faster and more precisely than slow thought.'

Since 1959 Gierowski has achieved a growing reputation not only within Poland but also in many other parts of the world. The inherently truthful quality of his work

Paintings in the Zapiecek Gallery, Warsaw (on right-hand wall) (Also shown, paintings by Ryszard Winiarski)

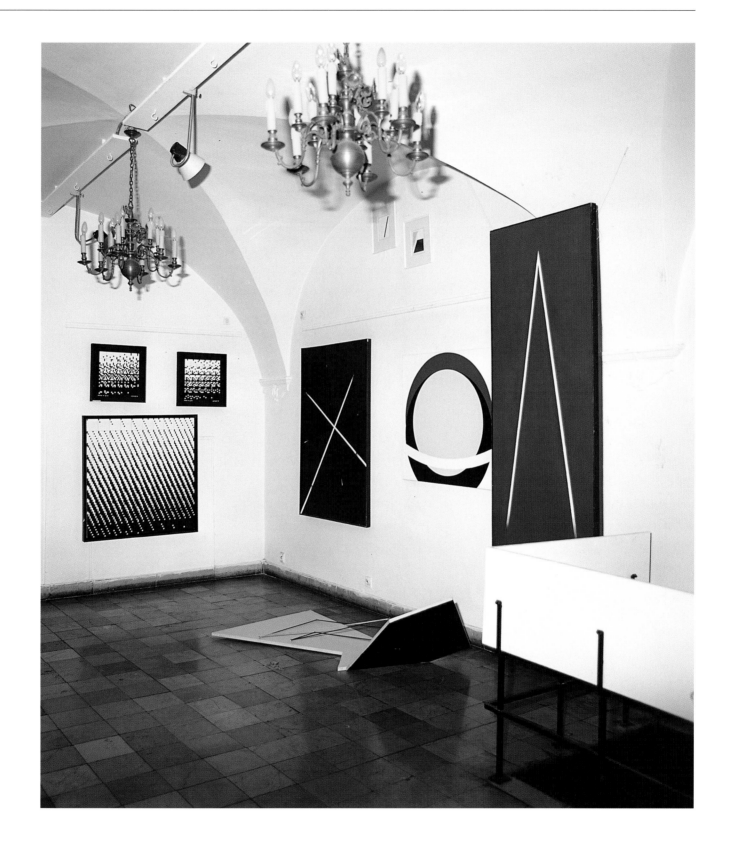

has an abiding appeal, dealing as it does with the world of visual perception, one based on the manipulation of colour through the contrast between light and darkness, and one which does not require the complicated semantics of lengthy theory to enable understanding. His painting is simply about painting, albeit with its own austerity of means, which communicates in a direct manner the whole realm of human emotions that must underlie such an honesty of expression. In one series of paintings from around 1988 he employed a simple approach, capable nonetheless of infinite variation. Using a thick impasto technique he applied black to the upper part of the canvas and colours to the lower part, blending them towards the centre. This simplicity did not result in yet another variation on colour field painting but in works of great richness, the black revealing a seemingly infinite depth, the colour pulsing with its own vitality, and their meeting creating a zone in which certainty of the physical presence of the paint dissolves into a shifting uncertainty where appearances can be deceptive.

Colour, light, form, space and matter remain the constants that Gierowski explores through his painting. His recent work reveals an artist who, using a profound but simple language, can produce paintings of great and lasting beauty which obtains a measure of timelessness.

Obiekt DXCVIII, 1989,
Oil on canvas, 135 x 100 cm,
Photograph: courtesy Zapiecek Gallery, Warsaw
Collection of the artist

Obiekt DCVI, 1990,
Oil on canvas, 135 x 100 cm,
Photograph: courtesy Zapiecek Gallery, Warsaw
Collection of the artist

ZBIGNIEW GOSTOMSKI

Zbigniew Gostomski occupies a particular place in the contemporary art scene in Poland, an exemplar for the 1990s of the type of fully engaged avant-garde artist that characterised the development of new art in Poland from the late-1930s onwards. His activity ranges from painting according to a self-imposed agenda to participating in theatre performances that extend the role of that medium as a means of creative exploration. He was born in Bydgoszcz in 1932 and followed a course of studies in the difficult post-war years, first at the Municipal School of Plastic Arts in his home town from 1948–53 and subsequently at the Warsaw Academy of Fine Arts where he studied painting in the studios of Janusz Stralecki and Michal Bylina, graduating in 1959. From 1960–72 he worked with Mieczyslaw Szymanski in the Department of Tapestry at the Academy while at the same time pursuing his career as a painter, and has since continued working in the Department of Painting where he is now a Professor. In 1965 he was one of the group of critics and artists who inspired the establishment of the Foksal Gallery in a wing of the Zamoyski Palace in Warsaw, a gallery that has since its foundation played a pivotal role in the advancement of new art in Poland. Following his meeting with Tadeusz Kantor in Lodz in 1965 he began a long association with Kantor's Cricot[2] Theatre, with whom he performed until Kantor's death in 1990, and since which he has been instrumental in ensuring the continuation of that unique theatre company.

The social and political situation in Poland has changed greatly during Gostomski's life and the development of his art can be seen to mirror many of those changes. His first major series, 'Optical Objects', in the 1960s explored the nature of light and dark in black and white paintings made according to rigorous principles. He continued these explorations, employing a variety of forms, throughout the next two decades, as well as exploring the possibilities of Conceptual Art in relation to his own development. His work of this period demands the intellectual involvement of the viewer as participant and will remain as documentary evidence of the manner in which Polish artists played their part in the international investigations into such means of expression. Throughout this phase of his work Gostomski retained his

Sunrise Still, 1991,
Oil on canvas, 160 x 240 cm,
Photograph: Jerzy Gladykowski
Collection of the artist

strong notions of the value of pictorial composition according the mathematical as well as emotional principles.

Towards the end of the 1980s he appeared to take a radically different route towards expression, although this is intellectually coherent with his previous work. Towards the end of December 1988 he made an installation, *How Green are Your Needles*, at the Foksal Gallery that consisted of two Christmas trees stripped of their needles, one mounted high in the centre of the gallery, illuminated by a bare light bulb, the other against the wall so that it appeared as the shadow of the first. The artist explained that it was a visualisation of the joyless situation in Poland at that time which should have had the feeling of the joy of Christmas. Around the same time he began to incorporate photography into his work as a further means of selecting and commenting upon perceived reality and also turned to a more pictorial form of painting, of which *Sunrise Still* is a potent example, the apparent banality of a sunset sky being mediated by the intrusion of a pale geometric wedge. In his recent work Gostomski proves yet again that the search continues for the means to encapsulate the uncertainties of his country as well as his power to give expression to possible solutions.

Left: *Optical Object XXXV*, 1965,
Painted relief, 150 x 100 cm,
Photograph: Piotr Tomczyk
Collection: Muzeum Sztuki, Lodz
Centre: *Untitled Drawing*, 1984,
Crayon on canvas, 164 x 164 cm,
Photograph: Piotr Tomczyk
Collection of the artist
Right: *Optical Object XXXIV*, 1965,
Painted relief, 150 x 100 cm,
Photograph: Piotr Tomczyk
Collection: Muzeum Sztuki, Lodz

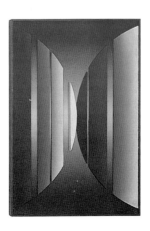

The Tower of Babel, 1992,
Crayon, charcoal on paper, 100 x 70 cm,
Collection of the artist

RYSZARD GREGORCZYK

One of the younger generation of Krakow artists, Ryszard Gregorczyk was born in 1958 in Scinawka Srednia and studied at the Krakow Academy of Fine Arts from 1982–86, graduating from the studio of Julius Joniak, receiving the Rector of the Academy of Fine Arts medal and a Polish Ministry of Culture and Art Scholarship. For the next two years he worked as an assistant in the Painting Studio of the Conservation Department at the Academy, since which time he has pursued his career as an artist, based in Krakow. Being of the younger generation and starting his career in the 1980s gave him a view of the possibilities of art very different from that of the preceding generation and, freed from the constraints of earlier decades, he was able to base his work on an individual discovery of the possibilities within painting.

His work of the late 1980s and early 1990s relied strongly on colour and a style that came between pure abstraction and figuration. In these works there can be discerned elements that are reminiscent of figures and landscape elements painted in vigorous brushstrokes against flat areas of primary colour. In 'Composition in Redness' (versions I and II) from 1991 he painted complex spatial arrangements of forms layered on canvas with a combination of oil and acrylic techniques, using the interplay of opaque and transparent to create dense illusions of a space which could either be urban or reflective of an response emotional to urban existence. There are partially realised suggestions of rows of buildings with serrated rooftops and darkened windows, open spaces, trees and figures which stand or stride across the space.

These responses to the experience of space were the precursors of his current work which shows a radical development, away from picture-making towards a more cerebral and reflective technique which offers new possibilities for interpretation. In this new work Gregorczyk addresses the complexity of cultural history, creating fragmentary images of an undefined past which paradoxically look newly made. Working with a mixed media on a ground that combines stretched canvas and plywood and a pristine control of his chosen materials he builds irregular shapes

In Triton's Embrace, 1993,
Individual technique on canvas and plywood, 135 x 170 cm,
Photograph: courtesy Stawski Gallery
Collection of the artist

which challenge the usually accepted rectilinear form of paintings, within which are resonances of ancient or more recent archaeology. These paintings suggest the fragments of old interiors, where the layers of evidence succeeding occupants are shown by the traces of wallpaper or paint but which bear hints of a far older civilisation. His colours have become more muted, mostly ochres and browns, with some black calligraphic traces, and these changes result in works which are essentially calm, requiring prolonged consideration of the manner in which they suggest the passing of a time beyond the lifespan of the artist.

Gregorczyk is working very much to his own agenda, linking his paintings to his own perception of the nature of memory and history. Through a rigorous use of materials he is symbolically recreating a distant anonymous past with its traces of other unknown lives while at the same time incorporating clear evidence of the newness of the work through the addition of a smooth area of new canvas painted in a neutral colour or a strip of smoothly finished wooden moulding. Through this technique he is creating paintings containing the sense of time and a clear acknowledgement that he, as an artist, is both entirely autonomous yet bound to a long cultural history.

From the series 'On the Edge'
Top left: *No. 3*, 1994,
Individual technique on canvas and plywood, 60 x 72 cm,
Top right: *No. 4*, 1994,
Individual technique on canvas and plywood, 60 x 73 cm,
Bottom: *No. 5*, 1994,
Individual technique on canvas and plywood, 80 x 165 cm,
Photograph: courtesy Stawski Gallery

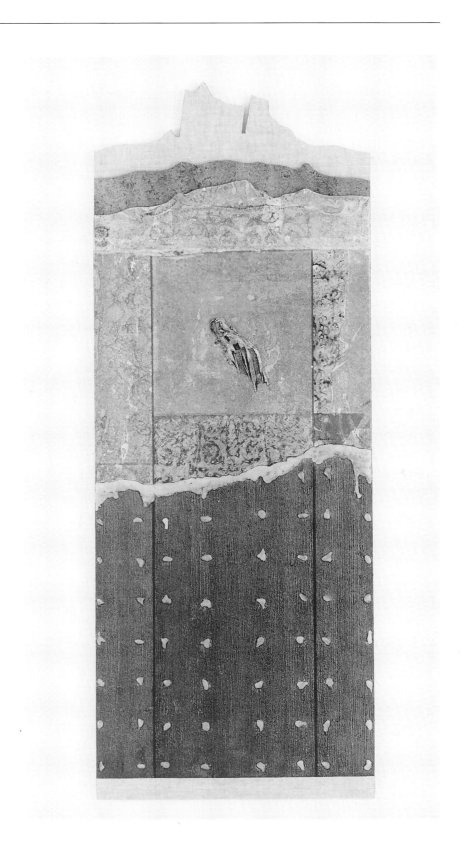

From the series 'On the Edge'
No. 7, 1994,
Individual technique on canvas and
plywood, 164 x 65 cm,
Photograph: courtesy Stawski Gallery

WLADYSLAW HASIOR

Wladyslaw Hasior is a unique figure in the Polish visual arts world whose range of techniques and their application defies categorisation. He was born in 1928 in Nowy Sacz, the market town in the Beskid Sadecky hills to the South-east of Krakow and studied at the State Secondary School of Plastic Techniques in Zakopane from 1947–52, then at the Academy of Fine Arts in Warsaw in the studio of Professor Marian Wnuk from 1952–58. In 1959 he was granted a Scholarship by the French Ministry of Culture which enabled him to spend a year studying in the studio of Ossip Zadkine in Paris. Since 1957 he has been teaching at the School of Plastic Techniques in Zakopane where he now lives in an apartment above the Muzeum Hasior, purpose-built in 1984 amongst pine woods in the Tatra Mountains. In this idyllic location he has developed a style of mixed-media art that is both highly personal and at the same time a profound meditation on Polish history and the nature of society in the twentieth century.

Hasior's work encompasses painting as well as sculpture and banners intended for both gallery and open-air situations. Much of his open-air work has included the elements of ceremony and memorial and has been the subject of numerous films. The unusual nature of his work has led to him being included at various times in exhibitions of Surrealism or Magical Realism, but he does not fit easily into either category: his work is emphatically idiosyncratic, recognisable instantly as Hasior's alone. This has led to exhibitions and commissions throughout Poland and internationally, and while criticisms of it being Kitsch or latter-day Folk-Art have been levelled at his work it retains a highly-developed integrity that elevates it above such facile descriptions.

In the lofty spaces of his Muzeum are displayed his mixed-media assemblages, and above all the banners for which is he is justly celebrated. These are frequently dedicated to Polish artists, such as *The Banner of T. Brzozowski s Adoration* which now takes the form of a memorial to the artist, or that dedicated to the Krakow singer Ewa Demarczyk. The banners relate to those familiar in churches and have a strongly iconic nature. While they have an undeniable presence in the gallery they

General view of the Muzeum Hasior in Zakopane,
Photograph: courtesy Stawski Gallery

take on a wholly different nature when they form the centre-pieces of outdoor ceremonial processions. Hasior's commitment to art in the open air is seen even more strongly in the monuments he has designed, for example *The Memorial to the Executed Guerillas* at Kuznice near Zakopane and the *Burning Birds* monument at Szczecin. He frequently designs sculpture to incorporate fire which adds a potent element to the work, for example in his major work, *Sun's Chariot* which comprises six horses cast in concrete in the earth of a Scandinavian hillside and covering an area of 160m x 60m to a height of 10m, symbolising the enduring spirit of the horse in Norse mythology. The resonances so visible in such works are present also in smaller more intimate works such as that which incorporates bars of soap manufactured by the Nazis from the victims of Auschwitz in a small glass case flanked by casts of human hands chained beneath a bronze Polish eagle.

Hasior reveals through his work a very private sensibility that is critical of those aspects of contemporary Man that are against nature and the essential humanity without which further progress is threatened. His art is didactic without being demagogic, profoundly humanitarian yet veiled in mystery. It is intimately linked to Polish history yet speaks of issues that affect all mankind.

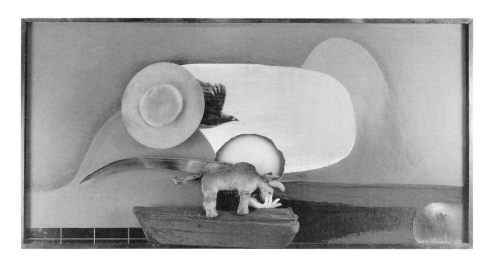

Ravishment of Europe, 1972–73,
Individual technique on board,
200 x 100 x 22 cm,
Photograph: courtesy Stawski Gallery

Banner of T. Brzozowski's Adoration, 1970,
Assemblage, 460 x 180 cm,
Photograph: courtesy Stawski Gallery

KOJI KAMOJI

Born in 1935 in Tokyo and graduating from the Musashino Academy of Fine Arts there in 1958, Koji Kamoji settled in Poland a year later and subsequently studied painting at the Warsaw Academy of Fine Arts under Artur Nacht-Samborski, graduating in 1966. Since then he has lived and worked in the Warsaw area and now maintains a studio that is a haven of calm near the centre of the city. The confluence of his Japanese origins and his life in Poland render Kamoji's art a unique thread in Polish contemporary painting, for while he has been closely involved in the development of the avant-garde, being closely allied to the Foksal Gallery, he has remained true to the philosophical traditions of his native Japan.

During his voyage to Poland in 1959 Kamoji passed through the Suez Canal and speaks of becoming aware of the sense of distance through the meeting of water, earth and sky. He says he understood that the concept of endless distance could not be expressed in his art and that he could only rely on the portraying of points on a limited plane. The earlier suicide of an artist friend in Japan, who had mixed paints on his palette before disappearing, affected him deeply and gave him a strong awareness of the urge for living through death. These experiences, and his abiding admiration for the work of the 17th century poet Matsuo Basho, have continued to influence him, merging with his life in his adopted country and giving his art the nature of the universal and international quest for the expression of the absolute.

While he has painted throughout his career he also extends his art into the form of installations and performances, often combining paintings with other elements conceived for specific spaces. There is a sense of the distillation of many factors in his work that creates a meditative calm. Much of his work in the 1970s was minimalist in nature, not so much because it followed or was influenced by other art being produced at the time but because Kamoji's approach is naturally reductive. The three paintings he sent to the 'Atelier '72' exhibition at the Richard Demarco Gallery were in oil on canvas, thin vertical lines on a warm grey ground, accompanied by specific instructions regarding their installation in a closed white room. The search for an appropriate stone of certain dimensions extended the concept beyond the confines

Underwater, 1992,
Oil on canvas, stone,
Photograph: Tadeusz Rolke
Collection of the artist

of the gallery and the resulting completion gave his work a unique resonance. In *Draught*, an installation of twenty-eight squares of suspended torn white tissue paper at the Foksal Gallery in 1975, the movement of air, either from natural draughts or the movement of visitors, gave a life to the elements through which the space in the gallery was defined. In 'The Flute' a consideration of the connections between the various elements of the work calls to mind the nature of silence and Man's interference with the natural world. The sense of time in of great importance to Kamoji and he frequently uses the presence of one or more stones, much in the same way as a stone in a Zen garden, as a reminder of the endless continuum in which art is made.

There are some elements in the painting of Kamoji that relate to Constructivism yet he is not a Constructivist, there are others which could lead to him being called a Minimalist, which he is not. The success of Kamoji's art lies in the fusion of eastern and western philosophies to create works which are mysterious and timeless, containing the essence of a deep spirituality, and revealing themselves gradually to the open mind.

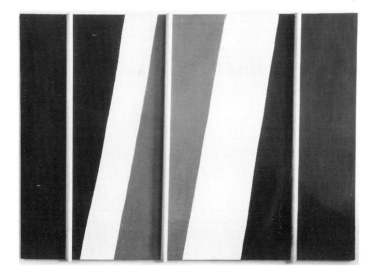

Haiku, Rain, 1993
Oil on canvas

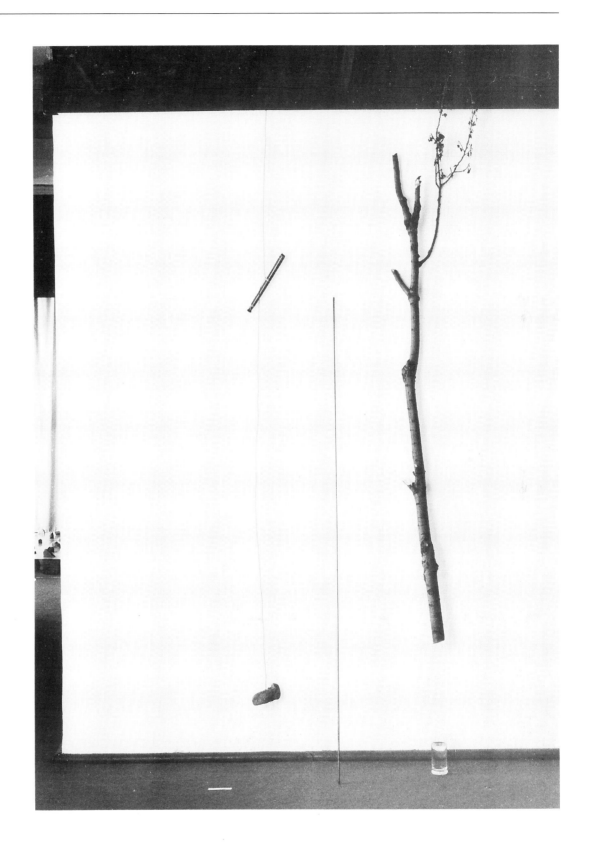

The Flute, 1988,
Installation, Galeria Dzialan,
Flute, wire, stone, rod, poplar
branch, glass, water,
Photograph: Erzam Ciotek

TADEUSZ KANTOR

Tadeusz Kantor was a central figure in the Polish art scene of the 20th century, instrumental in the development of the Krakow avant-garde of the late 1930s, one of the guiding forces of its survival through the years of the Nazi occupation and of major importance in its revival in the difficult post-war years. He is most celebrated for his work with the extraordinary Cricot[2] Theatre that gave such impetus to the work of Polish artists throughout the 1960s and 1970s, but for all the success of his work in experimental theatre he always considered himself primarily as a painter and wished to be remembered for his work in this medium.

He was born in Wielopole in 1915 and from 1933–39 studied painting with Zbigniew Pronaski and theatre design with Karol Frycza at the Academy of Fine Arts in Krakow. During the war years he worked underground with other young Krakow artists, often under very difficult circumstances, maintaining the explorations of the avant-garde through the Underground Experimental Theatre which, from 1942–44, sought to expand the notion of theatre from that of the traditional repertory form to a liberated medium in which the multiplicity of artistic theories could find form. These experiments found full expression from 1955 onwards in the work of the Cricot[2] Theatre in which the whole process of the creation was the result of a long collaborative effort of artists and actors under the mercurial guidance of Kantor, who moved through each performance as if the conductor, adjusting and fine-tuning the action with gestures and quiet instructions. The role of this unique theatre in the revival of Poland's cultural life since 1955 cannot be ignored, for it helped to set in motion a whole process of activities which have been central to many aspects of Poland's cultural life ever since, and through its wide acceptance internationally can also be seen as of major importance in world theatre terms.

That it was a potent visual form of theatre, despite having literary roots in the work of writers such as Witkiewicz as well as in Kantor's own biography is due largely to his background and primary interest in the power of visual expression. His large gestural paintings of the late 1950s owe much to the international move towards abstract expressionism. In the 1960s, as with many other artists in Poland,

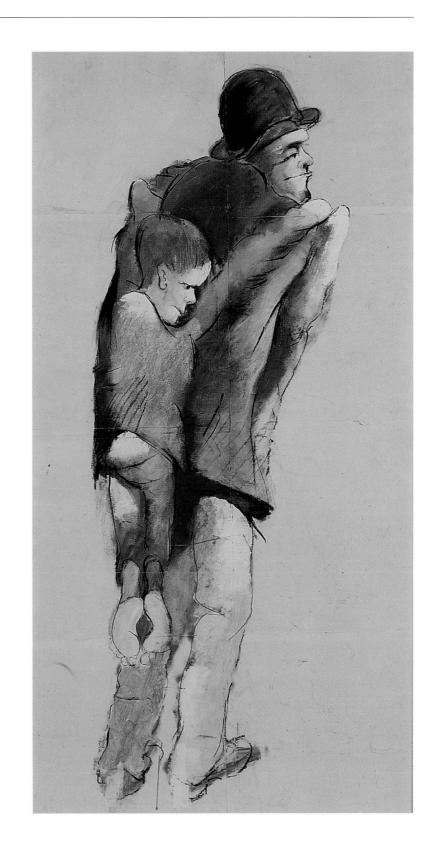

Untitled, 1982–83,
Mixed media on paper on board, 139 x 74.5 cm,
Photograph: courtesy Starmach Gallery

Kantor was involved in the creation of happenings, such as his Panoramic Sea Happening at Osieki in 1967 as part of which he conducted the Baltic, standing on a chair among the waves in full evening dress. Throughout this period he developed the ideas which were to become central to all his work, and his drawings and mixed-media pieces, as much as his theatre creations, bear witness to his idea of the importance of The Journey. His figures are weighed down with their baggage, their parcels and their rucksacks, they become the Eternal Wanderers always seeking the unattainable home which will mark the completion of the journey. Childhood memories, historical facts, dreams and emotions are given life in the drawings and paintings that formed the basis for later development in a powerfully visual style of dynamic theatre.

Towards the end of his life Kantor began designing the house that he intended should mark the end of his own journey, and his drawings in the series 'Dom' record the ideas that can be seen as the culmination of his fertile creative impulses. Sadly he did not live to enjoy the fruition of this final project, and his death in 1990 marked the end of a complex creative journey in the course of which his energy and vision was instrumental in making possible much of the work which now continues in Poland.

From the series 'My Home', 1972,
Felt-tip pen on paper, 20 x 30 cm,
Photograph: courtesy Starmach Gallery

From the series 'My Home', 1970,
Felt-tip pen on paper, 20 x 30 cm,
Photograph: courtesy Starmach Gallery

ANDRZEJ KAPUSTA

Andrzej Kapusta belongs to the generation for whom the propositions of art changed radically, from being the result of received impressions to offering the result of experienced emotions. The change came about in parallel with such developments elsewhere in Europe but in Poland, particularly in Krakow, brought a distinct change in direction which remains a powerful factor in contemporary painting in the country. Kapusta was born in Skawinie in 1956 and studied at the Krakow Academy of Fine Arts, graduating with distinction in 1981 from the studio of Jan Szancenbach, whose influence has proved crucial to many artists of that generation. The early 1980s were in any case a pivotal point in Polish history and the events of that time, coupled with a reassessment of the philosophy of art, will prove to be an equally pivotal point in Polish art history.

As with others of his generation the reassessment of values played an important part in the development of his art, and this remains evident in his recent work. Rejecting the accumulation of avant-garde attitudes from the 1960s and early 1970s left a void in the means available for exploration by young artists which was filled by a return to the acceptance of the value of emotional response, the relishing of colour and the essential role of drawing in art. This did not result in an immediate return to strictly formal figuration but to a new direction which included the depiction of the human figure as one of the fundamental motifs. In a series of paintings entitled, 'Machismo/Hembrismo' from the 1980s onwards Kapusta explored the contemporary role of man in terms of a longer history which led him back to the pre-Columbian Americas as well into Classical art history. These explorations were not applied literally, rather they provided a set of possibilities for him to express an understanding of some of the dilemmas facing contemporary man. The paintings and drawings from this cycle do not celebrate machismo as a virtue, but instead comment on it as a mis-direction of male energy.

In another cycle of works, 'Apollo and Marsyas', Kapusta draws inspiration from the ancient Greek world, in particular from the depiction of the nude human form on vases. There is no direct quotation from the figures that surround such vessels in the

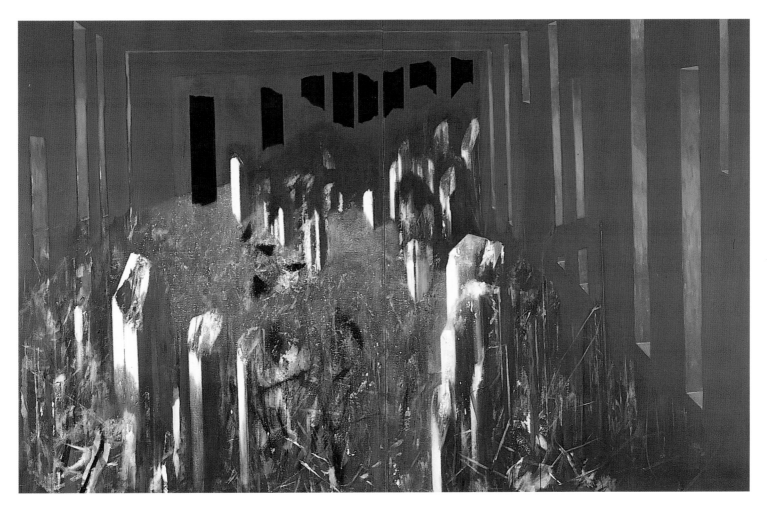

Fire and Ice XI, 1992,
Oil and acrylic on canvas, 180 x 290 cm,
Photograph: courtesy Dominik Rostworowski
Gallery

form of a pageant, instead the tight grouping of hard-edged figures is subjected to distortion, inversion and manipulation, the colours changed from near-monochrome to a range of lucid blues enclosed in cinnibar reds and stranded against a pale indeterminate background, distancing his work from the heightened emotional intensity of the vase figures and releasing their subjugation to a particular context of time. While he is obviously sincere in acknowledging the roots of his imagery Kapusta does not simply pay homage to them, instead he offers a slanted and sardonic view of the human figure and its social and cultural relationships.

The cycle of paintings, 'Fire and Ice', from the 1990s shows a new direction in his work. In these the figure is absent, replaced by complex fields of columnar forms of crystalline nature, some painted in blues and greys counterpointed with red, others in reddish-browns and whites. The references are less direct, drawn from the culminating point of Norse mythology, and symptomatic of the alienating effects of the late twentieth century world. Kapusta continues the restless quest for synthesis by different means, but the results speak of his firm engagement with the possibilities of an explanation of the human condition through painting.

Top: *Fire and Ice IV*, 1990,
Oil and acrylic on canvas,
180 x 290 cm,
Photograph: courtesy Dominik
Rostworowski Gallery

Bottom: *Fire and Ice V*, 1990,
Oil and acrylic on canvas,
180 x 290 cm,
Photograph: courtesy Dominik
Rostworowski Gallery

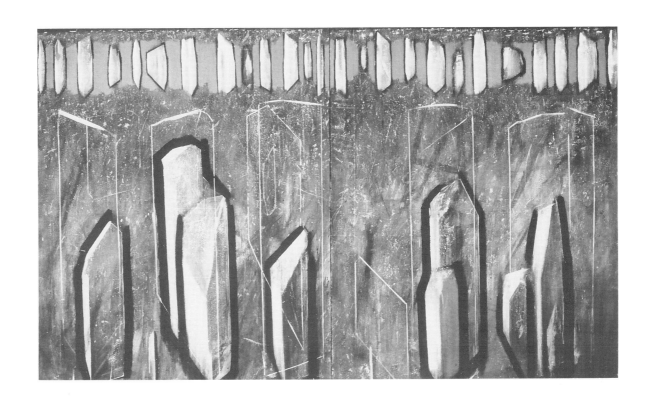

JAROSLAW KAWIORSKI

Jaroslaw Kawiorski was born in 1955 and studied at the Krakow Academy of Fine Arts, receiving his Diploma in 1980. He lives and works in Krakow and is one of the post-Solidarity generation of artists whose work, while linked historically to the long tradition of figuration in that city, is developing in an individual and original manner. His studio is at the top of an apartment block in a concrete suburb to the north of the city, overlooking the plain that stretches into the heartland of the country, a location distanced from the historic centre and open to the wide spaces beyond the city's edge.

His work, whether in drawing, painting or printmaking, in primarily concerned with the exploration of the naked human figure, usually in groups, and a consideration of the interaction of those figures with each other. The sources of his basic material vary from photographs to historical antecedents, so that his paintings reveal human forms that relate to both the photographic interpretation of reality and older forms of description. Most of his paintings of the early 1990s show the figures at near life-size, painted in a way that is controlled and yet loose at the same time. The elongation of the figures and the consequent reduction of the size of the head in proportion to the body is reminiscent in part of the figures depicted in aboriginal or prehistoric art establishing his work in a longer continuum of expression. Although clustered together the figures rarely touch each other — their nakedness is combined with a sense of alienation, their gestures are restricted to an extended arm or foot and a slight stiff bend at the waist. In the majority of this long series of paintings Kawiorski places his figures, thickly painted in a restricted range of colours that is almost monochromatic, against pale empty backgrounds devoid of any reference to structures or enclosures, so that they appear isolated in space.

In some of the paintings however there are manifestations which add another dimension; inverted or crouching figures, some in brighter colours are compressed or set at sharper angles to each other, setting up tensions and dramatic interactions. In some works that relate both to the series of figure paintings and a following sequence of black paintings different elements appear, fragments of objects or traces

Three Seated Figures, 1994,
Oil on canvas, 147 x 200 cm,
Collection of the artist

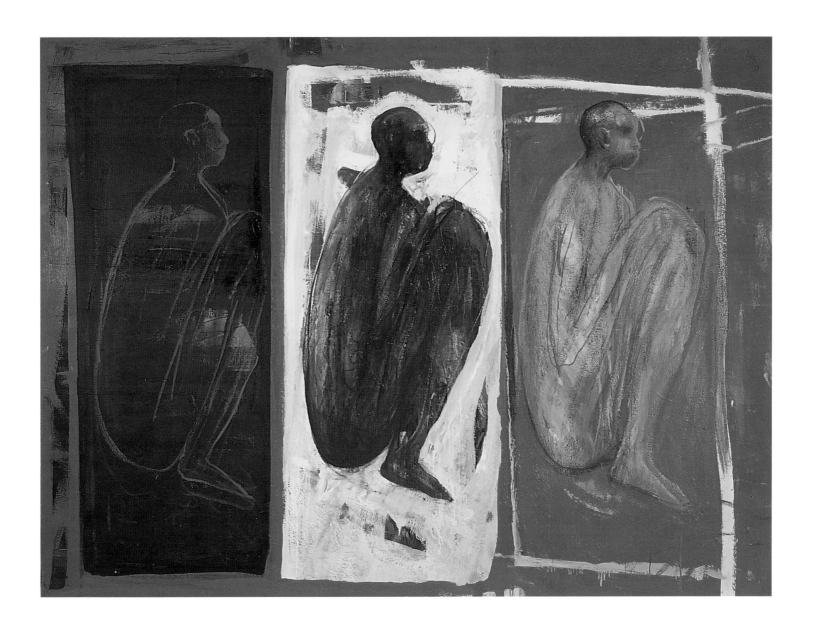

and patches of colour. In these paintings there is a greater sense of the questioning of the range of human inter-relationships, without answers being provided. The underlying philosophy is existential in nature as the figures occupy their own individual spaces, relating without passion only through their conjunction with others. The stories told are of mysterious intrigues and ultimately are without clear resolution.

The black paintings are closer to abstraction, with white shapes drawn into the encroaching darkness, creating traces that in part resemble maps, in part the remnants of anonymous objects. The resulting works offer no resolution but link with the inherent sense of anomie in the figure groups. In more recent work Kawiorski has turned to the use of brighter colour which liberates stronger emotive reaction. The figures in these paintings remain isolated from each other but the structure of the surrounding reds and yellows give a clearer sense of the occupation of a more specific space. With this development comes a sense of direction. with a greater notion of being able to identify with the situations in which the artist chooses to place his figures. The vision of the world revealed in these paintings is not always comfortable but it relates with quiet intensity both to the artist's immediate situation and also to the wider realm of Man's long quest for identity.

Nine Figures, 1990,
Oil on canvas, 147 x 200 cm,
Photograph: Pawel Zechenter
Collection of the artist

Three Figures, 1993,
Oil on canvas, 150 x 200 cm,
Photograph: Pawel Zechenter
Collection of the artist

LUKASZ KONIECZKO

Among the youngest generation of artists working in Krakow, Lukasz Konieczko is already establishing a reputation as a painter of promise and originality. He was born in the city, and through his subsequent studies there at the Academy of Fine Arts in the period 1984–90 became aware of not only the long tradition of enquiry into the art of painting in Krakow but also the rapidly changing social and political climate of Poland. These factors have combined, as with others of his generation, to give him a fresh and relatively uncluttered view of the potential of his chosen medium while continuing to work in the creative continuum of Krakow. His studies, under Zbigniew Grzybowski, from whose studio he graduated with a citation, led to him being awarded Ministry of Culture and Art Scholarships between 1988–90 which enabled him to study with Werner Knaupp at the Akademie der Bildenden Künst in Nürnberg. The international dimension has been important for this artist, giving him a view of his art even wider than that possible in a city which has long been at the forefront of links between Poland and other countries, and in 1992 he was enabled to take part in the innovative International Cultural Exchange Program founded by John D. Wilson in 1968 at the Lakeside Studio on Lake Michigan. He now lives and works in his native city.

Konieczko's large paintings in the early 1990s, particularly the series, 'Supporting the Sky', are built up in layers of dense impasto which are at first apparently devoid of any chromatic variation other than black and one colour. The structure is also seemingly simple, comprising one or two main vertical forms reaching up from the bottom of the canvas. Closer consideration reveals a greater complexity of colour and texture with other half-visible forms being perceptible. He also manipulates the finish of the surface so that the changing play of light falling on the canvas gradually alters the resonance of colour and texture. Apparent simplicity is modified through the concentration of the viewer into a rich complexity and the impression of energy constrained. In other paintings in the series, such as the Polyptych illustrated here, the variations within each high narrow canvas add together to create a serial impression of the changes in the interplay of light, texture and colour across the

From the series 'Supporting the Sky', 1994, Oil on canvas, 190 x 140 cm, Photograph: courtesy Stawski Gallery Collection of the artist

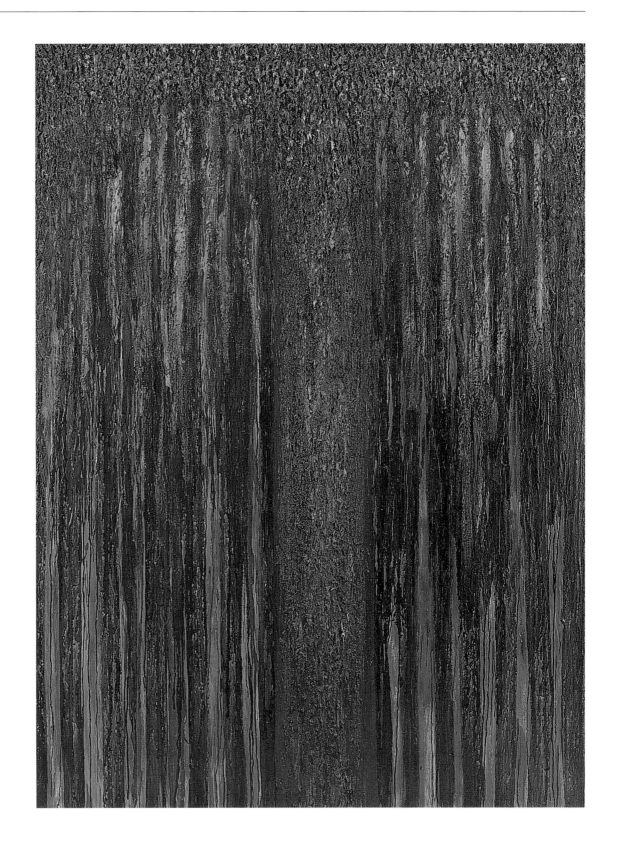

series. Essentially devoid of directly figurative references these paintings nonetheless suggest the textures resulting from ageing and decay in the natural and built environment which are fleetingly revealed by fugitive sunlight.

New work from early 1994 continues the exploration of light and texture but in an entirely different manner. While Konieczko maintains the long narrow format and the implied notion of decay he has approached these works from a different direction. Fragments of stained canvas bearing traces of wax hang from the top edge of pure white paper framed in a simple natural wood moulding. The forms created by this technique are offered as objects of precious worth, retrieved from the process of decay and preserved for further contemplation. A paradox is thus presented for consideration, that of the nature of intrinsic worth in something essentially worthless, suggesting that through the creative process even the humblest scraps of material evidence can have a value that approaches the conundrum of being both secular and spiritual at the same time. Konieczko's art has a specific integrity that cannot be readily absorbed at a glance, it requires and repays a deeper consideration that offers new possibilities for contemplation of the function of painting.

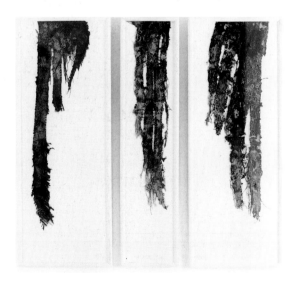

Survival Test IV, triptych, 1994,
Collage: canvas, wax on paper,
Left to right: 96 x 36 cm; 96 x 21 cm;
96 x 36 cm,
Photograph: courtesy Stawski Gallery

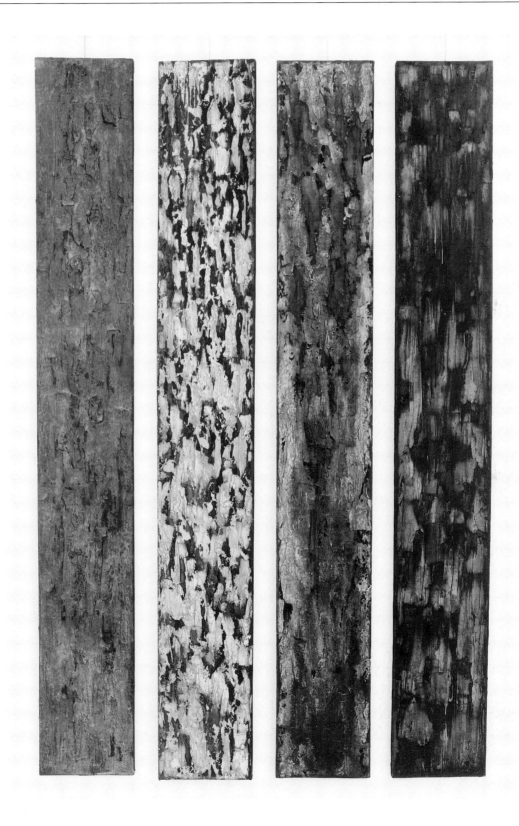

Polyptych from the series 'Supporting the Sky', 1993,
Oil on canvas,
Left to right: 200 x 27 cm; 200 x 27 cm; 200 x 27 cm; 200 x 27 cm;
Photograph: courtesy Stawski Gallery

WOJCIECH KOPCZYNSKI

For artists of Wojciech Kopczynski's generation their academic training came at an important transitional time in Poland, occupying the last years before the birth of Solidarity and the first difficult years of the 1980s, in which the visual arts went through a parallel period of re-assessment. Kopczynski was born in Krakow in 1955 and attended the Academy of Fine Arts there from 1975–1982, following a course in the Graphic Arts Department where he studied the Design of Advertising Forms with Witold Skulicz, Lithography with Wlodzimierz Kunz and Painting with Jan Swiderski. Following graduation he received a Ministry of Culture and Art Scholarship in 1984 and the Mayor of Krakow's Scholarship in 1986. He now lives and works in Krakow.

Kopczynski has developed a unique technique which builds up a heavily textured surface on the canvas, creating images that are hieratic and essentially mysterious. The first impression is of an assemblage of fragments cast from the remnants of some distant civilisation, clustered together in an attempt to reconstruct artefacts of which little can be known. The results appear confused but continued attention causes the details and relationships between them to become resolved. The structure of the paintings is in fact highly organised and while these paintings are not strictly figurative neither are they wholly abstract: that distinction insofar as works such as these are concerned is in any case somewhat arbitrary and open to suspicion.

In the untitled painting of 1990 illustrated here the impression is of an icon although without a specifically religious derivation. At a reduced scale the details become less obvious but embedded within the image are delicate patterns which relate to filigree jewellery, medieval windows or Islamic traceries — the total effect is one of sacredness, enhanced by the anonymous darkness of the background. In the Diptych of 1993 from the 'Monuments' series the fragments resolve themselves to include broken figures from crucifixions, in one part free from the tangle of shards, in the other trapped within a a more solid structure that appears to have been frozen in the process of crumbling.

The major polyptych of 1992, again untitled, allows for a consideration of how the imagery is constructed. The four sections relate obviously to each other, with

Untitled polyptych I, II, III, IV, 1992,
Individual technique on canvas,
each part 50 x 50 cm,
Photograph: courtesy Stawski Gallery

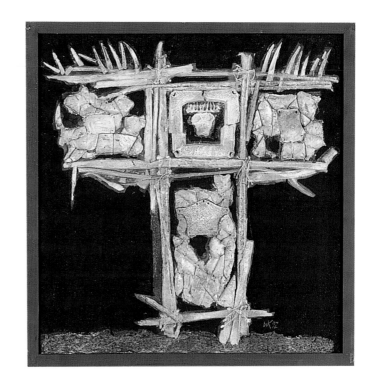
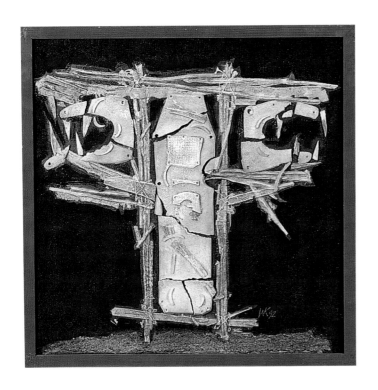
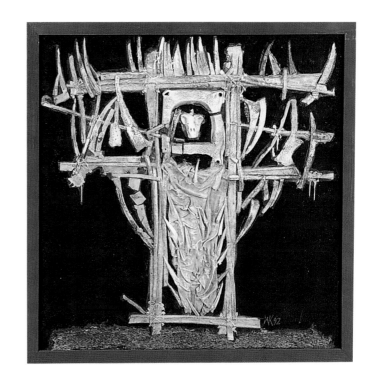

the main structure being formed by a skeletal tau cross. within which the fragments dissolve and coalesce as point and counterpoint. Lacking in any figurative elements these four small paintings, themselves arranged in a cross, lead the mind back through the imagery of established religion to a more distant place where the rituals are shamanic rather than Christian, and where the material traces break down to reveal the underlying structure. Kopczynski's references are open to interpretation but his intent, to focus the mind of the viewer on the process of Time, seems clear. His work relates to that of Jonasz Stern, but to a different stage in Poland's history in which it is possible for the artist to take a more positive view of the changes that are taking place in the country. At the same time, while his work in imbued with a strongly Polish sensibility, it is also the work of an artist whose certainty of the need to place himself within an extended global continuum of temporal awareness is obvious. In doing so he allows the viewer to become the participant in this quest and for each to find for themselves the meaning within the work.

Untitled, 1990,
Individual technique on canvas,
81 x 81 cm,
Photograph: courtesy Stawski Gallery

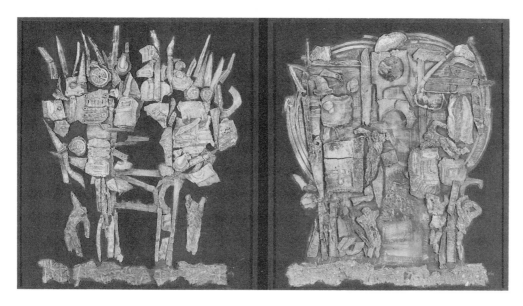

Diptych from the series 'Monuments', 1993,
Individual technique on canvas,
2 x 100 x 90 cm,
Photograph: courtesy Stawski Gallery

EDWARD KRASINSKI

Edward Krasinski is not strictly speaking a painter, although he uses paint as part of his work, neither is he strictly speaking a sculptor, although he uses three-dimensional form: rather he is a curious hybrid of the two opposing poles, an artist or perhaps a creator of works that relate to the gap between art and life, an interventionist in the perception of reality. He is nonetheless one who has played an important role in the development of the Polish avant-garde, one whose lightness of touch has served to enliven that avant-garde (which otherwise might at times have been in some danger of sinking under the weight of its own seriousness) with a gentle humour that gave due honour to all that it touched.

He was born in Luck in 1925 and began his studies at the Kunstgewerbeschule in Krakow in 1940, coming into contact with young artists such as Brzozowski and Nowosielski, in a time when the work of innovative artists was strengthened by its necessity to operate underground during the Nazi occupation. From 1945–50 he followed a more conventional course of study at the Academy of Fine Arts in Krakow, but one which confirmed his future mode of working on the further fringes of art, seeking his own solution to the problems of reconciling creative thinking with a post-war society in which certainties became increasingly less certain as the grip of Stalinism tightened. The result has been a succession of modes of expression which have defied the problems of the society in which they were made.

He is best known for his Blue Line interventions, in which blue plastic adhesive tape of a specific colour, 19mm wide, is fixed horizontally at precisely 130cm from the ground, continuing over any projections that are encountered. By this simple means (now unrepeatable by others without signifying Krasinski's original idea), which can be seen to represent time as it has in its conception neither beginning nor end, the artist denotes his presence, and in so doing intends to focus the attention of those who encounter the line on the reality that surrounds them. The line has appeared inside galleries, studios and apartments, affixed to the outside of buildings and man-made objects. It has been incorporated by the artist into exhibitions of his own paintings and wall-hung constructions — which consist of black lines on a white

Interventions XVI, 1977,
Acrylic on board with Scotch tape,
Collection of Muzeum Sztuki, Lodz

surface describing or building rectangular objects in space — and on life-sized photographs of paintings from a museum, as well as being transmitted by Telex to a gallery in Tokyo, on this occasion by the repetition of the word 'blue' five thousand times so that a line was formed down the centre of a long strip of paper which was exhibited in the place reserved for him. It has also appeared in his many exhibitions at the Foksal Gallery in Warsaw, as a line guiding the visitor through a constructed labyrinth and in an installation that comprised small trees and a large photo-mural of trees — on this occasion the line was removed after the completion of the mural, leaving a white trace of its former presence, with the intention of focusing the viewer's attention on the tension between the real trees and their photographic equivalents, the white symbolising the life-force of nature.

Krasinski shared an studio and apartment with Henryk Stazewski and after the death of Stazewski reconstructed that artist's studio in the Foksal Gallery, utilising real objects where possible, photographs of them where they were incapable of being transported. It was a fitting homage to one artist from another, a man who considers himself a Surrealist in his life and a Dadaist in his art, one who has, literally, made his mark on the art scene.

Fragment of exhibition, March 1994,
Galeria Foksal,
Photograph: Jerzy Gladykowski
Courtesy of the Foksal Gallery

Labyrinth, 1987,
View of exhibition, Galeria Foksal,
Photograph: Tadeusz Rolke
Courtesy of the Foksal Gallery

ZYGMUNT MAGNER

Zygmunt Magner was born in Katowice in 1937 and graduated in 1967 from the Warsaw Academy of Fine Arts where he now a professor in the Graphics Department. He lives in Warsaw and works with painting, drawing and graphic design. Together with a number of other artists connected with the Academy of approximately the same generation Magner shares the view that figuration remains a major strand in the rich diversity of painting in contemporary Poland. In the mid-1960s, in common with artistic trends elsewhere in the world, there was something of a polarisation in the Polish visual arts between three main tendencies: firstly, the avant-garde, who tended towards abstraction, secondly, the Colourists, who eventually reached something of a dead end, and thirdly, the Realists, attempting to inject new life into the, by that time discredited, style of the State-imposed Socialist Realism of the previous decade. For many of those who graduated in the 1960s none of these tendencies proved adequate for the expression of their ideas and, although individual techniques varied considerably, the New Figuration became a common trend, one which enabled young artists to address to better effect the humanist values that they considered important.

The development of Magner's painting follows a clearly defined pattern, underlying which is a deep meditation on the nature of time, both as an absolute (that is divine time) and in the human perception of that absolute. In the earlier stage in his work he used the portrait as the starting point, gradually degrading the clear image beneath wrinkled and textured paint and fragmenting the features until he approached closely abstraction. The face is perhaps that of Venus, symbolising the ideal human form, complete with the tangle of emotions that are revealed through the features of the face. By the early 1980s the disintegration was almost complete, physical time had all but eradicated the face and a new direction became necessary. The concept of time is a complex one and is in any case highly subjective, but through a process of reduction Magner approached the point at which a symbol for the intervention of time as a divine absolute became necessary. He found inspiration for the second stage in his work in the sculpture of the Apollo of Tenea, dating from

71189, 1989,
Oil on canvas, 110 x 130 cm,
Collection of the artist

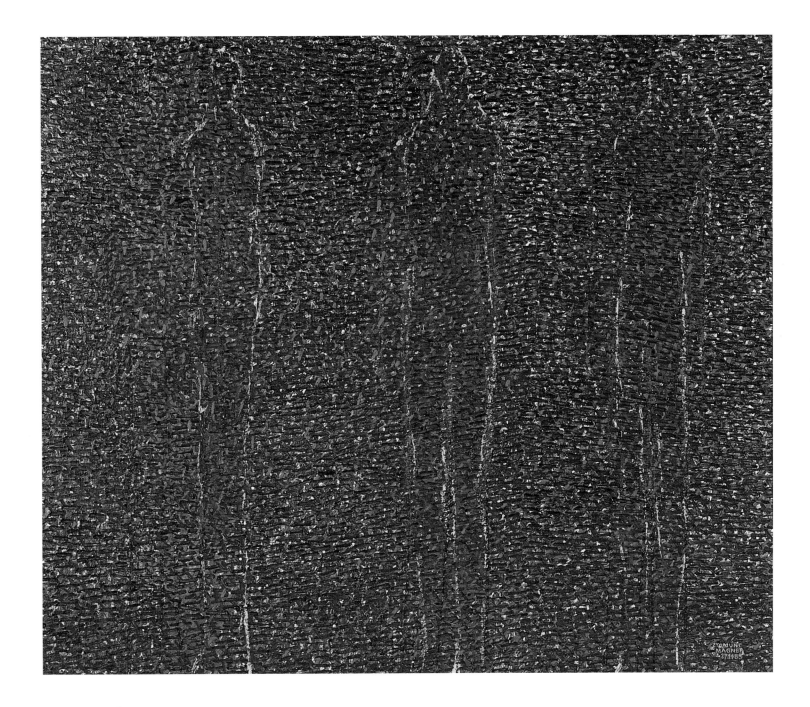

the 6th century B.C., a time in which sculpture was concerned with the absolute ideal human form rather than with the depiction of individual characteristics. This sculpture show Apollo standing erect, facing directly ahead, arms at the sides and one foot forward, as if moving slowly towards the viewer.

From 1983 onwards Magner has used this Apollo as his starting point for a long series of drawings and paintings. As with the first phase in his work this series has followed a process of disintegrating the image, then allowing it to emerge partially before dissolving it again into myriad points of complex colour. By replicating the figure, usually three times, within each drawing or painting he enables the process of change to become apparent. Viewed as a series this effect become even more potent, especially with his recent work in which Apollo, personified as the Sun-God, becomes pure light shattered into coloured fragments. Magner's work may be seen as obsessive, following a path that takes little account of the great human changes in the society in which it has been made. It can also be seen as a profound meditation on the way in which the eternal presence of time can be stated with direct honesty, as seen in these haunting drawings and paintings.

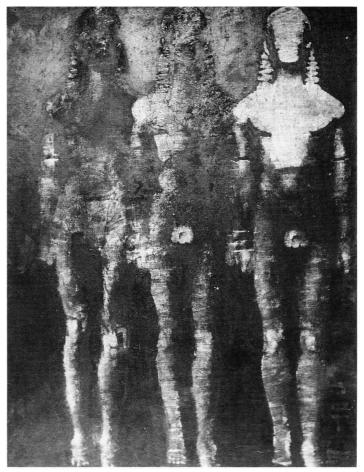

1483, 1983,
Oil on canvas, 100 x 82 cm,
Photograph: Franciszek Gorek

8487, 1987,
Oil on canvas, 100 x 80 cm

DOROTA MARTINI

Dorota Martini was born in Krakow into a family where her grandfather and father were engineers, but also part-time artists. She studied painting at the Academy of Fine Arts in Krakow between 1975 and 1980 graduating from the studio of Adam Marczynski, a prominent member of the Grupa Krakowska in the post-war years. During 1977 the murder by the secret police of a student, Stanislaw Pyjas, helped to harden the Students' Solidarity Committee's opposition to the Communist régime and in 1978 Dorota Martini was chosen as spokesman of the Committee, as well as working as designer for the underground press. In the last months of 1981 she also worked on the design of leaflets and posters for the main Solidarity organisation, and in the same year became a Art teacher in a secondary school, leaving in 1992 to work in a Cultural Centre.

Speaking of her work she says, 'I hope that now artists in Poland need not be politically engaged, but mostly I prefer art with the spirit of the time, art including the most important emotions of society.' This statement underlies her work which is centred on the human inter-relationships in this transitional stage in the development of Polish society. Through her decision to concentrate in this manner she has developed a body of work which gives a deceptively simple first impression, appearing child-like (but never childish) with an apparent lightness. But Martini is clearly fully engaged with the serious side of social development in her country, fully aware, from her position as a politicised woman artist, of the strengths and the fragilities, as well as the inherent dangers, of the society in which she lives. The serious nature of her work surfaces through the first impression to create tension and unease. In a major work from 1988–91, *Communism has died, but do we really want to be normal?* (illustrated here), she stacks four rows of five smaller canvases together, the first three rows representing some of the range of archetypes, centred on a distorted red face; in the bottom row the five faces have become disturbing masks, sinister and threatening. The naïveté is controlled and mediated by the skilful manner in which she paints each individual face and by the way she arranges them, in something of the form on an iconostasis where the total effect exceeds the sum of the parts.

Communism has died, but do we really want to be normal?, 1988–91, Acrylic on canvas, 130 x 135 cm

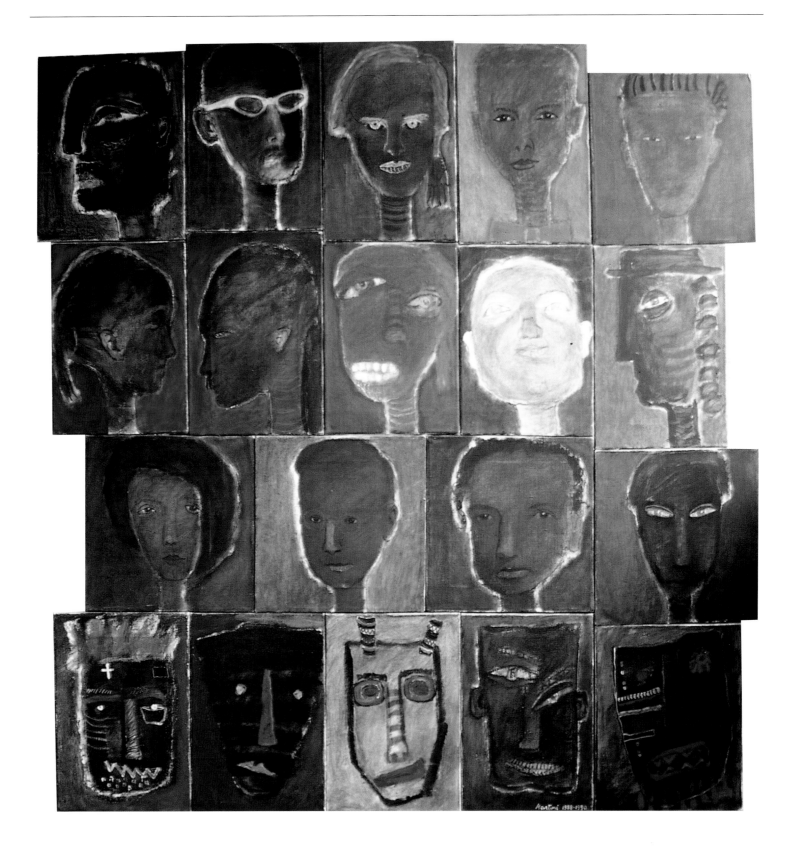

Martini has over the years rationalised somewhat the manner in which she arranges the figures in her work. In *Cyrk*, an etching from 1988, the figures tumble in chaotic order across the surface of the print, performers, musicians, animals and an angel frozen in the postures of their art. In *Men, where do we go?*, an acrylic from 1990, the figures are lined up in rows, some walking, others standing, all apparently lost in their search for direction. In *Under your Signs*, an oil painting of 1993, the figures are still in rows, but there is a greater sense of freedom in their postures, a hint of future developments. Martini uses an idiosyncratic technique to explore her particular reaction to the changing society in which she lives, but is proving to be an acute observer of a country undergoing rapid transition from totalitarian state to a truly, once again, European society in which the old values will resurface and regain their former power. The politics change and their manifestation will not always be comfortable, but, as seen in this artist's work, the underlying levity in the Polish character has a chance at least of bringing about the right conditions for coherent growth.

Cyrk, 1988,
Etching, 27 x 32 cm,
Photograph: Pawel Zechenter

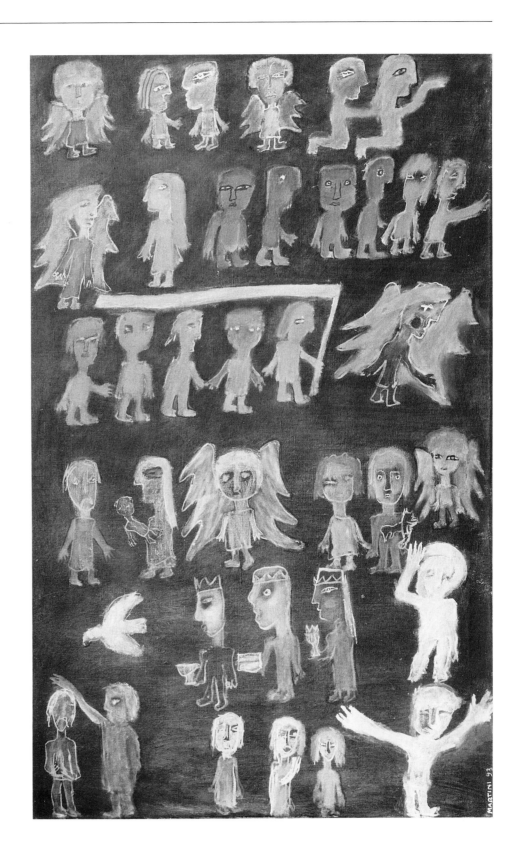

Under your Signs, 1993,
Oil on canvas, 64 x 99 cm,
Photograph: Pawel Zechenter

JADWIGA MAZIARSKA

Jadwiga Maziarska was born in 1913 in Sosnowiec and studied in Krakow, first at the Alfred Terlucki School of Painting (1933) and then at the Academy of Fine Arts (1934–39) in the studios of Wladyslaw Jarocki, Stefan Filipkiewicz and Ignacy Pienkowski. During her studies at the Academy she made contact with the pre-war Krakow Group as well as becoming involved with the Labour Youth movement. Following the war she joined the Group of Young Artists, which formed around Tadeusz Kantor and included many of the artists who later gained considerable reputations in Poland, including Tadeusz Brzozowski, Jerzy Nowosielski, Jonasz Stern and Maria Jarema. This group believed in the unity of art, be it abstract or representational, and that any division into the two tendencies was false. However they also held the view that abstract art approached most closely the necessary freedom in painting, and the influence of the Paris school, bringing new notions of the nature of visual perception, was important to them. In 1957 Maziarska joined the revived Krakow Group and her involvement in this influential group has continued ever since.

Maziarska has, almost without exception, worked as an abstract artist since she graduated. While other tendencies have come and gone she has remained true to her exploration of the means by which abstract art can give meaning to the realm of abstract philosophy, to illuminate the connections between the material and spiritual worlds, seeking to create a harmony between the artist's subjective creativity and the objective nature of the world at large. She sees her work as an artist as being akin to that of a scientific researcher, seeking an understanding of the nature of the cosmos as represented by colour, light and space, and of how her painting may be a means of bringing order out of chaos. Her knowledge of scientific and philosophical research has enabled her to formulate her own views on the nature of these apparently conflicting realms. She considers that one is impossible without the other, and that chaos has its own rules which are very different from those of order. While her paintings differ greatly in essential ways from the creation of fractal images by a computer there is a philosophical link between them.

Untitled, 1992,
Oil on canvas, 64 x 64 cm,
Photograph: courtesy Zderzak Gallery
Collection of the artist

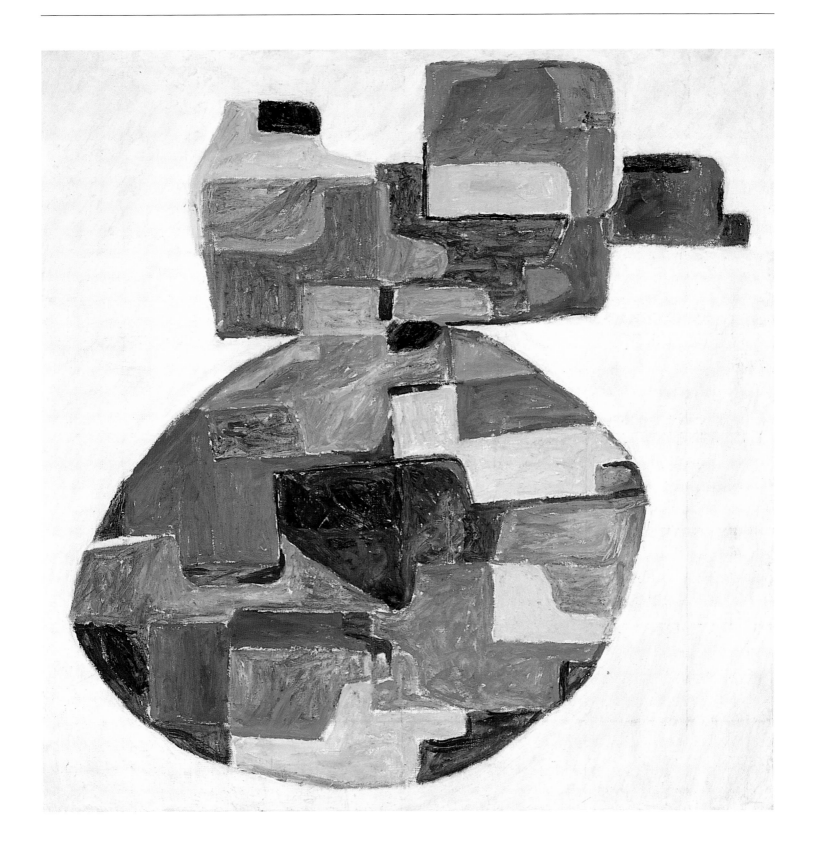

Given that this artist has maintained a clear vision, that of the importance of abstraction as the primary motivation for her work, its development over the past fifty years provides an insight into the way in which her concepts have evolved. In the late 1940s her paintings were characterised by a patchwork agglomeration of shapes, some of pure texture, others enlivened by repeated line or circles. In some work of this period it is possible to discern figurative references which almost resolve themselves. In the early 1950s her work became sparser, her colour more restrained, leading to a series of paintings towards the end of that decade and through the 1960s that resemble microscopic cellular images. In the 1970s her paintings and mixed-media works became more structured, leading to a series of works of the late 1970s and into the 1980s in which repetitions of lines built up rippling textures across the surface of the canvas. Her work of recent years has returned to a looser style where colour and form, often exuberant, have been allowed a greater liberty, affirming a more positive and optimistic view of the world. For Maziarska the relationships between form, texture and colour remain a fascinating field for exploration, one that continues to inspire her work in the 1990s as it has done for the past five decades.

Untitled, 1967–68,
Mixed technique,
Photograph: courtesy Zderzak Gallery,
Krakow and Jozef Chrobak

Egzekucja programowa, 1968,
Mixed technique, 68 x 85 cm,
Photograph: courtesy Zderzak Gallery,
Krakow and Jozef Chrobak

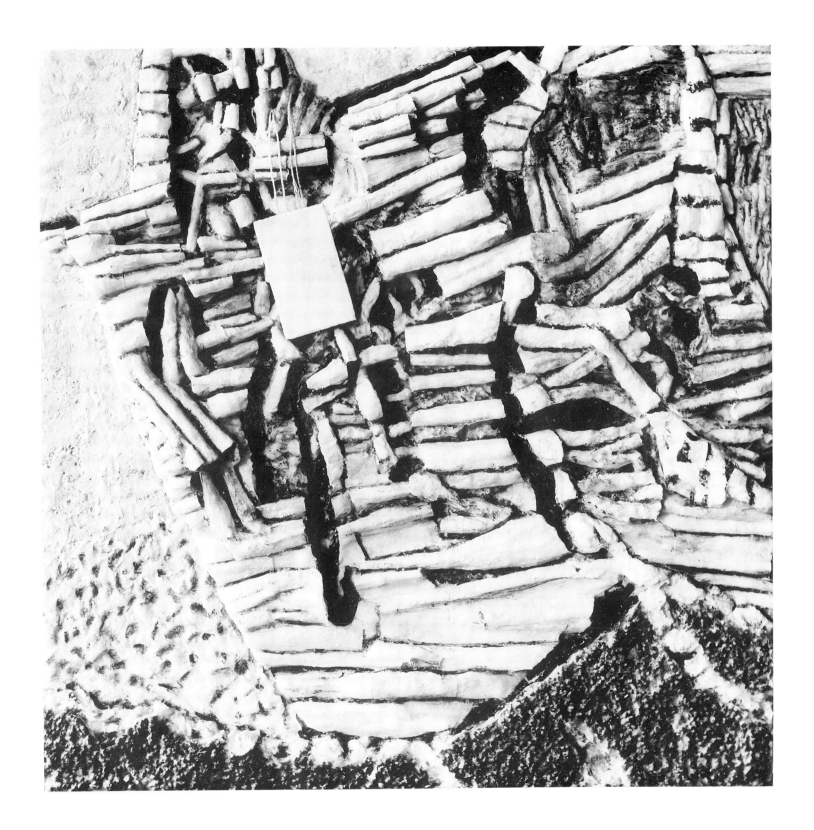

HANNA MICHALSKA

There is a curious paradox in the work of Hanna Michalska which turns on the essentially anonymous character of her work, an almost mechanical approach, yet one which renders it instantly recognisable. She has reduced her technique to a very basic set of stencils of people in the various postures of characters which she uses in differing combinations so that they populate her canvases and installation work. In the repeated simplicity of these elements, and their in recurrence in the relationships in which she places them, comes a growing familiarity and the possibility of identifying their changing roles.

Hanna Michalska was born in Torun in 1963 and studied at the Academy of Fine Arts in Krakow from 1983–1988 in the Graphic Faculty, graduating from the etching studio of Andrzej Pietsch and the typography and book design studio of Roman Banaszewski. Since 1989 she has been a member of the Polish Artists' Society and is also a member of the TE 7 EM group. She lives in Krakow and works in painting, printmaking and book illustration. From her academic studies and her current practice she is set somewhat apart from others among her contemporaries in that her primary orientation was towards the graphic arts rather than painting. Nonetheless her paintings have within them a strong sense of the values of painting and an awareness of how space, whether on a canvas or in an environment, can be manipulated so that the total becomes more than the sum of the parts.

It may appear that Michalska has little interest in the nature of paint as her colour range is very monochromatic. She does not use colour in the same way as some of her contemporaries in Krakow and her work does not reveal the same concern for drawing. This however does not make her work less interesting, rather it persuades the viewer to shift the focus of interest towards the syntax that the work contains. Her paintings are not pictorial and do not seek to describe particular places or specific situations. Instead Michalska engages the viewer's attention in the dynamic posture of the figures. Each one can be applied through the metal stencil from either side, they can be combined and superimposed, the paint can be applied thickly or thinly and the figures clustered together or spaced widely apart. With these

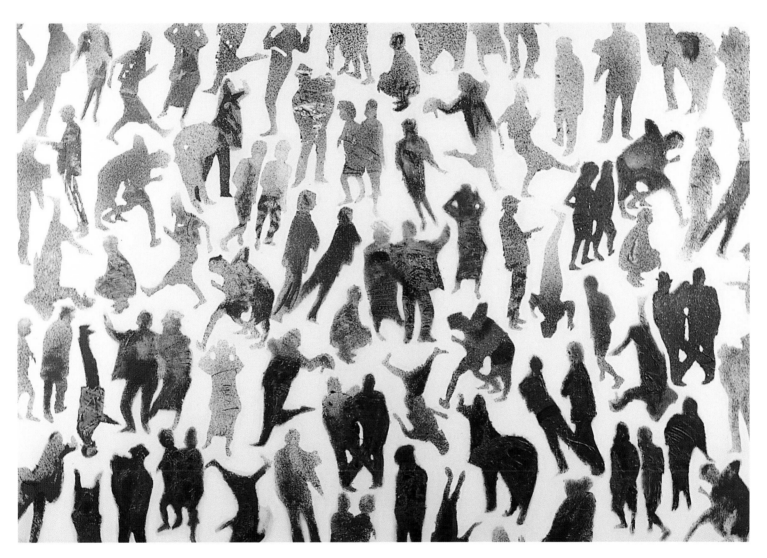

Untitled, 1991,
From the series 'Parties',
Acrylic on canvas, 120 x 170 cm,
Collection of the artist

intentionally limited means Michalska sets up a form of wordless language which can be read across the surface in any direction. The choice of title for the series, 'Parties', is also open to interpretation, and does not necessarily refer to a gathering for the purpose of celebration.

In her contribution to a group activity in 1993 Michalska took one of the rooms in an old house on Micholajska Street in Krakow selected by the group for a series of personal interpretations and applied her stencilled figures in greyish white to the faded orange walls of the room. Freed from the constraints of a white canvas the figures became ghostly echoes of those who may have inhabited the room in the past. The context changed towards the creation of an environment which itself was temporary and now persists only in photographic documentation.

The society into which Michalska graduated is in a state of flux, the certainties of which are shifting away from the suppressed rigidity of the totalitarian post-war years and into a less structured and far less predictable state. With this context her paintings can be seen as a reflection of contemporary Polish society, one that contains the potential for further development as the situation changes further.

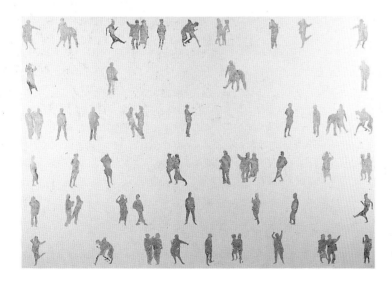

Grey, 1991,
From the series 'Parties',
Acrylic on canvas, 120 x 170 cm,
Collection of the artist

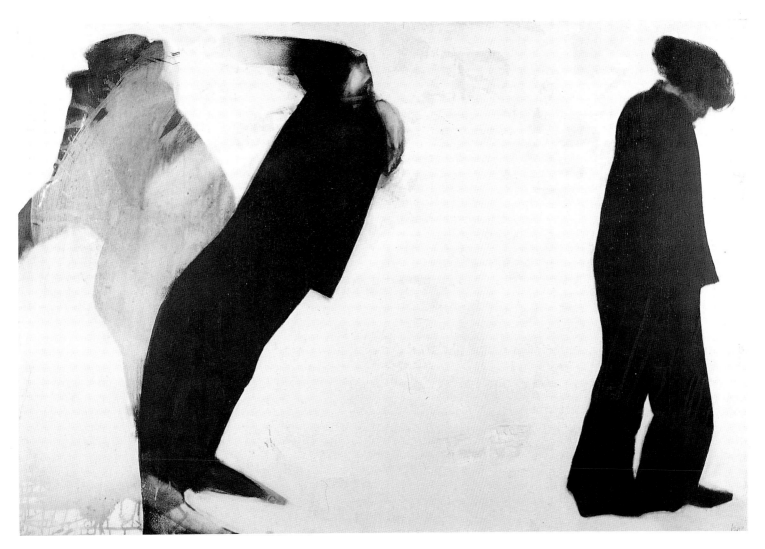

They and I, 1991,
From the series 'Parties',
Acrylic on canvas, 120 x 170 cm,
Collection of the artist

JAROSLAW MODZELEWSKI

Jaroslaw Modzelewski was born in Warsaw in 1955 and studied there, firstly at the Electronic Secondary School (he remembers exhausting journeys to school and the view of the Palace of Culture and Science at sunrise), and then from 1975–80 at the Academy of Fine Arts, studying painting in the studio of Stefan Gierowski. His graduation coincided with the beginning of the social and political upheaval that was to bring about Poland's emergence from the shadow of Communism into the equally uncertain world of late twentieth century Capitalism. From 1980–81 he served his military training in a company of non-Party artists at the Party Centre for Training Political Officers in Lodz and observed the changes in Polish life from that particular perspective. He also started working on texts and poems with the artist Marek Sobczyk.

The start of his work as a professional artist in the time of Martial Law and subsequent events meant that he, like others of his generation, was faced with a situation in which the official art scene of State-run galleries and organisations was in disarray, and young artists had to find alternative means for showing their work and co-operating with others. Modzelewski participated in various exhibitions in churches including several in the church on Zytnia Street, and in 1983 participated in the establishment of Gruppa — one of the associations of young artists whose work, either as individuals or in collaborative groups, was to characterise the 1980s. Since then he has shown his work in numerous one-man and group exhibitions, establishing himself as one of the most challenging and successful young artists in Poland.

The work of some of the younger generation of artists in the 1980s can be seen as a cynical reworking of the Socialist Realism of the early 1950s. However, while the work of the State-approved artists of that period sought to glorify the achievements of Communism, the work of the later generation sought to point out its failings, choosing a style closer to Expressionism, often harsh and brash in its colour and form. In contrast with this style Modzelewski's work from the mid-1980s places figures in stiff postures against predominantly flat coloured backgrounds. His abilities

Pedalowanie pod Lampa, 1993, Oil on canvas, 190 x 160 cm, Photograph: M. Michalski and B. Wojcik
Courtesy of the Zderzak Gallery

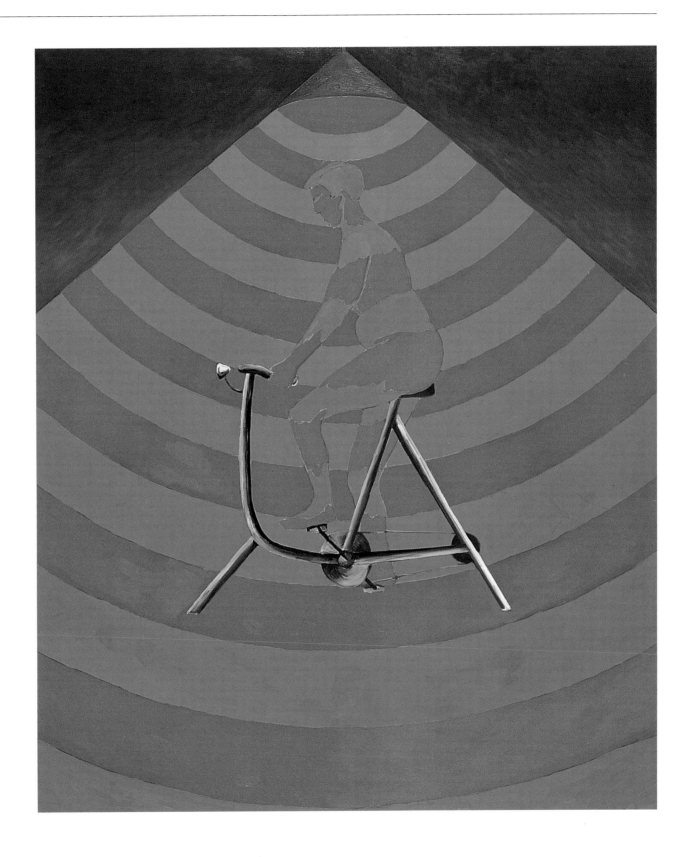

in composition and colour are clear but the role of his figures appear to be without major significance, they are simply caught at ordinary moments in the course of unexceptional activities, devoid of emotion or symbolism — a metaphor perhaps for the bleakness of the period in which the Polish people found themselves without the paternalistic support of the former State, yet without any clear idea of what the future would bring.

Towards the end of the decade Modzelewski's work changed markedly, his depiction of space becomes more complex, his colour richer, leading to his work of the 1990s in which his figures are once more lost in flat fields of colour, reduced in scale, often seemingly waiting or searching for something undefined. The bleakness of his earlier work is replaced by something approaching a tentative romanticism, although this too is without final resolution. Modzelewski remains an important artist in the new Poland, one whose future development may well prove to be an indicator of the manner in which perceptions are changing as the social and political situation clarifies and offers new challenges. In the meantime his paintings offer a tantalising comment on the stage that has so far been reached in Poland's evolution.

Illumination of the Little Dog, 1991/92,
Oil on canvas, 136 x 166 cm,
Photograph: Elzbieta Bliszczynska
and Mariusz Pietron
Courtesy of Zderzak Gallery

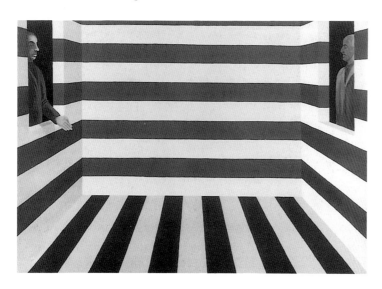

Romanica Toscana, 1987,
Oil on canvas, 140 x 200 cm,
Photograph: Jerzy Gladykowski
Collection of Muzeum Sztuki, Lodz

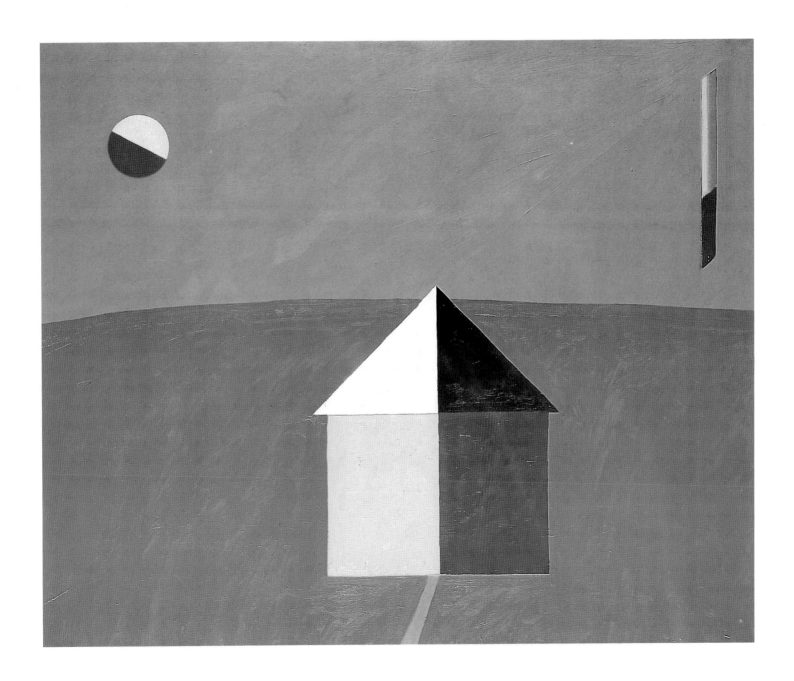

EUGENIUSZ MUCHA

The work of Eugeniusz Mucha is imbued with a deeply-felt sense of the 'sacrum' which marks his work as being religious without being overtly didactic, containing a sincerity that depends equally on his individual technique and the implied narrative within his images. His paintings balance between the observed world of reality and the realm of the fantastic, where one aspect intertwines with the other to create a highly personal world in which those who see his work can find correspondences in their own experience and imagination.

Mucha was born in 1927 in Niedowna and studied at the Academy of Fine Arts in Krakow from 1945–55, graduating from the studio of Tadeusz Lakomski. He lives in Krakow where he is active as an easel painter and muralist. He has exhibited widely in Poland and elsewhere in Europe and has made mural paintings in many churches, among them those in Niedowna and at the Catholic University of Lublin. The key text he applies to his work is, '… admiration, exultation, love, anger, pain, death — I mill them in mother's quern hidden in the house from an invader and bake wholemeal bread, the bread of my life, to share it with people in hunger …'

The acceptability of Socialist Realism was becoming questionable at the time he graduated and the gap left by the removal of the need to fulfil artificially created obligations brought about a time of new possibilities in Polish art. Mucha chose to align his work with the new figuration and in the 1960s he began returning to his inherited family beliefs and the images in his collection of primitive Folk art, which became the firm roots of his subsequent work. The undeniable presence of Mucha's painting is helped greatly by his individual mastery of the medium, usually oil or oil and tempera, and occasionally acrylic, on canvas. His control of colour and brush strokes does not aim to mirror reality but to use it as a vehicle for the deeper poetic sense of his imagination, modelling the fall of light on flesh, fabric and solid surfaces alike, delineating the private drama of the figures. This effect is heightened by the manner in which the artist modifies their proportions and emphasises their eyes.

Far from creating idealised visions of the sacred thread within daily life Mucha chooses instead to place his figures in the continuing cycle of life and death, linking

Decorated, 1980,
Oil on canvas, 130 x 109 cm,
Photograph: Tadeusz Szklarczyk
Courtesy of Dominik Rostworowski
Gallery

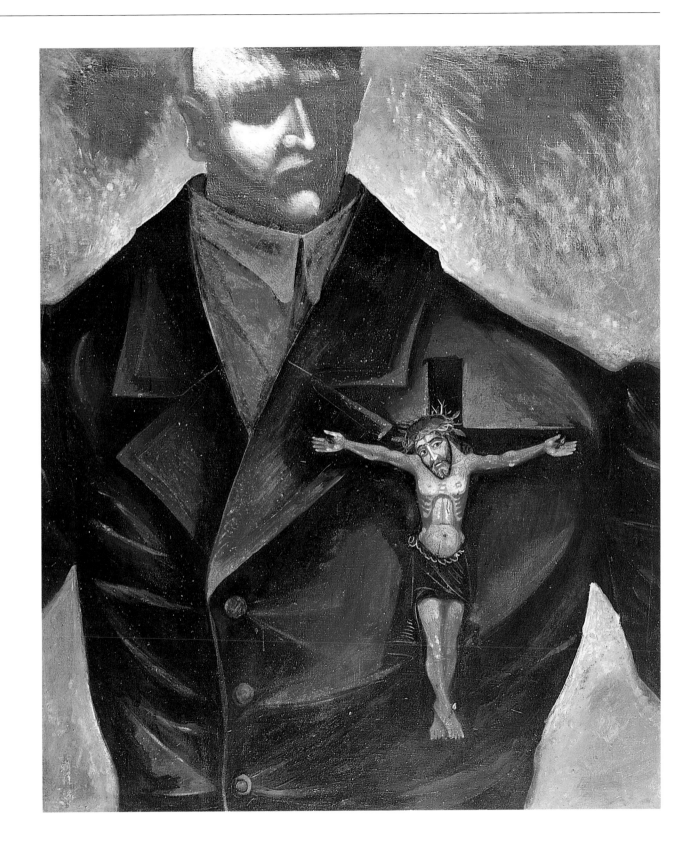

the full range of human emotions to the hard realities of a life tied to the working of the land. While his figures are caught in moments of supreme joy or deepest despair one is always made aware of the balance of sense and non-sense that mark the passage through life of those for whom hard toil is the norm. He does not choose to depict such events through the heroic ideas of socialist realist painting but rather through his awareness of the essential pathos of life, where a continuing struggle is made to balance love and sex, work, exhaustion and community celebration with the need for community with God. This he does not only through his religious works and transpositions of Biblical stories but also in his secular paintings that celebrate carnal emotions. Mucha does not labour his commenting on the social changes in his country in a directly political manner, rather he chooses to place his subjects in the context of a timeless place where the ordinary theatre of daily life is played out as it always has been, and where the recurring cycle of existence changes little.

Emaus, 1973,
Acrylic on canvas, 130 x 270 cm,
Photograph: courtesy Dominik
Rostworowski Gallery

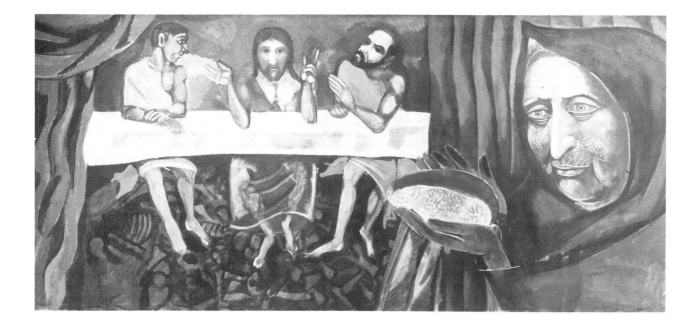

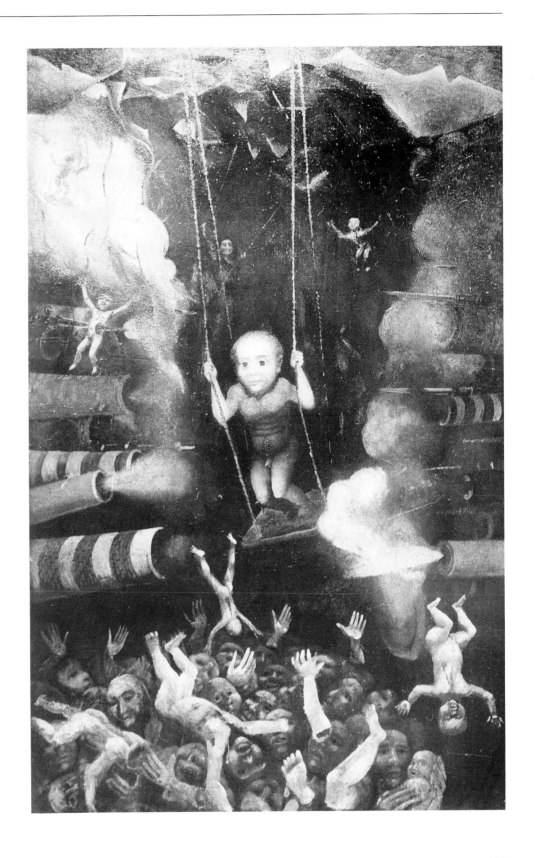

Swing, 1982,
Oil on canvas, 200 x 130 cm,
Photograph: courtesy Dominik
Rostworowski Gallery

HENRYK MUSIALOWICZ

Henryk Musialowicz was born in 1914 in Gniezno, a small city 50 km to the east of Poznan, and generally accepted as the first capital of Poland, being the site of the court of Mieszko I in the late tenth century. Although the capital was moved to Krakow not many years later Gniezno has remained the official seat of the Primate of Poland and thus is of major ecclesiastical importance. These origins are of importance when considering the work of Musialowicz, as they formed the root of his philosophy from which his considerable output has stemmed.

He studied at the Academy of Fine Arts in Warsaw under the supervision of Felicjan Kowarski and Leonard Pekalski in the difficult years following World War II, graduating in 1947. His early work was in the colourist tradition but visits to exhibitions and museums elsewhere in Europe, where he was impressed by early art as well as by that of Rembrandt, caused him to abandon that style and begin the long search for a style of his own. His work has been called religious by critics in the past and something of that nature remains in his paintings. But the driving force for many years has been his search for a means to express the 'sacrum', a more universal doctrine rather than that fixed to any particular religious faith, relating to a history far longer than that of the Catholic Church and to a far more ancient need for understanding. Musialowicz has lived for over fifty years in the heart of Warsaw, occupying a studio and apartment just off the main square of the Old Town which was totally rebuilt following its destruction in 1944. His studio is small, crammed with paintings. The initial impression is one of the enveloping blackness of his paintings, deceptive, because a closer acquaintance with his work reveals depths of pure colour enhanced with gold which shine out of the darkness. His technique is highly individual, building up encrustations and textures that are worked on over a long period of reconsideration and refinement, leading towards a state of completion derived from an approach that is meditative, rather than an immediate reaction to a situation or event.

In common with many artists the paintings of Musialowicz fall into cycles, each related to the other but seeking expression for a particular aspect of his philosophy.

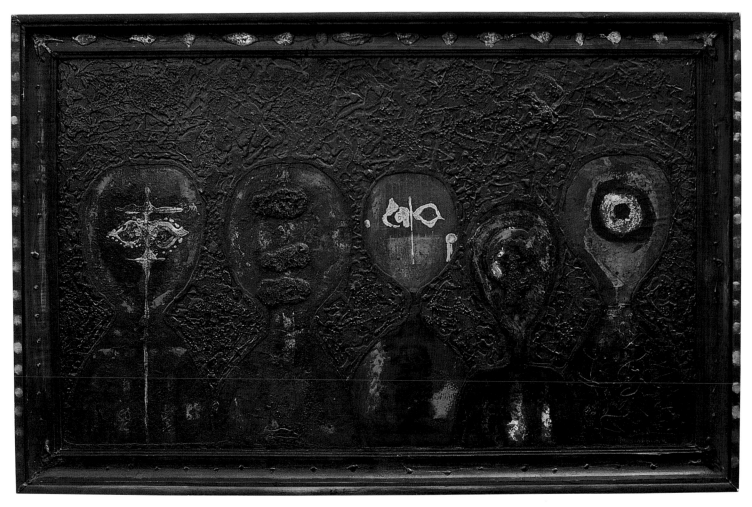

Awaiting, 1989–91,
Mixed technique, 86 x 135 cm,
Collection of the artist

In his series, 'War against Man', for example he does not seek to describe his or any other's particular experience of War but rather the general experience of the depths of tragedy and suffering, and in 'The Family' cycle he explores the nature of family relationships set against ancient and mysterious rituals. He seeks to reach down into the collective unconscious, to contact the archetypes of behaviour and experience, and in doing so has developed a means of painting which is deeply humanitarian, speaking from ancient roots of time and space. The symbols which inhabit his work, the eye, the cross, the circle and the horns, are not drawn from Christianity but from the millenia of faiths that preceded it.

Musialowicz is an artist who has remained true to himself despite all the changes through which his long life has taken him. His art remains as the record of one who has neither followed fashion nor shaped it, remaining as an individual testimony of the search for eternal verities, which he sees as being the responsibility of any true artist. In his own words: 'Only he for whom creation means the essence of thought and life has the right to paint. For painting is Man — Man alone who paints in order to discover himself and what is within him, what unites individual experiences with those of mankind.'

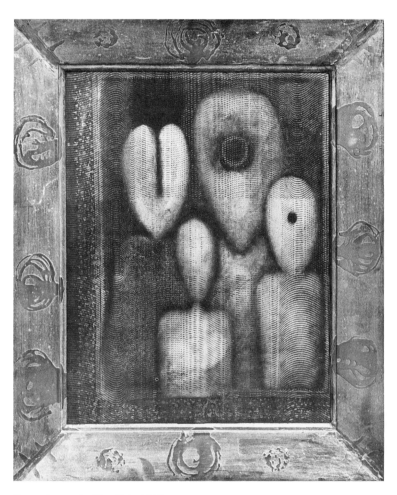

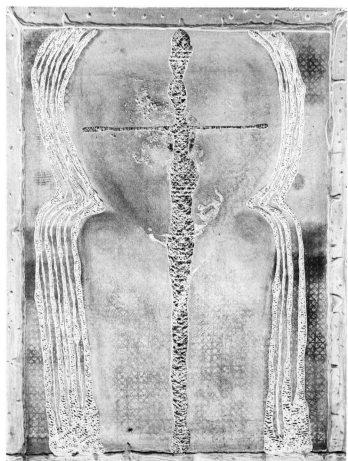

From the cycle 'Family', 1980,
Mixed technique, 50 x 70 cm,
Photograph: Tomasz Chelmonski
Collection: Joachim Müller, Frankfurt

From the cycle 'Reminiscences', 1981,
Mixed technique, 50 x 70 cm,
Photograph: Tomasz Chelmonski
Collection: Warsaw Episcopal Museum

EDWARD NARKIEWICZ

Edward Narkiewicz is an artist whose vision and superlative technique have combined to create paintings of an imaginary world rooted in a readily recognisable reality. He was born in Troki in 1938 and graduated from the Academy of Fine Arts in Warsaw, where he now lives and works. There is an immediate sense of visual enjoyment in his work, his images are clear and, apparently, without complexity, his skill as a draughtsman is unquestionable and his colour sense highly refined. However, a closer examination of his paintings reveals intriguing complexities akin to those of dreams.

It would be easy to dismiss the work of Narkiewicz as naïve, but it is much more than merely this. There are similarities with the naïve paintings of Central Europe, this much is true, but his work has a greater intellectual rigour and makes allusions to the worlds of magic and allegory which provoke a curiousity beneath the immediacy of the first impression. While he has, understandably, been likened to Henri 'Douanier' Rousseau there is a greater precision in both his concepts and technique. In 1967 he completed his *Map of the World*, at 130 x 165 cm a painting much larger than the size he normally makes, which mingles quotations from the art of many times and cultures — Van Gogh, Leonardo, *Guernica*, a Polish wooden church, a Chinese painting and Egyptian art — with a painstaking depiction of the world map. Superimposed on these images are imprints of his bare feet which circle the painting as if, by the act of painting elements of our shared cultural history, he feels able to undertake a marathon journey of exploration, one in which we too can share. Yet this painting, now in a private collection in Johannesburg, suggests the danger in summing up world culture through a few iconic paintings and Man's threat to the world in general. 'The sleep of Reason,' as Goya claimed, 'begets Monsters'.

Narkiewicz is a superlative painter of portraits, including artists such as Henryk Stazewski and Koji Kamoji, Pope John Paul II and the critic Mariusz Tchorek, whose head floats in the sky above storks on their nest, accompanied by giant butterflies and caterpillars and a watchful owl. Each element is carefully painted but the full meaning of the correspondence remains a mystery. His skill lies in the depiction of

Untitled, 1985,
Oil on canvas, 73 x 55 cm,
Photograph: Tadeusz Rolke
Courtesy of Foksal Gallery

nature, each plant, bird and animal is exactly painted in all respects except relative scale. But somehow this doesn't matter, any more than the combination of predators and prey in *The Peaceable Kingdom* does — it is easy to accept that his vision of the world is accurate in detail yet at the same time quite irrational. Narkiewicz doesn't paint reality but a version of it that is entirely congruous with the realm of dreams; somehow this marks him as a neither a Surrealist nor a Hyper-realist. In the end the apparition of a Polish Madonna and Child above an Autumn Birch wood in which there are three huge fungi becomes perfectly acceptable, as does the addition of a large lizard to a board on which a careful rendition of Goya's *Naked Maja* has been painted — the lizard appears to have eaten its way out of the corner of the painting — again, nothing seems very strange.

The work of this artist is out of step with all the other major trends in contemporary Polish painting, but his vision remains important. He paints dream-like images that relate to the wealth of natural resources in a style that is timeless, making real his imagination and stimulating our own. In the end he creates a world in which '... peace rules unperturbed'.

Island of the Animals, 1985,
Oil on canvas, 45 x 45 cm,
Photograph: Piotr Baracz
Collection: Muzeum Sztuki, Lodz

Naked Maria, 1985,
Oil on board, 30.8 x 57 cm,
Photograph: Tadeusz Rolke
Courtesy of Foksal Gallery

JERZY NOWOSIELSKI

Jerzy Nowosielski is one of the major figures in contemporary Polish painting, an artist whose single-minded devotion to the development of his art has resulted in an impressive body of work that has a unique individual style unlike any style that preceded it and which is incapable of being repeated. Nowosielski was born in Krakow in 1923 and showed a keen interest in art from an early age, becoming competent in the painting of water-colours in his early 'teens. Significantly for his later development he was brought up in the Eastern Orthodox faith, and from his early years became fascinated by the traditions and music of that church. At the outbreak of the Second World War he was in Lwow and received some education there, but returned to Krakow in 1941 where he was enrolled in the Kunstgewerbeschule which functioned as an underground art academy. There he came into contact with artists such as Adam Hoffmann, Tadeusz Brzozowski and Janina Kraupe. In 1942 he attended a Ukrainian graduation course, intending to join an Orthodox monastery, and began painting icons according to the strict traditions of the church. However, following at illness that took him back to Krakow he broke contact with the monastery and became an atheist, although the philosophy of the church has remained of central importance in his thinking and artistic development. Once back in Krakow he met Tadeusz Kantor and those of his circle who were to form the core of the post-war avant-garde. He continued to paint and began exhibiting from 1945 onwards, and in 1947 became Kantor's assistant at the Advanced School of Fine Arts in Krakow.

The imposition of Socialist Realism as the only officially acceptable style under the Stalinist government of the early 1950s led to Nowosielski giving up exhibiting for a few years and moving to Lodz where he supported himself as best he could while continuing painting. He did however begin painting murals in churches, a facet of his work that has continued to be important despite his atheism, and in 1957 became a lecturer at the Advanced School of Plastic Arts in Lodz where he remained until 1962 when he returned to Krakow to become an first an associate professor at the Academy of Fine Arts and then in 1984 a full professor. He has continued to

Orthodox Church, 1990,
Oil on canvas, 63 x 45 cm,
Photograph: courtesy Starmach Gallery

paint, both his own works and those for churches, both Orthodox and Catholic, throughout Poland and elsewhere (including one at Lourdes), has exhibited with great success in many parts of the world, and has travelled widely. In 1994 he was honoured by a major retrospective exhibition in Poznan, Wroclaw, Warsaw and his native Krakow.

There is, throughout Nowosielski's work, an essential quality of stillness. The influence of the traditional canons of icon painting suffuses his work, whether it be abstract or figurative, landscape, townscape, still-life or portrait, or the female nudes for which he is justly celebrated. He has spoken on many occasions of his fascination with the female form, seeing this as being the ultimate perfection of creation, and, whether in his paintings or his deceptively simple drawings that form an important part of his work, he succeeds in capturing the quiet poise of a moment in the living body. This stillness has a spiritual resonance, one in which the primal qualities of light and colour are predominant. His paintings have a sense of 'otherness', but in this there is also the clear recognition of the need to represent a version of reality. Nowosielski remarked in 1992, 'Nothing ever happens, there are no incidents, no events.' This, finally, sums up the nature of his work which nonetheless achieves a rare perfection in the realm of painting.

Standing Nude, 1980,
Ink on paper, 70 x 50 cm,
Photograph: courtesy Starmach Gallery

Portrait, 1980,
Ink on paper, 70 x 50 cm,
Photograph: courtesy Starmach Gallery

WLODZIMIERZ PAWLAK

Wlodzimierz Pawlak was born in Korytow, a small village on the flat plain between Warsaw and Lodz, in 1957 and now lives and works there. From 1980–85, the years of Solidarity, Martial Law and its aftermath, he studied painting at the Academy of Fine Arts in Warsaw, graduating from the studios of Rajmund Ziemski and Ryszard Winiarski. In 1982 he joined Gruppa, an association of young painters who sought through their collective activities of exhibitions, performances and the magazine, *Oj dobrze juz* (*Its Enough Now*), to question the status quo of painting at a time of political and social upheaval. Throughout the mid-1980s Gruppa made their mark on the Polish art scene through their frequently controversial activities which gave voice to their comprehensive questioning of the function and value of art. Their voice was, at the time, a valid contribution to the debate then current, and built to some extent on the pre-war theories of Wladyslaw Strzeminski and his theory of Unism which sought to unite the principles and making of art and its relationship with society. However, just as Strzeminski's theory lost ground with the coming of the Second World War, so did the work of Gruppa stumble when faced with the realities of Poland's transition from a Communist satellite state to one moving towards a free market economy. The group ceased to function collectively in 1989 and Pawlak considers that their last exhibition took place at the Zacheta Gallery in Warsaw in 1992, by which time the changes in society in Poland had gathered pace, relegating the theories of Gruppa to the annals of history as surely as those of Unism.

While Strzeminski's theories continue to inform some of the work currently being undertaken in present day Poland, so does the work of Gruppa continue to have some relevance, even if collective action is no longer seen as being viable. Pawlak's connections with the group continue and have helped to shape his work but he, like the other members of the group, now has to come to terms in his art with a society greatly changed from that of the early 1980s. From 1979–88 Pawlak's work was much concerned with his attempts to describe reality as he perceived it but since 1988 he has entered a phase in which he has questioned much of went before, while

Wladyslaw Strzeminski — Theory of Looking at Van Gogh's painting 'The Plain of La Crau' No.2, 1992, Oil on canvas, 115 x 135 cm, Collection of the artist

seeking new solutions to the problems he addressed in those years.

In an ongoing series he titles 'Didactic Tables' he is exploring the content and open-ness to analysis of paintings, the *Theory of Looking at a Painting* of which his analysis of the Van Gogh painting illustrated here is a good example. By referring back to an historical work and analysing it in terms of his own perception informed by Unism he seeks to relate the older painting to the present 100 years or so after Van Gogh, intoxicated by the light of the Midi, sought to illuminate his perception of light. Concurrently with the Didactic Table series, Pawlak has undertaken his own analysis of White, a quality of paint that he considers, '… does not constitute a positive definition but only indicates that something is free from any admixtures … dealing with light itself, deprived of all contamination.' This idealism may prove to be leading nowhere but the search is worth the making. Pawlak is an artist fully engaged with a quest for intellectual enrichment but has yet to find fully his direction in the new Poland. That the search is being made is enough — the outcome is not yet resolved but it does offer an interesting aspect of the diversity of the current Polish art scene.

Diary No. 12, (detail), 1990,
Oil on canvas, 190 x 135 cm,
Collection of the artist

Twenty-one Churches, 1990,
Oil on canvas, 135x 190 cm,
Collection of the artist

IRENEUSZ PIERZGALSKI

I reneusz Pierzgalski was born in Lodz in 1929 and has lived and worked in this industrial city in the heart of Poland ever since. He studied at the State Higher School of Fine Arts in the city, graduating in 1955. Since 1976 he has been Professor in the Graphic Faculty at the same institution, following twenty-one years as Lecturer at the Higher Film School in the city. His work has encompassed painting, graphic art and photography together with experiments in audio-visual media.

There is a danger, when considering Pierzgalski's work from the 1980s, of seeing it as nothing more than the careful repetition of a formula, when in fact nothing could be further from the truth. Despite locating himself in Lodz, a city whose pre-war industrial might was all but destroyed during the Nazi occupation and which has only recently started to show some signs of regeneration, this artist has a range and depths of interest that transcend the nature of his surroundings. He has long had a fascination with Oriental philosophy, in particular with that underlying the martial arts and the *I Ching* or *Book of Changes*, the encapsulation of Tao-ism. The nature of dualities fascinates him, dark/light, form/void, being/non-being, and these complexes underlie his work. Earlier his work with photography led him into a consideration of the way in which that medium can create a world of illusion as well as its possibilities in the capturing of a fleeting reality. He writes of being able to create a meadow through projecting a slide on a wall, and of switching from that to a seashore or the projection of people who appear as fleeting spirits. He considers that, '… the reproduction of what was is nothing but a playful disturbance in the course of events, a wilful fight against time at the cost of fiction.' (Notes for 'Atelier '72' 1972)

Pierzgalski is of course aware of the essential paradox in his work, that of attempting to capture in a permanent form something which is by its very nature transient. His work is not figurative, but neither is it strictly speaking abstract. Instead it occupies a position somewhere between the two extremes, creating paintings using the traditional means of oil or acrylic on stretched canvas which are formed by networks of coloured lines against coloured backgrounds, yet which are derived from a deep understanding of the Tao-ist philosophy of constant change and interaction

Pentagram, 1992,
Acrylic on canvas, 81 x 65 cm,
Collection of the artist

138

between the eternal opposing principles of Yin and Yang.

His work in the past few years has started to take on a looser aspect, while remaining linked generically to his long series of Hexagram paintings from the previous two decades. Colour remains a prime consideration but the resulting paintings are becoming less dense, the colous more transparent, the lines delineating the hexagram less congested. In *Pentagram* (1992) he explores new territory with the introduction of the notion of landscape, whereby the fastidious construction of the geometric figure is placed within a series of softly painted circles above the representation of a land mass. In *Three Heads — Joke* of the following year he has abandoned entirely the use of geometric construction, preferring instead the use of expressionist strokes of loosely applied colour. Whether or not this represents a new direction remains to be seen but it does demonstrate a wish to continue the whole process of exploration of possibilities. Ireneusz Pierzgalski remains an artist whose work is distinct and not related in any obvious way to the work of other Polish artists.

'When I was young it seemed to me that tradition was a great hindrance to the development of one's own creativity. I therefore fought it with all my might. Now I see that I was not right. However it is not totally clear to me why I changed my opinion. Probably I am getting old and the past has managed to build a kind of bridge in me from which I can look at tradition with a friendlier eye.' (Notebook, 1994)

Sun, 57, 1982,
Oil on canvas, 73 x 60 cm,
Collection of the artist

Wei Chi, 64, 1982,
Oil on canvas, 73 x 60 cm,
Collection of the artist

JANUSZ PRZYBYLSKI

Born in 1937, Janusz Przybylski graduated in 1963 from the Academy of Fine Arts in Warsaw where he is now a Professor. His work as an artist is in the fields of painting, drawing and printmaking, and is characterised by a highly individual development of subject matter which is pursued differently in the three disciplines, but in ways which have resulted in an interweaving of themes and variations. He does not consider that one form is subservient to the other but rather that they are mutually supportive. His mastery of the skills he employs has resulted in works which are largely figurative in nature but which in turn question the whole range of emotional responses that are engendered by such representations of reality, often with a lightness of touch which is akin to humour. Przybylski is not afraid of including references to pre-existing images and styles but is in no sense guilty of pastiche.

At the time of his graduation the post-war dominance of abstraction was beginning to crumble and doubts were being raised widely on its validity as a means for expression through painting. This aesthetic crisis was as acute in Poland as elsewhere and the formality of abstraction did in any case not suit his artistic personality, aware as he was of his emerging skill as a draughtsman and the fascination that existential philosophy had for him. He therefore embarked on the development of a personal style of working which drew heavily on the possibilities of the figurative depiction of the human form as its primary focus. His search led him through notions of art as metaphor, art as Pop and the persistence of surrealism, and he has at various times since included references to all these while maintaining his own integrity. His work in the mid to late 1960s brought him early critical success which, combined with private traumas led him towards a reconsideration of the direction of his art. As Przybylski readily admits such periods of reconsideration are typified by a restriction in the colours he uses enabling his to concentrate more on the focus of the forms. This pulling back in order to reach forward is a recurring part of his development and while it may perplex it does have a clear logic.

There are some elements in Przybylski's work of the late 1960s and 1970s that

Master and Margaret, 1990,
Oil on canvas, 81 x 100 cm

are allied to Pop imagery, and he uses them to highlight aspects of his relationship with the world around him. In particular his portrayal of the expressive qualities of the human face allows him to create something akin to a sense of theatre in which the participants play out their mysterious roles in an unspoken drama. In *Chlopcy*, an acrylic and pastel diptych of 1973, four figures adopt exaggerated poses in a flower-filled meadow, with a chair painted so as to appear floating in front of the picture plane: the meaning is unclear but the tension remains. Following a journey to Spain the imagery of the late 1970s develops to include references to the work of Velazquez, Goya and Picasso, yet never in the form of direct copies. Instead it seems that the artist's sensibility to events and to art history allows him to incorporate such images as part of his cast of characters, heightening their power. Przybylski's signature at one time was 'Janus' and this perhaps gives a clue to his use of imagery from history, as if he, like the Roman deity, is able to look both forwards and backwards in his quest for meaning. The work of recent years extends still further the range of imagery he uses and indicates that for this artist, the journey is far from its ending.

Teatrum, 1988,
Oil and acrylic on canvas, 46 x 55 cm

Vicious Circle, 1977,
Gouache, 59.5 x 78 cm

TOMASZ PSUJA

There are new directions in Polish art that result more or less directly from the opening of the borders to new influences and technologies that were difficult for artists to experience and work with under the totalitarian regime. Now that a greater freedom of access is possible the introduction of computers into Polish life is having a marked effect on many areas of business and commerce, likewise on the world of the graphic arts. Tomasz Psuja is one of the few artists who has seized on the new technology as a means of extending the possibilities of the visual arts. He was born in Poznan in 1956 and studied at the faculty of painting and graphic art at the State College of Fine Arts in that city from 1976–81, graduating from the studios of Eugeniusz Markowski; he has taught in the same faculty since his graduation while pursuing the development of his own art.

It is arguable whether or not Psuja's art is truly painting, or whether it is more properly graphic art. The techniques are more akin to the latter, but the scale of his work, around 240x300 cm., takes it well beyond the normal bounds of printmaking into the realm of gallery painting. Definitions are, in this case, difficult if not fraught with the danger of falling into the trap of using one complex medium, words, to describe another, the resulting images. By accepting a wider definition of painting one can include Psuja's art because it is a logical extension of landscape painting, one of the primary areas of artistic activity. At the same time it can be seen to be a further development of the long history of the exploration of painting that has characterised the Polish avant-garde during the 20th century.

Psuja works with the creation of primary images by traditional graphic means or through the use of computer generated images and then, through the repetition of these images by photocopying, builds up complex collages on canvas to create large-scale landscapes with a mysterious presence. In works from 1989–90 palm trees cast their shadows so that the trunks and fronds are joined in patterns that resemble chromosomes, fish plunge back into water, or swim in shoals and rock shapes are lit as if by the bright light of the sun. the atmosphere is strangely tropical, the tones, as in all Psuja's recent work, are reduced to the tones of grey allowed by the technology

XXX, 1992,
Individual technique on canvas and paper, 240 x 280 cm,

146

so that the viewer is left with the task of applying imagination to colour these curious worlds. In more recent work, from 1992 onwards, the images have changed into vast towers reaching into the clouds, lit by strong light so that the chiaroscuro sets up the impression of immense depth. The earth, upon which these towers are set is out of sight far below and the presence of human beings is not even hinted at. The majesty of such towers is at once poetic and disturbing, grandeur is offset by the unease of not being able to discern these structures' meaning or purpose.

In harnessing the power of cold technology to his work Psuja has embarked on a personal voyage of exploration. He handles the elements of picture making with an idiosyncratic skill so that the initial apparent simplicity of photocopied sheets of paper collaged together is transcended by the final result in which complexity of the surface images allows one to ignore the obvious patchwork of textures and to become absorbed by the power of this artist's vision.

XXX, 1989,
Individual technique on canvas and paper, 240 x 290 cm,
Photograph: Jerzy Nowakowski

XXX, 1989,
Individual technique on canvas and paper,
240 x 290 cm,
Photograph: Jerzy Nowakowski

ALINA RACZKIEWICZ-BEC

Alina Raczkiewicz-Bec was born in Tomaszów Lubelski in 1958 and now lives in Krakow where she studied at the Painting Department of the Academy of Fine Arts from 1980–86, graduating from the studio of Jerzy Nowosielski. She is establishing an international reputation through her highly physical paintings which have a quiet but incontrovertible inner strength, open to a range of interpretations. While there have been a few celebrated women artists in Poland in the past it is only comparatively recently that the position of women in the Polish art world has begun to be accorded parity with that of male artists. For women of Raczkiewicz-Bec's generation the changing nature of society in their country has opened out new possibilities for interpretation of their role as artists, and while there is no firmly established feminist movement such as has existed in Western countries for some years there is nonetheless a groundswell of change that is helping to shape the future balance between the genders. The work of these artists is starting to effect an attitudinal change, the product of which is promising for the future.

In the case of Raczkiewicz-Bec painting is a means for exploring the inner tensions and pain of being and relationships. Her figures are hunched, compressed within the edges of the canvas and essentially isolated, in the case of single figures from the exterior world and in the case of pairs or groups from each other as well. There is an implied silence which describes a sense of unease beyond the inability to communicate, or through attempts at communication to fail to make meaningful contact that may allow for a movement away from sad isolation. While her work deals with the desperation of such situations it does not show the abandonment of hope. This is especially so in the case of the paired figures whose mutual support through close embraces offers the very real possibilities of solace through human touch even though a solution to their problems is not evident. The paintings may not contain within them the evidence of joy or elation they do offer it as potential.

Whether in her paintings in oil on canvas or her acrylic and pastel drawings, Raczkiewicz-Bec uses colour in a restrained manner, counterpointing dense blacks and browns with vibrant red or blue highlights. Set against flat neutral backgrounds

Without Words, 1993, Oil on canvas, 130 x 100 cm, Photograph: courtesy Dominik Rostworowski Gallery

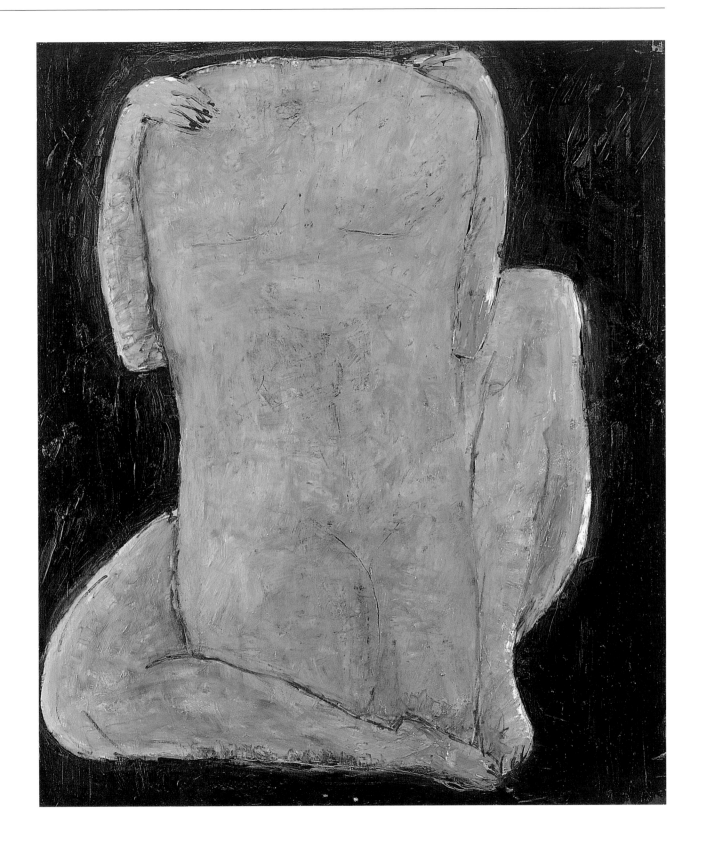

her dark figures are worked in a mixture of scrubbed out strokes and heavy impasto which lends them a distinctly sculptural presence. They are massive, often with distorted proportions, head and limbs reduced at the expense of massive torsos. In some, as in the example from the series 'Without Words' illustrated here in colour, the heads are absent and the limbs are reduced to a function of the embrace which delineates the possibility of release and relaxation following physical union. Such works are at the same time intensely personal and brutally honest, yet at the same time symbolic of the increasing need for open-ness and freedom within a society that has yet to slough off the final remnants of the suppression of individuality that characterised the recent past and led to a sense of deracination on a massive scale. In this reading they can be seen as critical of society or even as political statements. Documenting personal emotive crises while allowing the suggestion of a wider meaning is a risky act, even in these more enlightened times, but the paintings of Raczkiewicz-Bec succeed in facing this dilemma with assurance.

Without Words III, 1991,
Oil on canvas, 170 x 140 cm,
Photograph: courtesy Dominik
Rostworowski Gallery

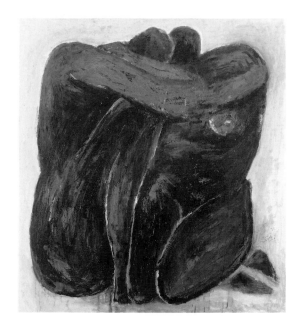

Without Words V, 1993,
Oil on canvas, 140 x 130 cm,
Photograph: courtesy Dominik
Rostworowski Gallery

JADWIGA SAWICKA

Born in Przemysl in 1959, Jadwiga Sawicka studied at the Academy of Fine Arts in Krakow under Professor Jerzy Nowosielski from 1979–84, and is thus a member of the generation whose Art Academy experience coincided with the rise of Solidarity and the subsequent turmoil of Martial Law. The events of that time, coupled with a growing awareness of her role as an artist, have given her work a sharp edge which does not, however, obscure its essentially humanitarian nature.

Living and working in Przemysl, a town founded in the eighth century, now situated in South-East Poland just 10Km from the border with the Ukraine Republic, she has also seen the way in which events of recent years have altered beyond recognition the way of life resulting from the tension and disruption that developed after the Second World War. As Poland's border with the Soviet Union was shifted westwards the former Polish city of Lwow was swallowed up and renamed Lvov, its population was forcibly shifted back across the new border to settle elsewhere, leaving Przemysl very much in border country. The various influences of her education and subsequent working life have undoubtedly provided a particular accent for her art — it deals not only with the whole framework of social and political uncertainty but also her perceptions as a woman artist working within that framework. The resulting paintings reveal a strength of vision that is informed by feminine awareness while not being overtly feminist, although her work in the medium of installation reveals this aspect to a greater degree, combining fresh flowers, fruit and raw minced meat in an unsettling way .

In her recent paintings Sawicka has turned more towards the use of colour and has incorporated images of naked female figures adrift in water or, as in the case of the 1993 painting *Piramida*, a nude woman stranded in transparent box atop a structure that is reminiscent of traditional portrayals of the Tower of Babel. These new works indicate the direction in which her work seems to be heading, involving a consideration of the role of the female in a changing society. The strength of these new paintings, worked in much the same expressionist manner as those illustrated here, lies in the vigourous drawing with thick paint, a very physical style which gives

Untitled, 1991,
Oil on canvas, 150 x 120 cm

her work an undeniable presence and is evidence of the firm basis in drawing of her years at the Academy, a basis which comes through clearly but does not align her work with cold traditional academicism.

In the paintings of 1991 she portrays the male nude, often bound or hooded, revealed as physical strength restrained, the potency of the figure limited by its confinement, painted in almost exclusively monochromatic tones. The vision is bleak but does not appear to be a harsh indictment of male sexuality, rather it comes across as a sad reflection on how the role of the male can be limited by his own inability to understand his condition, or to break the bonds of society, losing sight of his own power to see clearly the world in which he lives. In a subsequent series from 1992–3 Sawicka uses the dog, muzzled or headless, a recurring theme in the work of a number of artists of her generation, as an symbol of animal power deprived of direction or control. Seen in conjunction with other aspects of her work it reveals Jadwiga Sawicka as an artist aware of the essential conflicts both within the country in which she lives but more importantly within the whole nature of Mankind and the quest for an understanding of the confusing world in which we live.

Untitled, 1992,
Oil on canvas, 110 x 110 cm

Untitled, 1991,
Oil on canvas, 140 x 130 cm

LUKASZ SKAPSKI

Lukasz Skapski is an artist whose work does not fit neatly into a category. He works with painting, sculpture and in semi-permanent and temporary forms of installation. The underlying philosophy is derived from his readings of Lao-Tzu and related works, and his work therefore tends towards the minimal, enjoining the observer to a contemplation of the deeper meanings. He was born in Katowice in 1958 and studied at the Krakow Academy of Fine Arts from 1977–82 in the studios of Tadeusz Brzozowski, Jan Szancenbach and Stanislaw Rodzinski, graduating with a Master of Fine Arts Diploma. In 1985 he was the recipient of a scholarship at the Artist's House at Boswil in Switzerland, in 1988 he was guest artist at l'École des Beaux Arts in Aix-en-Provence, and in 1989–91 he lived in Beijing in the People's Republic of China. This varied experience, coupled with exhibitions and activities in many parts of the world has given him a world view that extends well beyond the borders of his country. He now lives and works in Krakow, teaching part-time and pursuing the development of his art.

Like many of his generation, graduating at a uncertain time in recent Polish history, he chose to reject many of the established routes to the making of art and instead sought his own way towards an art that is essentially introspective. He considers that, '... any obtrusive search for meanings in works of art ... often becomes a futile attempt to explain the inexplicable, or the mystery which needs no explanation. The longer I work with the matter, the more convinced I become that the reduction of meanings enriches its tone, the more I believe in the phenomenal picture, untranslatable into words.' (from *Sztaby/Szczeliny* 1993) However, it is possible to interpret his work and perhaps also to elucidate its meaning.

In *Clouds Coming* (to A. Tarkowski) of 1987 Skapski painted a large expanse of green with three elemental trees seen as if from a high point, with a triangle of pure blue intruding from one side and a dark elliptical cloud in the background against a yellow sky. Along the bottom edge of the painting he painted a numbered scale — the resulting atmosphere is redolent of the existential bleakness of the late Russian film-maker's work. Over the next few years he adopted gradually a process of

Beijing Street, n.d.,
Oil on canvas, 75 x 220 cm

reduction in his paintings, limiting his palette until he reached the work of 1992–93 where all colour other than grey and black has been lost. Form too has been reduced towards a minimalist interpretation of massive blocks of anonymous architecture. Three paintings from his period in China add an interesting diversion: two depict a massive black car with headlights and chrome in white against an ochre background, while the third, illustrated here, has parts of traditional Chinese buildings in red and two cars, one black, one red. These paintings speak of the anonymity of 20th century bureaucracy seen through the reductive filter of Taoism.

In his recent (1993) installation work, *Solar Series*, Skapski created a memorable set of temporary works on the beach of the Hel peninsula on Poland's Baltic coast. Using carefully considered placements of sticks he drew geometric shapes, square, triangle and more complex variations, on the sand with the shadows from the sun. These works, which now exist only in photographic documentation, have a quiet beauty, speaking of the transitory nature of the world. They provide a clue to the nature of Skapski's work, linking the processes of thought to a simple means of expression, requiring the involvement of the observer to render them permanent in memory.

Untitled, n.d.,
Oil on canvas, 75 x 220 cm

From the series 'Solar Series', 1993,
Environmental work, Hel peninsula 1993,
Twigs, sand, shadow, approx. 16 cm wide

ANNA SLAWKOWSKA-RODE

Anna Slawkowska-Rode was born in 1953 in Warsaw where she lived and worked as a painter and designer. She studied Design and Painting at the Warsaw Academy of Fine Arts from 1972–77, graduating with honours from the studios of Kazimierz Nita and Rajmund Ziemski, and then taught Exhibition and Graphic Design at the Academy where she headed the Studio of Graphic Design in Spatial Arrangements. Since the early 1980s painting has taken an increasing amount of her time, as it is in this medium that she finds the greatest possibilities of direct expression. As well as a series of exhibitions of her paintings in Poland, Australia, Canada and the USA she has designed for exhibitions of art and international fairs in many parts of Europe. In 1995 she moved to London.

Philosophically her work is derived from an abstract realisation of natural phenomena, and from an internal insight based on her personal dialogue with her perception of the external world. She considers that abstraction is often more closely related to nature than realism, in that it offers a short-cut to a distillation of visual and other sensations which offers an alternative means for communication, and a greater range of individual possibilities. Her paintings create transformations of experience, sometimes provocatively, at other times lyrically, but always with a carefully controlled use of colour which adds resonance to what are, initially at least, relatively simple forms. Her work usually results in a series based on a repertoire of themes to which she returns as necessary. She does not necessarily choose the series as a vehicle but finds that it usually comes about from a need to explore her sensations from different points of view and through this search to approach more closely the essence of the point of origin of the series.

Slawkowska-Rode's adoption of abstraction does not come from a conventional alignment with one part of the abstraction/realism polarisation that runs through Polish 20th Century art, but from an individual predisposition to investigating what she terms 'the field of vision' of her perception of the natural world. Images from this world are explored from different directions, through the continuing use of drawings and notebook entries. She categorises her experience into three sections, firstly the

Flying Ones, n.d.,
Oil on canvas, 140 x 160 cm,
Photograph: courtesy Stawski Gallery
and the artist

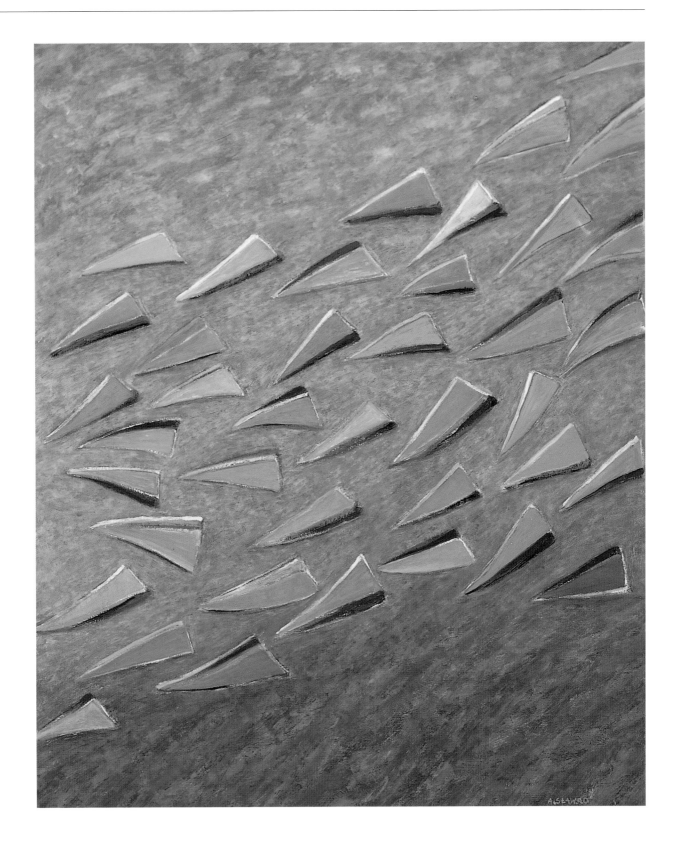

record of things perceived in the real world, taken out of context as if frozen in a film-frame, secondly the record of things not so much seen as imagined or guessed at, and thirdly the record of impressions expressed through coded symbols and a visual 'handwriting'. In all three there is the sense that the results of these explorations are not fixed, rather they are interim statements, steps along the way towards a more perfect realisation. She says, 'I paint because I need to, yet the painting is not an end in itself. It is a key to something that lies beyond, a key found by others in Music, dance, solitude or following a road.'

There is a stillness in her paintings, not fixed but transitory, implying motion through fixity, and dependent very much of the changing circumstances of the light in which the work is viewed. While a brief first impression conveys Slawkowska-Rode's obvious enjoyment of paint as a medium, the apparent paradox of attempting to encapsulate fugitive experiences in a permanent form resolves itself with prolonged observation during which the viewer can enter into a complicity with the results of the artist's thinking. Delicacy and strength, solidity and the void are counter-balanced, elements from the natural world are summoned up, examined, manipulated and re-presented for further consideration: the journey continues.

Notebook entry, n.d.,
Oil on paper, 50 x 50 cm,
Photograph: Courtesy Stawski Gallery
and the artist

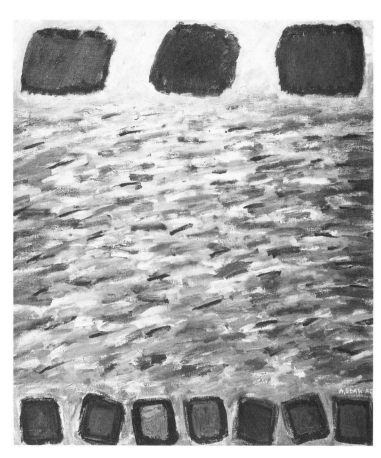

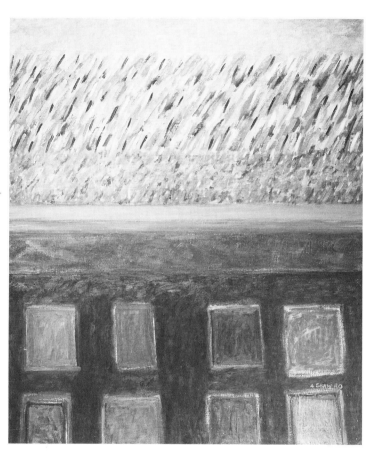

Dawn, (left half of diptych) n.d.,
Oil on canvas, 90 x 100 cm,
Photograph: Courtesy Stawski Gallery
and the artist

Dusk, (right half of diptych) n.d.,
Oil on canvas, 90 x 100 cm,
Photograph: Courtesy Stawski Gallery
and the artist

JACEK SROKA

Jacek Sroka was born in Krakow in 1957 and studied there in the Graphics
faculty of the Academy of Fine Arts from 1976–81, graduating from the studios
of Mieczyslaw Wejman and Witold Skulicz. He worked as an Assistant Professor
in the Etching Department of the Academy from 1981–89, and has since then
pursued his work as a painter. He lives in the industrial city of Nowa Huta, from
which comes much of the pollution that is damaging the ancient architecture and
environment of Krakow. Sroka's prolific output has been exhibited widely throughout
Europe and North America, achieving considerable success for this artist who is able
to juggle the serious and the comic, the tragic and banal in paintings which relate
strongly to the changing socio-political atmosphere of contemporary Poland.

The sense of the comic in Sroka's work is never flippant, but rather speaks of the
grimness of the evolving situation which can only be dealt with through the mask of
the clown. This is a deep-seated trait in the Polish character, which has contributed
significantly to the nation's ability to survive the vicissitudes of the past centuries. It
was common in the 17th century for a portrait of a dead person to be painted on the
end of the coffin and kept as a souvenir after the burial. This pentagonal format has
been adopted by Sroka in some of his paintings, partly in homage to the past, partly
as a satiric comment. Such a format was used, for example, in his 1988 painting of
the Lenin monument in Nowa Huta in which the Communist leader is shown about
to topple from his cracked pedestal beneath a cloud bearing the red triangle of the
Trinity. As the world of Communism crumbled this artist depicted its progenitor with
a harshness that would have been unthinkable, heretical even, a short time before,
but in so doing gave vent to feelings that had been long suppressed, and with a
verve that is remarkable.

Sroka has long excelled in the use of colour in his work, and throughout the
1980s his large scale paintings were characterised by vigourous brush strokes and
gross physical images that almost seemed to burst through the picture plane. In *Car
with Guardian Angel* (1989) a massive blue car confronts the observer, swerving
forwards from a grey ground with a smaller ghostly image of a winged car hovering

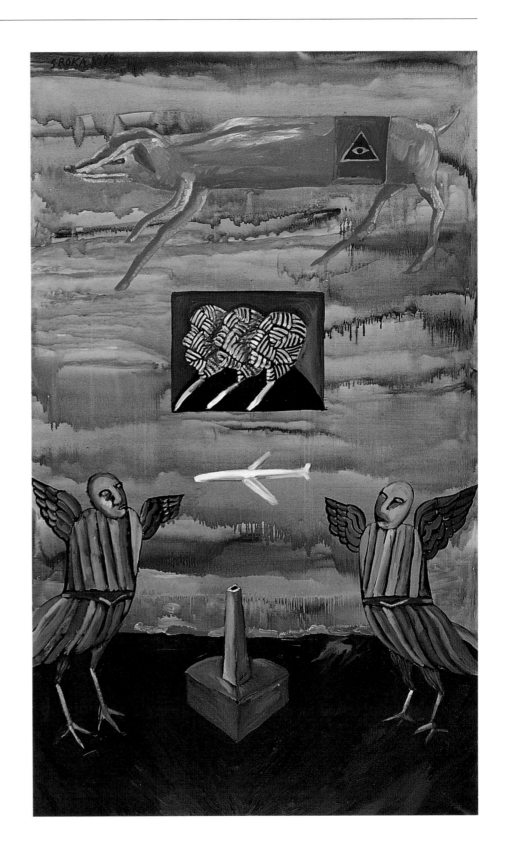

Structuring the World, 1990,
Oil on canvas, 200 x 120 cm,
Courtesy of D. Canteux
Collection: D. Canteux

above it, as if even Man's machines were part of some divine plan. However, it would not be accurate to ascribe excessive religious meanings to Sroka's work because he has long included images of priests that border on the libellous in his paintings and graphic works, including church figures in much the same way as politicians in his cast of burlesque characters that can be seen to relate to the popular cabaret milieu of Krakow.

In his more recent work Sroka seems to be taking a more considered approach, certainly a more ordered one, in response to the changes of recent years. In paintings such as *Lovers* (1994) a less immediately confrontational situation is depicted. Two figures emerge from a softly painted background and merge into an embrace. But the irony of his earlier paintings has not disappeared, for the figures are shown behind a foreground array of curiously spiked utensils, which also appear in *Five Good Deeds* (1993) which shows a priest creating the shadow-puppet of a vicious dog — an animal that is something of a trademark image in Sroka's work (he is an avowed dog-hater). While the mood of the country softens the hard truths remain and this artist continues to employ his characters to tragi-comic effect with all the aplomb and skill of a cabaret artist.

Left: *Bathroom*, 1993,
Oil on canvas, 180 x 120 cm

Right: *Five Good Deeds*, 1993,
Oil on canvas, 200 x 120 cm

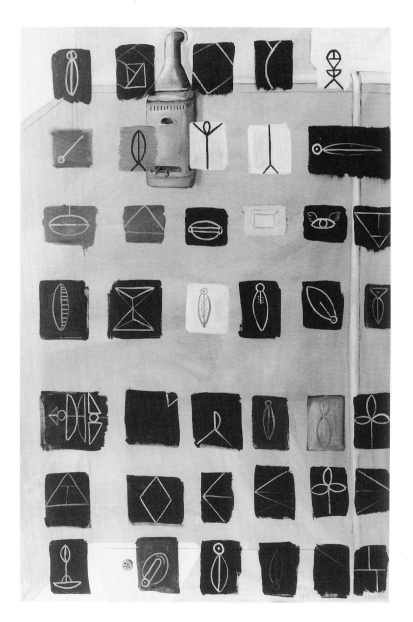

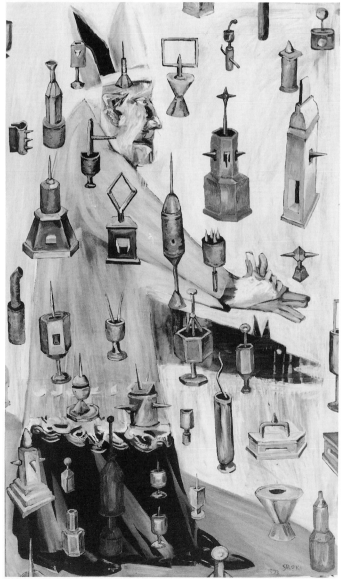

HENRYK STAZEWSKI

Henryk Stazewski was the final surviving Polish link between the fertile avant-garde revolution in Europe in the 1920s and its developments in Poland towards the end of the twentieth century. He was born in Warsaw in 1894 and died there in 1988. He studied at the School of Fine Arts (later to become the Academy) in Warsaw, graduating in 1920. In 1924 he was a co-founder (with Strzeminski, Kobro, Szczuka and Zarnower) of the influential group Blok and edited their magazine, a role which brought him into contact with all the important members of the avant-garde constructivist movement in Europe, including Malevich, Mondrian, Arp and Vantongerloo. The energy of the early avant-garde was such that groups formed and dissolved as theories and practices developed, and Stazewski moved from Blok to Praesens (a group which included architects — Stazewski practised architecture at this time as well as painting) in 1926 and then in 1929 to a.r. which he formed with Kobro and Strzeminski. At the same time his frequent visits to Paris enabled him to join both Cercle et Carré (1929), a group which also included Arp, Mondrian and Kandinsky, and Abstraction-Création (1932).

Throughout his long and productive life Stazewski was involved with the ideals of abstraction and constructivism, of an art that aimed to be a visual equivalent of nature, governed by its own laws. For Stazewski this meant an absolute commitment to geometric abstraction and the exploration of colour and texture. He participated in the important New Art exhibition of avant-garde painting and sculpture in Wilno which was organised by Strzeminski in 1923, and all the subsequent exhibitions of the groups to which he belonged. This, and his work with the groups' journals, enabled the first major collection of European avant-garde art in Poland, which formed the core of the collection of the Lodz Art Museum, whose international influence dates from this time.

Stazewski's early work was influenced by the theories of both Neo-Plasticism and Unism, using a limited repertoire of formal geometric shapes, some incorporating primary colours, others monochromatic, relying for their surface modulation on texture. Following the war, during which he did not paint, the period of group activity

Relief No. 1, 1972,
Acrylic and metal on board,
71.5 x 71 cm,
Photograph: Mariusz Likawski
Collection: Muzeum Sztuki, Lodz
Courtesy Muzeum Sztuki, Lodz

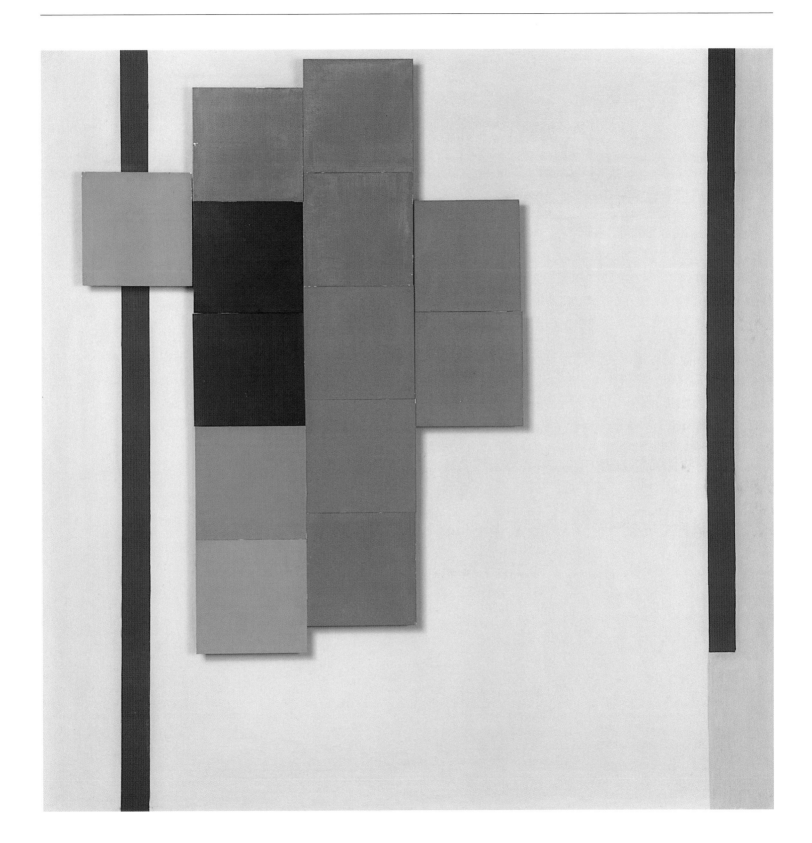

was over, and he began to rebuild his work, continuing as before with austere means. Most of his paintings since 1945 are on a small scale, giving them an intensity that relies on his strictly controlled use of colour and form. At one stage, in the 1970s, he made a series of paintings utilising only black lines on a white canvas. He also began working with reliefs, usually monochromatic or in tones of grey or white, incorporating ideas connected with repetition and serial evolution. The 1980s saw a return to a more lyrical use of colour and a greater degree of internal freedom in forms. Some of his late works utilise intense pinks, blues and yellows, often in startling combination, but always being subject to the same strict laws of composition that he set himself at the beginning of his career.

Towards the end of his life Stazewski became the elder statesman of the Polish avant-garde, and those who visited him in his cluttered studio as he held court, dressed in his magnificent striped dressing gown, were left in no doubt as to the importance of this artist whose views on art, anarchy and freedom continue to have an important influence on succeeding generations of young artists. In 1980 he said that he considered, 'Today's art is a prostitution and that artists who sell a lot of paintings are prostitutes' adding that the State should support artists so that their work could be given away. The present developments in Polish painting would no doubt have astonished him.

Relief No. 6, 1972,
Acrylic, wood, 60 x 60 cm,
Photograph: Jerzy Borowski
Collection: Foksal Gallery
Courtesy of Foksal Gallery

Relief No. 2, 1972,
Acrylic, wood, 71.5 x 71.5 cm,
Photograph: Jerzy Borowski
Collection: Foksal Gallery
Courtesy of Foksal Gallery

IRENEUSZ STELMACH

B orn in 1967 in Warsaw, Ireneusz Stelmach is one of the youngest generation of Polish artists who is beginning to establish a reputation for innovation and the continuation of the well-established Polish tradition for exploring the limits of painting. He was born in Warsaw and studied first in the ancient Baltic city of Gdansk at the State Higher School of Fine Arts from 1987–89 in the studio of Mieczyslaw Olszewski, then at the Academy of Fine Arts in Krakow from 1989–92, graduating from the studio of Juliusz Joniak and being awarded a Ministry of Culture and Art Scholarship. He now lives and works in Krakow, and while he has had relatively few exhibitions is already considered to be among the promising young artists in Poland.

Stelmach's work is much concerned with signs and traces, utilising a mixture of techniques to create intriguing textures which are essentially abstract but which retain an element of figurative allusion. In his large canvases he explores the potential for relatively simple shapes to establish tensions and their own sense of spatial relationships. The almost complete elimination of the spectrum — Stelmach relies on black, white and tones of grey tinted with very small traces of colour enables a closer consideration of the nature of subtlety in colour. This, combined with a developing skill in the manipulation of the characteristics of his chosen materials, oil, ink and emulsion, in various combinations to create a dialogue of transparency and opacity, gives his work the nature of objects that reward contemplation. Instead of having to consider the relationship of figurative elements (which can nonetheless be equally rewarding in the work of other artists) one can consider the subtle implications of line, form and texture that are present in these works.

More recently, in works dating from 1992, Stelmach has introduced other intriguing elements that come about from the development of his earlier techniques, transferring his image-making from canvas to aluminium sheets and adding new variations, and also from the possibility of the individual parts of each work — twelve in the case of *Aluminium I* and *Aluminium II* — being rearranged according to whim. The overall size of each of these works is large with the constituent parts combining

Aluminium II, (12 parts), 1992,
Acrylic, pencil, ink, paper on Aluminium,
240 x 252 cm,
Photograph: courtesy Stawski Gallery

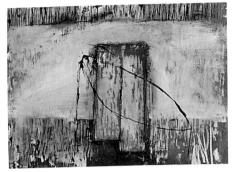 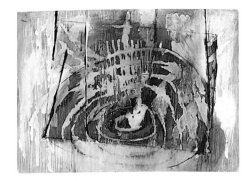

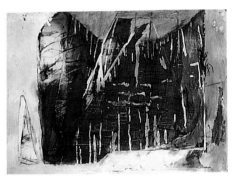 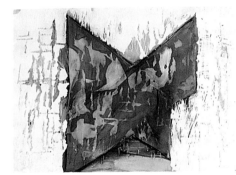 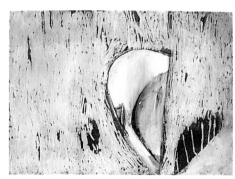

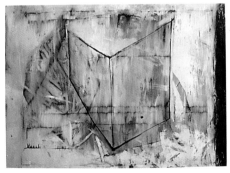 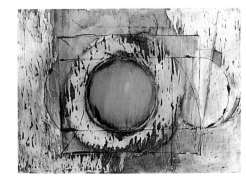 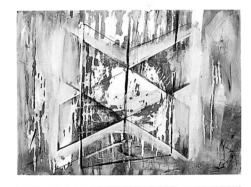

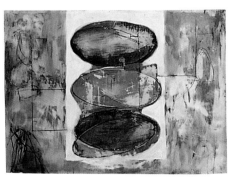 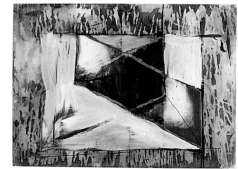 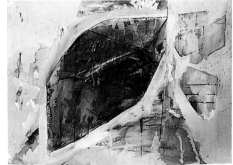

to create a work over two metres square, but within each the individual characteristics of each part extend the notion of dialogue, enabling each to be read individually or in conjunction with others. The nature of aluminium is exploited to give varying reflective qualities and the materials, now extended to included applied paper, have a wide range of textural variations. In addition the metal sheets are not uniformly flat, some bowing inwards or outwards which makes the work hang clear of the wall to varying extents and at the same time allows the sections to move in relation to each other with air currents — the effect is one of floating. Underlying all the work of Ireneusz Stelmach there is the power of the drawn image and the implication of space which ensures that repeated viewings of the work have a fixed point about which the possible variations can evolve.

Conversation, 1993,
Oil, emulsion, ink on canvas,
170 x 200 cm,
Photograph: courtesy Stawski Gallery

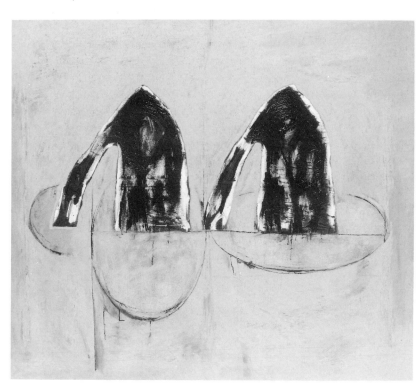

From the series 'Wings I', 1992,
Oil, ink on canvas, 174 x 200 cm,
Photograph: courtesy Stawski Gallery

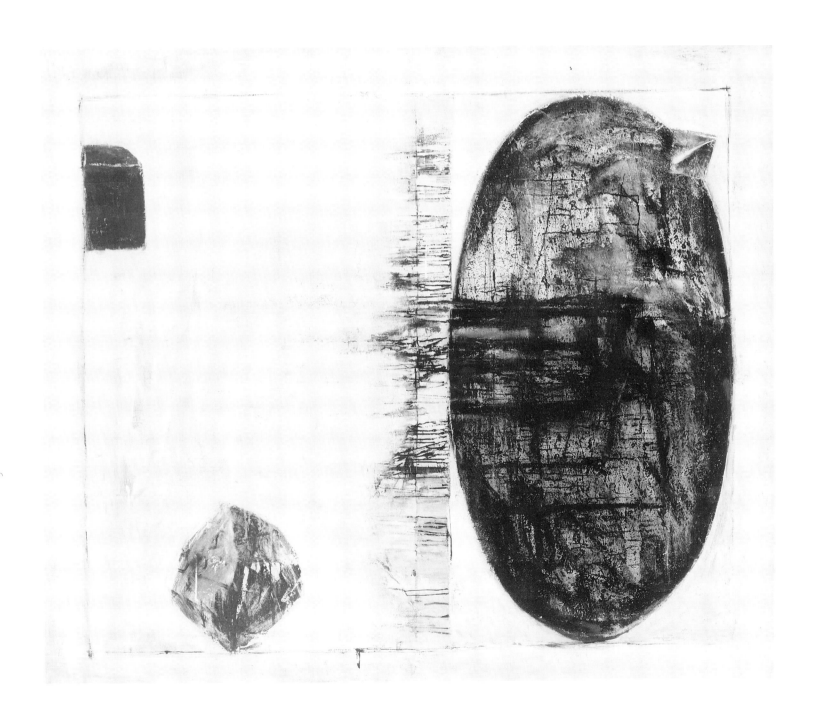

JONASZ STERN

The work of Jonasz Stern remains a powerful testament to the ability of art to transcend the worst that may befall a man and a nation. Born in 1904 in Kalusz at the foot of the Carpathian Mountains of Galicia, now in the Republic of Ukraine, Stern studied first at the State Industrial School in Lvov and then at the Academy of Fine Arts in Krakow from 1929–35 where he later became a Professor from 1954–74 and also served as Vice-Rector. He was active in the first Krakow Group from 1932–37 and participated in many of the important activities of this avant-garde group. He was a member of the Polish Communist Party before the Second World War, which, together with his being Jewish marked him as undesirable to the Nazi regime, and from 1939–43 was confined to the Lvov Ghetto. In 1943 he miraculously survived the Nazi's mass execution of Jews in a ravine near the town, and escaped by night to Hungary where he spent the rest of the war years. These traumatic events, and the death of his wife at Auschwitz, were to affect his work for the rest of his life until his death in Zakopane in 1988.

Following the end of the war Jonasz Stern returned to Krakow and resumed his work as an artist and became a central figure in the revival of the Krakow Group as well as participating in the work of the Cricot[2] Theatre. His pre-war work had explored the possibilities of abstract composition with colour and pure form taking precedence, but his work reached full maturity in the 1960s when he started to incorporate the elements of collage, using fish and animal bones, feathers and remnants of net, in his paintings. By the inclusion of traces of past life Stern sought to emphasise the dimension of Time while stimulating the consideration of the importance of memory. He said that these traces also expressed the sense of life and that by including them he prolonged that life, ensuring that it was not destroyed. In other paintings he incorporated prayer shawls, especially in a series of works titled 'Upokorzenie' ('Humiliation') which also include a photograph of an elderly Jew walking in the gutter watched by a young soldier in Nazi uniform. In *The Year 1941–42 in Kalusz* the shawl appears soaring into a sky with a crescent moon above the town of his birth, the ends of the cloth fraying into the darkness between the

Desert Landscape, 1982,
Oil and collage on canvas, 72 x 92 cm,
Photograph: courtesy the artist's family

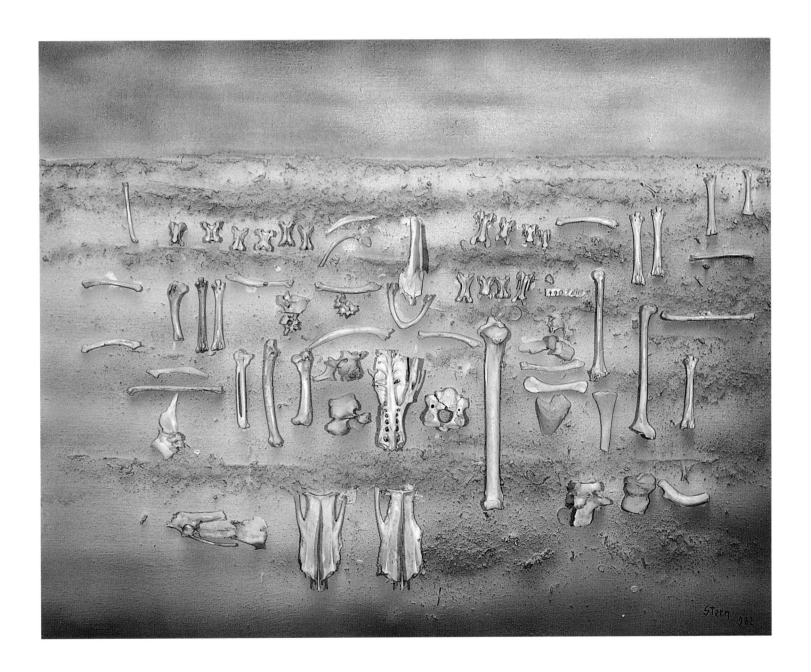

houses. As with the use of bones such elements achieve a powerful metaphoric resonance.

Many of Stern's paintings, particularly those of the later period, are sombre and, as the artist himself agreed, are in the form of the 'memento mori', but some achieve a lighter, perhaps more lyrical, effect, as in *The Birds which attempted to fly* which contains the sense of hope even in failure. Jonasz Stern did not flinch from expressing the redemptive power of humanity in his work which honours death but does not resent it, accepting that even in the most extreme circumstances such as those he experienced there can be found the strength to continue. While he created collages of bones sprayed red in the form of Jewish tombstones or synagogue windows, sometimes using them to spell out words in Hebrew, they do not create a morbid feeling, nor do they resemble the scientific arrangement of bones by the archaeologist, instead they are an affirmation of Life. Stern himself said that this, combined with the placing of glass in front of the collages so that the viewer is reflected, becoming part of the work, was intended as optimism, and it is this that marks him as a remarkable artist in both Polish and Jewish terms.

Waves, 1981,
Oil and collage on canvas, 53 x 120 cm,
Photograph: courtesy the artist's family

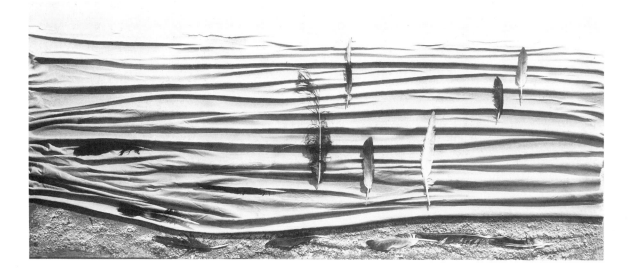

Kalusz in 1942, 1988,
Oil and collage on canvas, 50 x 70 cm,
Photograph: courtesy the artist's family

ANDRZEJ SZEWCZYK

Born in 1950 in the Silesian town of Katowice, Andrzej Szewczyk studied from 1974–78 in the Department of Art Education at the Silesian University in Cieszyn. He has since taught at that University and at a Primary School in Kazycze Gorne, where he now lives and pursues his art. It is not strictly accurate to call Szewczyk a 'painter' in that his work is not, in the usual sense, 'painting'. He would agree with this non-definition and would rather consider himself an artist whose work encompasses both the visual and literary arts, linked to a continuing search for meaning in his work and in that of artists and writers of all eras.

Since 1977 he has been connected with the Foksal Gallery in Warsaw, exhibiting there and at numerous galleries throughout Poland and Europe. His work has always been based on his explorations of works which seek to enlighten, to pursue the quest for art's meaning and its simple essence in a world which becomes denser with the complications of conflicting information. Thus he has immersed himself in the great literature of the world and the writings of other artists — for him William Blake, Franz Kafka, Barnett Newman, Kasimir Malevich, Paul Valéry and Kenneth Rexroth have all been important at various stages of his work. He returns to them, as to the world of music, as a means for understanding more deeply the way in which creativity works in the mind of the artist and through their works in the mind of the viewer or participant. There is therefore a deeply intellectual level in his work, one which is implicit and requires that the participant should find his or her own means for decoding it. Szewczyk's work can be seen as a series of sign posts, not the way, but the finger pointing the way.

In a long series of works, either on board or as installations, he uses carefully cut sections of coloured pencil arranged in systematic rows. In these the material normally associated with the making of drawings is subverted and reconstituted as a material in its own right, the colour of the casing and the core setting up rhythmic patterns across the surface on which they are placed. The titles vary from *Space is always the same, whether it expands or shrinks* (installation at the Foksal Gallery, 1981) through *Page 1: Tristan and Isolde* (1986–87) and *To Malcolm Lowry's*

Didache — Sunflowers, 1989,
Coloured pencils, wax, oil on wood,
Photograph: Tadeusz Rolke
Courtesy of Foksal Gallery

Drunkenness — Heaven (1987–88) to *Didache — Sunflowers* (1989, illustrated here).

In another series Szewczyk has developed his technique of using lead and wood to create his 'Monuments of F. Kafka's letters to F. Bauer', based on Kafka's letters of unfulfilled love for Felicija Bauer. Taking rectangular blocks of oak he drills rows of holes into them and pours in molten lead, sealing each so that the lead flows over the lip of the hole. Well aware of the importance of lead in alchemy and equally that tradition's insistence on making everything by hand Szewczyk has created what he calls his own 'private wailing walls'. The technique was developed further in the major installation, *Basilica*, shown at the Krzysztofory Gallery in Krakow in 1989, where semi-circular headed blocks of oak with rows of lead-filled holes were arranged in the form of a Romanesque basilica, the blocks being placed in a deep bed of salt, within the vaulted brick space of the gallery, recalling the early architecture of the Polish kingdom and equally the rows of memorial stones in cemetaries. There is a subtle beauty and fascination in Szewczyk's work which transcends the normal bounds of painting yet belongs within its long tradition of celebrating the essence of light.

From the series 'Monuments of F. Kafka's letters to F. Bauer', n.d., Lead on wood,
Photograph: Stanislaw Wenglorz
Courtesy of Foksal Gallery

Basilica, n.d.,
Installation at the Krzysztofory
Gallery, now in the collection of
the Muzeum Sztuki, Lodz,
Lead on wood, salt,
Photograph: Tadeusz Rolke

JANUSZ TARABULA

J anusz Tarabula was born in Krakow in 1931 and studied firstly at a secondary
school in Bytom where his education included advanced studies in mathematics
and physics, then at the Krakow Academy of Fine Arts from 1950–56, graduating
from the studio of Czeslaw Rzepinski. His early paintings took the form of geometric
abstraction and collage, and he began exhibiting soon after completing his studies.
In the early 1960s he explored new ways of painting, reducing the means to a
minimum, and also becoming involved in sculpture, producing his *Monument for
the Lublin Ghetto* in 1963. He joined the Krakow Group in 1961 and was also active
with the Nowa Huta group. He has travelled to Central Asia and spent some time
also in East Germany and Italy. His interests beyond painting include astronomy and
physics, both of which inform his painting, and the conservation of art.

There is in Tarabula's painting a sense of bleakness and in much of his work a
minimum of colour. The serious foundation of his work is based very much on his
philosophy of painting which originates in the belief that a painting has an essential
quality that goes beyond its mere pictorial form. In this he relates to Jerzy Nowosielski's
beliefs that come from the Orthodox Church tradition, in particular that the world,
although linked to the Fall and therefore imbued with the presence of evil as well as
good, is essentially good as it is part of the sacred, and that even though the sacred
may appear to be lacking it is nonetheless present within the core of all things,
awaiting the 'coming into being', in the case of Tarabula, through his painting. His
art is not 'sacred' in the traditional, formal, sense, but owes its nature to an aesthetic
and metaphysical understanding of the term. While he was aware during his years
at the Academy of the work of the Colourists who drew inspiration from the Post-
Impressionists and who were influential in the mid-1950s, his work soon became a
negation of the superficial principles of that group, and he sought for the manner
in which the underlying creative force of nature could be expressed. The resulting
paintings have a contemplative quality and require equally the contemplation of the
viewer and a degree of intellectual effort in order to approach their essence.

In a series of early works from the 1960s Tarabula makes a conscious reference

Rzeka Zapomnienia, 1989,
Acrylic on canvas, 128 x 145 cm,
Photograph: Marek Gardulski
Courtesy of Zderzak Gallery

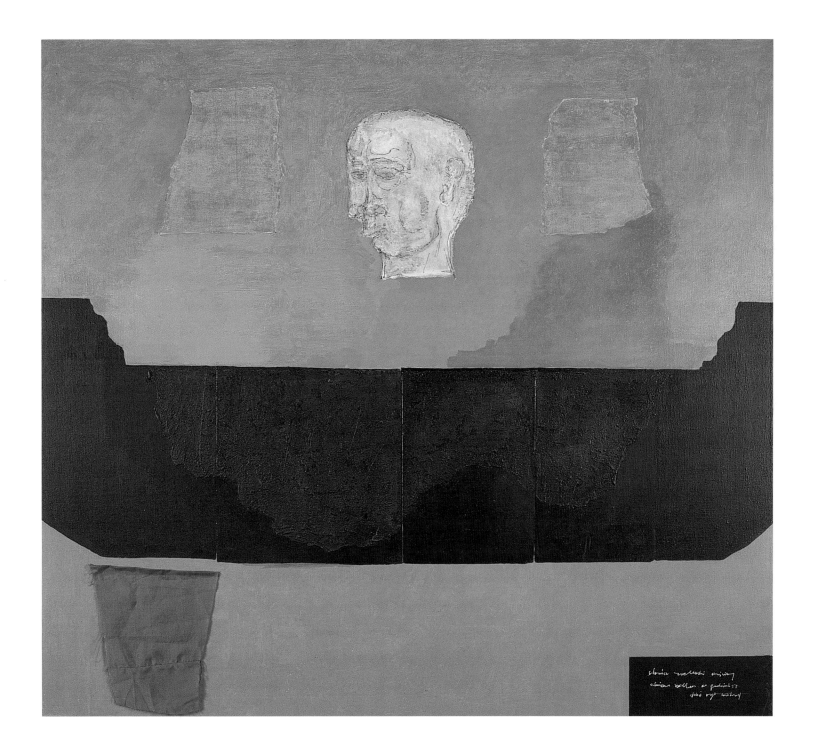

to the fate of the Jewish people, and these 'monuments' possess a haunting quality, appearing as age-worn stones do, drained of almost all colour except browns and greys, built up with textures into the third dimension, some with strips of cloth incorporated in the surface. They are sombre and become a form of the 'Kaddish' or prayers for the dead. Through contemplation comes the realisation that there are subtleties of colour, greens and blues, that emerge from the chaos of the surface, suggesting a deeper space beyond in which sadness finds its complementary opposite. Tarabula's search for the description of this deeper space and the uncreated potential light is more apparent in his work of the 1970s which is more conceptual in nature, incorporating text and photographs. In his work from the late 1980s there is a return to colour and a greater sense of open-ness which brings a more optimistic view. The work of this artist is not easy to approach but it does offer its own distinctive quietness in which the uncertainty of Man's existence as well as the truth of the sacred is mirrored as in the vibrations of all matter.

Zachod Slonca, 1989,
Acrylic on canvas, 110 x 145 cm,
Photograph: Marek Gardulski
Courtesy of Zderzak Gallery

Janusz Tarabula in association with
Bogomil Zagajewski,
Monument to the Lublin Ghetto,
1963, Stone,
Photograph: courtesy of Zderzak
Gallery

LEON TARASEWICZ

Although he is associated with the Foksal Gallery in Warsaw where he has shown successfully since the mid-1980s, Leon Tarasewicz lives and works in, and derives his inspiration from, a remote village to the north-east of Bialystok, close to the Belorussian border. He was born in the village of Stacja Walily in 1957 and studied at the Academy of Fine Arts in Warsaw from 1979–84, but returned to live in his birthplace where he now occupies a purpose-built house and studio, accompanied by his cats, dogs and a collection of exotic birds from around the world. His decision to base himself in the familiar surroundings of a natural world came from his need for the security and calmness he finds in that world, where he is, '… impressed by its balance, eliminating the sick and the degenerate; this creates beautiful, self-regulating, harmony.'

Since completing his studies Tarasewicz has worked steadily on the development of his painting which is recognised widely for its absolute integrity and the clarity of its vision. The bleak surroundings of the forgotten corner of Europe in which he lives has provided him with a rich soil from which to draw his art. In his early work he created memorable images of bare trees and furrowed fields in snow, where any colour is bleached out leaving only the slightest of traces of Man's presence. These paintings are however far from being empty of deeper meaning as they require the consideration of the place of Man in the wider scheme of things and at the same time are a powerful testament of the artist's presence in the landscape. This provides a key to the understanding of his later works which are larger and incorporate a wider range of colours and resonances. The painting of Leon Tarasewicz can be considered as a continuation of the tradition of Romantic painting in Europe but speaks for the end of the twentieth century rather than the nineteenth and of a reverence for the primal nature of landscape rather than for the idea of God within that landscape. While inevitably being seen as 'Polish' it is not about Polish history nor does it offer itself for comparison with his contemporaries, having a relevance that is universal rather than national. In choosing not to title his work he requires the attention of the observer to its implicit meanings and a closer understanding of the

Untitled, 1988,
Oil on canvas, 190 x 260 cm,
Photograph: Jerzy Gladykowski
Courtesy of Foksal Gallery

nature of painting itself.

In his later work the virtuosity with which he controls the application of paint becomes more evident. He tends to paint thickly, allowing the material to flow, congeal and build up into textures that reveal traces of colour built up in alternating harmonies and discords, which suggest the fugitive colours of the passing seasons without recourse to any form of figuration. Yet, for all the abstracted quality of the work there are the recollections of keenly observed nature — the flashes of colour from wild flowers and passing sunlight on the land. The scale at which Tarasewicz chooses to work (up to ten metres wide) imbues his paintings with a scale that is both epic and intimate at the same time, allowing equally for close inspection which reveals the subtleties of colour and for distant contemplation which allows the strictly managed composition to emerge. Rhythm and the power of light are equally important, which, combined with the manner in which colour is used give his work a similar breadth to that of music, with tonal variations running through the work to create a sense of progression and unity. Underlying everything within the painting of Leon Tarasewicz is a profound respect for the natural world and an equal respect for the nature of painting.

Untitled, 1993,
Oil on canvas, 130 x 130 cm,
Photograph: courtesy of Galerie
Nordenhake, Stockholm, Sweden

Untitled, 1984,
Oil on canvas,
Photograph: Jerzy Borowski
Collection: Galerie Nordenhake, Stockholm, Sweden
Courtesy of Foksal Gallery

JAN TARASIN

Jan Tarasin was born in Kalisz near Krakow in 1926 and studied at the Krakow Academy of Fine Arts from 1946–51. He was a guest lecturer at that Academy from 1963–67, and from 1967 taught at the Warsaw Academy of Fine Arts, where he was elected Rector in 1987. He lives in Warsaw and is active in painting, graphics, and drawing. He has exhibited widely in Poland and internationally and is represented in many public and private collections.

There is a levity about the work of Tarasin but an underlying seriousness which is derived from an essentially Polish approach to the solution of the problems of visual expression. At the time of his graduation Poland was in the grip of post-war reconstruction by a Stalinist government which, amidst a general repression, viewed Socialist realism as the only publicly acceptable style in the visual arts. For young artists of Tarasin's generation there was a choice — either to follow state dictates or to reject them, seeking instead a more truthful personal exploration of the values of art: it was the latter course that Tarasin chose, one which has led him to produce a unique and extensive body of work. This stems partly from the isolation of Polish culture from wider world trends in the 1950s and early 1960s, an isolation that, instead of leading to a diminution of originality, resulted in the development of a distinct Polish approach, as varied in its results as the artists who chose the way of individual development.

The recurrent motif in Tarasin's work is the use of a language of abstract signs which are superimposed on the surface of his paintings, prints and drawings, adding a dimension in front of the picture plane through which the underlying images emerge and by which they are partially concealed. This duality leads to a contemplation of the relationship between the chosen elements, where the notation of signs develops in each individual work and throughout his work in general, suggesting movement and evolution as well as a mysterious language that relates to the colours and forms beneath the signs. Much of Tarasin's painting is abstract in nature, relying on colour applied in carefully considered chromatic and tonal contrasting patches on a plain ground. This technique is used in pastels and water-colour works as well as in

Untitled, 1987,
Oil on canvas, 95 x 67 cm,
Photograph: Artur Rogalski
Collection of the artist
Courtesy of Zapiecek Gallery, Warsaw

oil paintings with significant variations that come from the honest adherence to the nature of each medium. In his graphic work, mostly in the form of silk-screen prints and etchings, there are some figurative references — animals, landscapes and buildings as well as portraits manipulated through graphic means. These are usually overlaid with abstract signs. In others dense concentrations of parallel or concentric lines created a receding space across which the signs are clustered or spaced out as if in some archaic language. The references are obscure, apparently intentionally so, requiring that observers should decode the works according to their own perception and experience.

In certain recent works Jan Tarasin has used figurative references in his oil paintings. Notable amongst these are *Breughel* (1987) in which a winter landscape reminiscent of the Dutch master is partially concealed by signs in black and read that are spaced out across the canvas, establishing a dialogue between the two apparent surfaces, and *Dalmatian 2* (1990), in which the spotted marking of the dog seen in profile are complemented by the signs that overlay the surface — as before a dialogue, in this case approaching levity, is created. Tarasin has achieved an immediately recognisable style which continues to develop and in so doing has made a masterly contribution to the diverse originality of Polish painting.

Duze i male gry I, 1989,
Oil on canvas, 100 x 80 cm,
Collection of the artist
Courtesy of Zapiecek Gallery, Warsaw

Niestabilne Obiekty, 1988,
Oil on canvas, 95 x 67 cm,
Collection of the artist
Courtesy of Zapiecek Gallery, Warsaw

TOMASZ TATARCZYK

Tomasz Tatarczyk was born in 1947 in Katowice, the central town of the heavily polluted industrial area of Upper Silesia. He studied in Warsaw, first at the Polytechnic Institute from 1966–72 and from 1976–81 at the Academy of Fine Arts, graduating from the studio of Jan Tarasin. He worked as an assistant in the Department of Painting at the Academy from 1980–86 and was granted a Scholarship for 1987–88 at the Kosciusko Foundation in New York. Working with traditional materials, oil or oil and wax on canvas, he has created a body of work that has a quiet intensity, largely without colour, and which has received considerable international recognition.

His work from the mid-1980s spoke eloquently of the hard times through which his country was passing. Using black as the predominant colour, building up layers of impasto, he painted closed gates that reflected the light falling on them through a carefully worked attention to texture and surface. In these works he acknowledged the inspiration of Grünewald and Caspar David Friedrich and expressed his attitude to darkness and the underlying feeling of not knowing what might lie on the other side of the gate — the light of day or the darkness of night. Concurrent with the Gates series was a series of canvases that showed ranks of saws, their white sharp teeth appearing as symbols of oppression against the black ground. Towards the end of the 1980s however there came a change in direction in Tatarczyk's work as he began a long series of paintings with a more lyrical atmosphere which nonetheless still referred back to the visionary romanticism of Friedrich. In the 'Hill' paintings he depicts an apparently less threatening world, one of tree-covered hillsides against deep blue or sunset skies, or highlighted in the crisp light of a snowy winter, or lit by the slanting light of early morning. Within these paintings there remains something of the mystery of the gates, but one feels less enclosed and the possibilities of escape seem greater.

The change in Tatarczyk's work coincided with him spending less time in the concrete suburbs of Warsaw and more in the village of Mecmierz outside Kazimierz Dolny, an historic small town dating from the fourteenth century on a bend of the

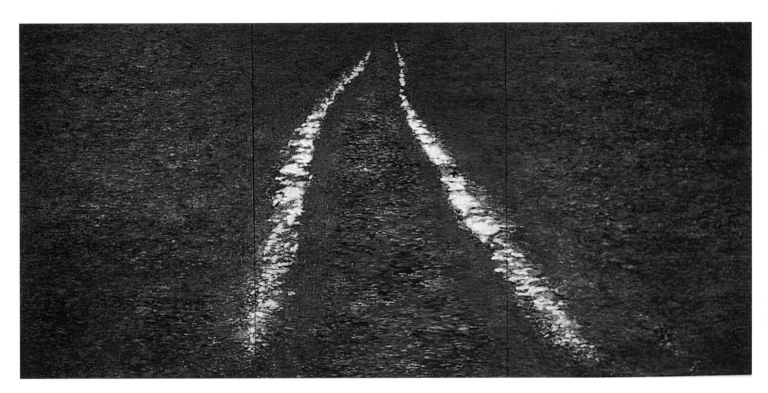

In the Moonlight, 1993,
Oil on canvas, 170 x 360 cm

Vistula. He now lives in this village and admits that the change of environment has had an important effect on the development of his work. As an artist deeply aware of the sensitivity required to give expression to the symbolic power of simple objects and the natural environment he prefers the solitude that Mecmierz allows him. His work is contemplative, obedient as much to the need to work within the long continuum of art history as it is to the need for absolute honesty in the re-creation of observed forms.

In the latest series, 'Roads', which dates from around 1992 Tomasz Tatarczyk reveals himself fully as an artist engaged with the quest for truth that is symbolised by these large paintings (made up of two or three sections as his studio space is small) of roads leading away into the distance, their heightened perspective creating a potent sense of the space within a painting. While derived from the experience of real roads these are much more than that, dealing with the indeterminacy of rural roads as contrasted with the harsh certainty of city streets, and more importantly with the connections with the earth and space that such roads give. The awareness of darkness from his earlier work persists, but the inherent pessimism of the dark gates is replaced with a sense of optimism — the mystery is not solved but the possibility of resolution seems closer.

Caspar David Friedrich's Gate, 1985,
Oil and wax on canvas, 170 x 240 cm,
Photograph: Tadeusz Rolke
Courtesy of Foksal Gallery

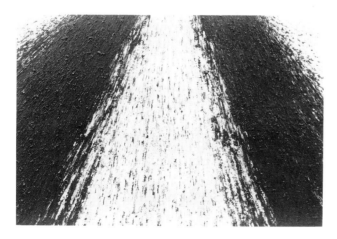

Black Road, 1992,
Oil on canvas, 170 x 260 cm,
Photograph: Grzegorz Borowski

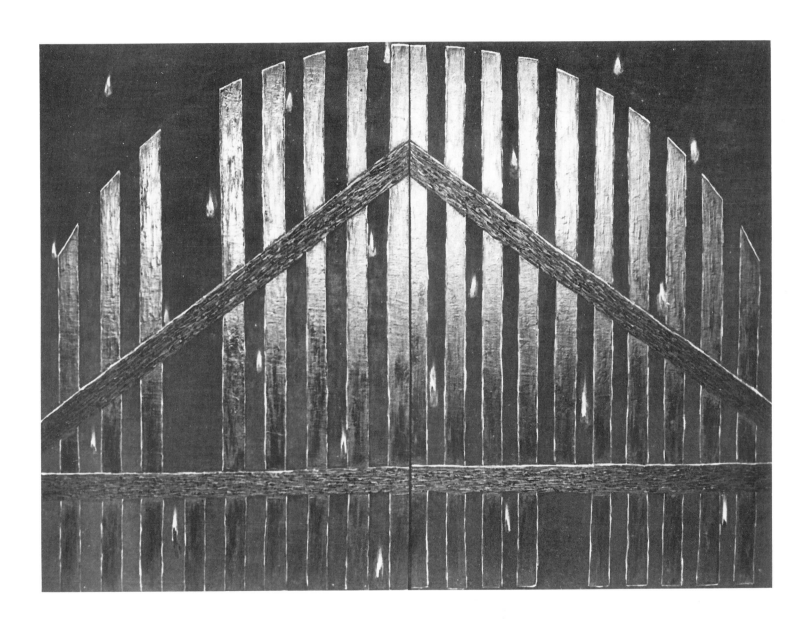

JACEK WALTOS

Jacek Waltos was born in Chorzow in 1938 and studied at the Academy of Fine Arts in Krakow from 1959–63. His work encompasses Painting, sculpture, drawing and printmaking, and he has also been involved in exhibition organisation and art criticism. In 1966 he joined the Wprost (Direct) group which also included Maciej Bieniasz, Zbylut Grzywacz, Barbara Skapska and Leszek Sobocki, a group whose work from its inception until 1986 was allied to the movement towards the new figurative style and sought to describe reality through direct means of representation. At the same time these painters sought to confront the changing social and political situation in their country and achieved a degree of prominence in the years of Martial Law and Solidarity. While Grzywacz and Sobocki developed a hard-edged realism and immediacy in their work which rendered it popular in the early 1980s, Waltos chose instead to work in a style which is looser and contains a more diffuse symbolism, and which has allowed him to continue developing his work in the greatly different climate of the post-Communist world.

Representation in painting is of central importance to Waltos, not so much in the sense of a literal transcription of perceived reality, but rather by means of a technique that alludes to that reality through the portrayal of impressions. His use of colour tends towards translucency and luminosity and this, combined with a skilful use of drawing, gives his work the sense of having captured a moment in an ongoing event, the paradox being that of transitory emotions caught in a permanent form. Central to his work is the question of human destiny, the cycle of life and death and also the connection between subjective and objective understanding of events. His paintings deal with an objective realisation of those events but with a clear identification with the subjective emotions of the figures within them.

In common with many other Polish artists he chooses to develop his themes through a series of paintings and allied drawings. In the 'Good Samaritan's Cloak' series from the mid-1980s onwards, which received the 1986 Solidarity Award for Art, Waltos identifies closely with the victim whose naked body is enfolded by the protecting cloak that almost takes on bodily form. The form of the victim becomes

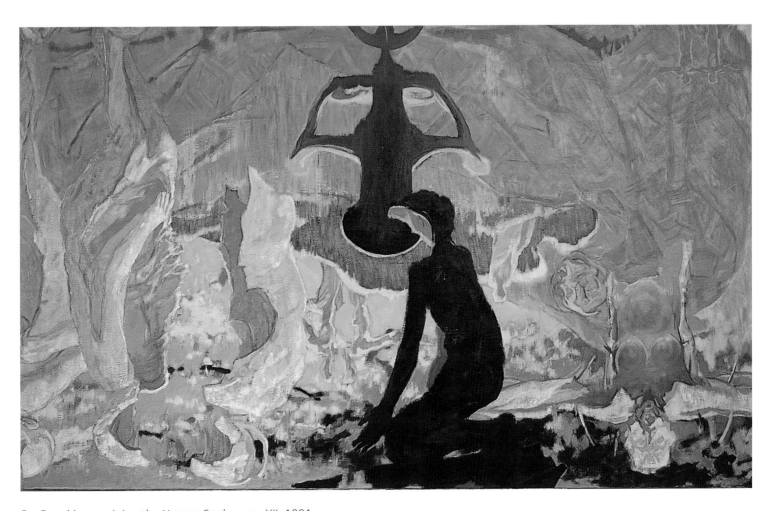

Dr. Freud is examining the Human Soul ... no. XII, 1991,
Oil on canvas, 140 x 225 cm,
Collection: National Museum, Krakow

substance while the cloak becomes the essence of the humanity by which all victims may be saved. A visit to Freud's house in Hampstead provided the starting point for the following extensive series, 'Dr. Freud is examining the human soul', in which the use of symbolic forms is dominant. The door of Freud's house, his famous chair and couch provide the framework within which figures appear and fade through the series. In some there is a figure on the couch, in others it is empty, and the figures that move in and out of the void beyond resemble sculptural forms (including those from Waltos' own work as well as a Michaelangelo Slave) and sometimes ghostly human forms. The chair is always shown empty, presiding over the events within each work, its back towards the viewer who stands, as it were, behind the chair, observing as did Freud the mysterious pageant of the human soul.

In a more recent series, 'I. sacrificed by A.' an androgynous figure (Isaac or Iphegenia) is threatened by a male figure (Abraham or Agamemnon) whose knife hovers in mid-air. The event is captured at the moment of possible redemption but the final outcome is not made clear. Waltos does not paint pictures that are initially easy to understand but does allow the viewer to participate in his search for humane understanding of life.

Good Samaritan's Cloak XII, 1986/87,
Oil on canvas, 100 x 200 cm,
Photograph: Stanislaw Michta

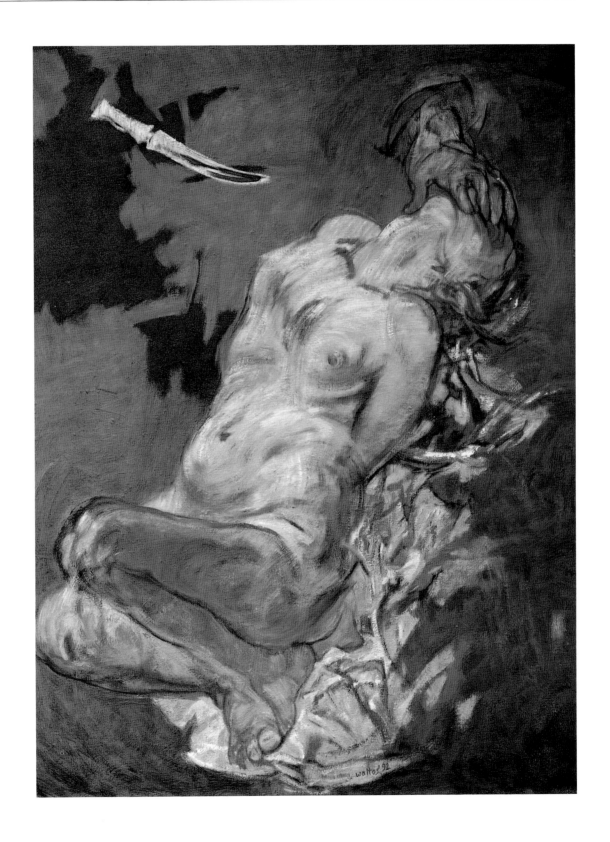

I. sacrificed by A., I, 1992,
Oil on canvas, 120 x 90 cm

ANDRZEJ WELMINSKI

Andrzej Welminski was born in Krakow in 1952 and studied in the Graphics Faculty of the Krakow Academy of Fine Arts, graduating in 1977. The following year he was awarded a scholarship by the Goethe Foundation. In 1973 he joined the Cricot 2 Theatre and participated in all the subsequent activities and spectacles of that celebrated experimental theatre company until the death of its founder, Tadeusz Kantor, in 1990. He has been instrumental in developing the work of the company since Kantor's death, in 1991 participating in the 'Homage' that marked its first anniversary, as well as playing an important role in the consolidation of members of the company to present a new spectacle in 1993 which was presented with some success in Poland, Spain and Sardinia,

He therefore represents a link between the avant-garde activity of the 1970s and the work of artists who now face the situation of developing that activity in a Poland that has changed completely following the fall of Communism and is now evolving rapidly into a country coming to terms with the realities of a free-market economy. Whether or not the spirit of Cricot 2 can survive the death of Kantor and the changes in Poland remains to be seen, but it is certain that the mercurial influence of its founder will continue to inspire a sector of the Polish visual arts world for some time to come. Welminski's work as an artist deals with the world of memory and illusion and the need to make positive those traces of reality that comprise a personal recollection of life that remain important and worthy of communicating to others. Kantor's style of theatre was based very much on the same premise and often resulted in a tumultuous spectacle with few moments of calm amidst what may at times have appeared to be chaos.

By contrast Welminski's almost monochromatic work from 1991 contains a sense of stillness, of the moment captured. This comes not only from his use of photographs from Kantor's final work with the Cricot 2 Theatre, *Today is my Birthday*, but also from the manner in which he has incorporated them with fragments of other materials and gestural paint marks (themselves the trace of movements of the artist's hand) within polished metal frames. The result is elegiac, akin to the freezing of an

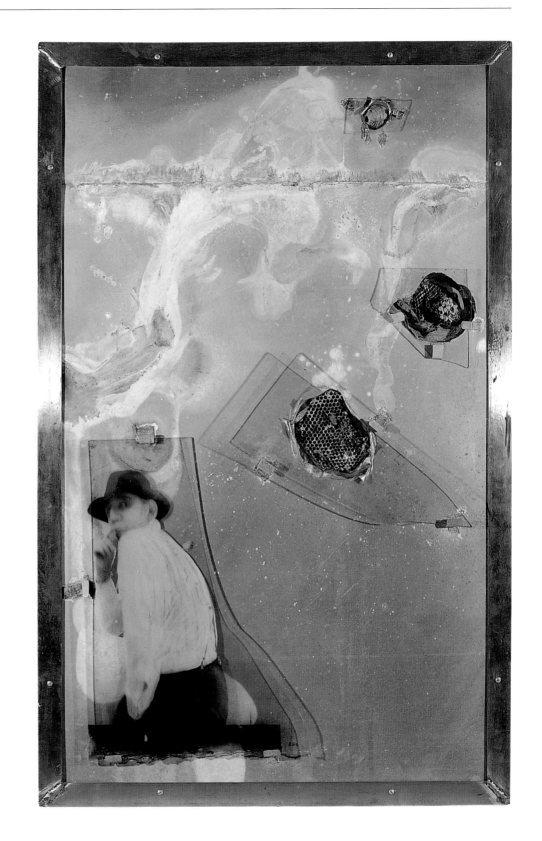

Self-Portrait, 1991,
Mixed media, 120 x 72 cm,
Photograph: courtesy of Starmach Gallery

event in time, one that is wholly congruent with one's memories of theatre. Kantor, in an introduction to an exhibition catalogue, stated that he saw all the characters played by Welminski in his time with the theatre company as being self-portraits, and of his paintings having something of the sense of the circus, the laugh of the clown. He added that '... a picture is not to be looked at, it is to be approached.'

In his recent work Welminski has returned to the use of colour while still incorporating materials other than paint. In one painting a railway line curves into a the impression of a landscape, disappearing only to re-emerge as lines spiralling up into the sky to be transformed from paint into metal tracks that curve upwards and outwards from the surface of the canvas. In another, *Belief*, an empty glass bottle sealed with wax and string bearing the title painted in gold, emerges from the cracked earth beneath an opened potato clamp in a wintry field, part painted, part constructed of straw. In these works, as in the world of theatre, reality and fantasy merge, the memorable is remembered.

My Mother, 1991,
Mixed media, 120 x 72 cm,
Photograph: courtesy of Starmach Gallery

From the cycle 'Ruins', *In Ruins*, 1993,
Photographic emulsion on paper with drawing and silver leaf, 23 x 20 cm

BIOGRAPHIES

ANDRZEJ BEDNARCZYK

1960 Born in Lesna
Assistant, Painting Department, Academy of Fine Arts, Krakow

Education and Awards

1981–86 Studied at the Academy of Fine Arts, Krakow: Graphic Department (1981–83); Painting Department (1983–86); graduated from the studio of Professor Zbigniew Frzybowski (1986)

1987 Ministry of Culture and Art Award
Ministry of Culture and Art Scholarship
Award, 5th Confrontations of the Youngest Artists from Krakow, Myslenice

1988 Ministry of Culture and Art Scholarship

1991 Award, 'Bielsko Autumn', Bielsko-Biala

1992 Pollock-Krasner Foundation Grant, New York
Honorary Award, 12th International Biennial of Woodcut, Banska Bistrica, Czechoslovakia
Honorary Award, 'Ibizagrafic '92', 12th International Biennial of Graphic Art, Spain

Other Activities

1985 Scenography of 'Treasures and Nightmares', Norwid Theater, Jelenia Gora

1986 'Passion', mime performance, Warsaw

1988 'Loze', performance, Bialystok

1993 Artistic trip to Siberia, Russia

1994 Published book of poetry 'The Stones of My God'

Solo Exhibitions

1988 Student Cultural Centre 'Rotunda', Krakow

1989 Gallery of the Academy, Krakow Centrum, Krakow

1990 U Ambrozego, Krakow
NO TU NO, Geneva, Switzerland

1991 Stawski Gallery, Krakow
Piano Nobile, Krakow
Gallery of the Art Exposition Bureau, Lodz

1993 Stawski Gallery, Krakow

1994 Galerie '90, Bruxelles, Belgium
'Conversations with Paper', International Triennial of Graphic Art, Stawski Gallery, Krakow

Group Exhibitions

1986 'Greenbelt Festival', England
Arts Centre Group, London

1987 'Diploma Works '86', Lodz
5th Confrontations of the Youngest Artists from Krakow, Myslenice

1988 'Dialogue', Nurnberg, Germany
'Autumn Review of Krakow's Art', Nurnberg, Germany

1990 '58 Gallery', Chicago, USA
'Beyond the Picture', Krakow
'New Art in the Palace', Krakow
'Green Earth Festival', Legnica
'Artistes Polonaises Contemporains', Geneva, Switzerland

1991 'Dotyk/Touch: Iconography of the Eighties', BWA Gallery, Palace of Art, Krakow
International Triennial of Graphic Art, Krakow; Nurnberg, Germany
19th International Triennial of Graphic Art, Ljubljana, Slovenia
The Krakow Art Fair, Krakow
'Bielsko Autumn', Bielsko-Biala
'Intergrafia', International Graphic Exhibition, Katowice; La Louviere, Belgium; AFA Fair, Augsburg, Germany
'Neighbours', International exhibition, Nurnberg, Germany
'Professors of the Academy of Fine Arts', Krakow

1992 'Decouvertes '92', Grand Palais, Paris
5th International Drawing Triennial, Wroclaw
12th International Biennial of Woodcut, Banska Bistrica, Czechoslovakia
'Ibizagrafic '92', 12th International Biennial of Graphic Art, Spain
Yokohama International Print Auction '92, Japan
17th International Independent Exhibition of Prints, Kanagawa, Japan

1993 'Stawski Gallery Presents', International exhibition, Krakow
'Art Chicago 1993: The New Pier Show', Chicago, USA
'Inter-Kontakt-Grafik', International exhibition, Prague, Czech Republic
12th Seoul International Print Exhibition, Korea
10th International Exhibition of Graphic Art, Frechen, Germany
International Biennial of Drawing, Taiwan
'Artists from Krakow', Zacheta Gallery, Warsaw
'Generations: Graphic in Krakow', Poland
SIAC, International exhibition, Palace of Art, Krakow
'Dusseldorf Great Art Exhibition', Germany
'Polish Contemporary Graphic Art', The Polish Museum of America, Chicago, USA
1st Egyptian International Print Triennale, Giza, Egypt
2nd International Biennial of Graphic Arts, Gyor, Hungary

1994 Budapest Art Expo 1994, Hungary
'EuropArt', Geneva, Switzerland

Public Collections

Urzedu Miasta, Krakow
Universal Graphic Museum, Egypt
Oxygen—Biennial Foundation
Polish Museum of America, Chicago, USA
National Gallery, Prague, Czech Republic
Museu D'Art Contemporani D'Eivissa, Spain
State Gallery, Banska Bystrica, Slovakia

TADEUSZ BRZOZOWSKI

Solo Exhibitions

1956 Warsaw
1960 Warsaw; Paris
1961 Chicago
1963 Poznan; Szczecin; Torun
1964 Chicago; Warsaw
1965 Poznan

1966	Paris; Krakow; Warsaw	
1967	Krakow	
1968	Warsaw	
1969	Torun	
1970	Krakow; Katowice	
1972	Wroclaw	

1974–75 Retrospective exhibition, National Museum, Poznan

1976 Wschowa
1977 Chelm
1978 Warsaw; Lodz
1979 Warsaw; Rzeszow; Kolobrzeg
1980 Kracow; Bialystok
1981 Poznan
1983 Kracow; Zakopane
1984 Bordeaux; Nowy Sacz
1986 Varrelbusch, Germany; tapestry exhibition Sarmatian Quartet in Krakow, Warsaw, Zakopane and Bydgoszcz
1987 Krakow; Warsaw; Cieszyn; Zamosc; Rzeszow; Herford

Posthumous Solo Exhibitions
1987 Poznan; Krakow (twice); Zakopane
1988 Zakopane
1989 Krosno; Zakopane
1990 Lublin

Selected Group Exhibitions
1948 1st Exhibition of Modern Art, Krakow
1957 2nd Exhibition of Modern Art, Warsaw
 11th Triennial, Milan
1958 1st Biennale van de Jonge Hadendaagse Schilderkunst, Bruges, Belgium
1959 5th Biennial, Sao Paulo, Brazil
1960 5th International Hallmark Art Award, New York
 'Confrontations '60', Warsaw
 Guggenheim International Award, New York
1961 Internazionale Malerei 1960–61, Wolframs Eschenback
1962 31st Biennale, Venice
 'Alternative Attuali', l'Aquilla
 'Art Since 1950', Seattle World's Fair, Seattle, USA
1964 'Defiguratie en Defiguratie', De

Menselijke
 'Figuur Sedert Picasso', Gent, Belgium
 'Profile IV: Polnische Kunst Heute', Bochum and Kassel, Germany
1966 Exposition de l'Association Internationale des Art Plastiques, Tokyo
1967 Internationale der Zeitung, Darmstadt, Germany
 'The Poetry of Vision', ROSC '67, Dublin
1968 Premio Lignano, Lignano
1970 '1000 Years of Art in Poland', London
 2nd Exposition Internationale de Dessins Originaux, Rijeka, Croatia
1973 1st Triennial of Painting and Graphic Art, Lodz
1974 4th Exposition Internationale de Dessins Originaux, Rijeka, Croatia
1975 13th Biennial, Sao Paulo, Brazil
 'Romanticism in Polish Art of the 19th and 20th Centuries', Warsaw
1977 Exhibition of Prize-Winners of the 'Golden Grapevine' Competition, Zielona Gora
 Der Sammler Theodor Ahrenberg, Dusseldorf, Germany
1978 1st Triennial of Drawing, Wroclaw
1979 'The Poles: A Self-Portrait', Krakow
1980 'Hommage a Witkiewicz', Dusseldorf, Germany
1981 'Brzozowski–Friends–Disciples,' Poznan
1983 'Presences polonaises', Paris
1984 Exhibition of Polish Painting, Moscow
1985 Exhibition of Polish Painting, Beijing

Selected Public Collections
National Museums in Warsaw, Krakow, Lodz, Wroclaw and Poznan
District Museum, Radom
Tatras Museum, Zakopane
Museum of Modern Art, New York
Guggenheim Museum, New York
Stedelijk Museum, Amsterdam
Vatican Museum, Rome
Museum of Modern Art, Skopje, Macedonia
Museum of Modern Art, Rijeka, Croatia
Museum of Modern Art, Bratislava, Czech

Republic
Polish Museum, Chicago, USA
Stadt collection, Herford, Germany
Also in many private collections in Poland and abroad

Selected Bibliography
Andrzej Jakimowicz (trans in French), *Tadeusz Brzozowski*, WAG, Warsaw, 1961
Mieczyslaw Porebski, *Tadeusz Brzozowski: Paintings and Drawings* (edited by Irena Moderska—contains bibliography and a complete catalogue of works until 1974), catalogue of a retrospective in Poznan, 1974
Mieczyslaw Porebski, *Tadeusz Brzozowski: Poland at the 13th Biennial in Sao Paulo*, catalogue of an exhibition in Krakow, 1975
Marceli Baciarelli and Andrzej Azwalbe, *Tadeusz Brzozowski, Kwartet Zapustny*, Pomerania Philharmonic Publications, 1986
Mieczyslaw Szewczuk, *Tadeusz Brzozowski's Drawings: Works from 1937–86*, catalogue of an exhibition, Radom, 1986
Maria Markiewicz (editor), *Tadeusz Brzozowski*, Arkady, Warsaw, 1987
Jerzy Nowosielski, Mieczyslaw Porebski and Jerzy Tchorzewski, *Tadeusz Brzozowski* (edited by Jan Trzupek), catalogue of an exhibition, 'Krakow Group' Artistic Association, Krakow, 1987

BOZENA BURZYM-CHAWINSKA

1954 Born in Krakow
Engaged in painting and drawing

Education and Awards
1975–80 Studied painting at the State Higher School of Art and Design, Poznan; graduated (MA) from the studios of Professor Tadeusz Brzozowski and Dr Jacek Waltos
1988 Main Prize for a Young Painter, 14th Festival of Contemporary Polish Painting

Solo exhibitions
1980 Diploma show, Nowa Gallery, Poznan
1985 Farbiarnia Gallery, Krakow
1986 Propozycje Gallery, Krakow
1992 BWA Gallery, Bialystok

Selected Group Exhibitions
1981 Pryzmat Gallery, Krakow
'Tadeusz Brzozowski – Friends –
Disciples', BWA Gallery, Poznan
1983 Church of St Joseph, Krakow
1984 35th Salon de Jeune Peinture, Grand
Palais, Paris
'Drawings', Farbiarnia Gallery,
Krakow
'Press Paper 84', Strasbourg, France
1986 'Poland Painting', Ashley Gallery,
Epsom, England
'Contemporary Polish Painting',
Richard Demarco Gallery, Edinburgh
1987 'Belfast–Krakow Exchange', Belfast,
Ireland
1988 'Consument Art', Nurnberg, Germany
14th Festival of Contemporary Polish
Painting
1989 Winners of the 14th Festival of
Contemporary Polish Painting,
Szczecin
Pristagare vid Festivalen for Modern
Polskt Maleri i Szczecin
Institutet, Stockholm, Sweden
Laureati Festivalu soucasneho
polskeho maliarstva v Stetina
Kulturni Stredisko, Bratislava, Czech
Republic
'Krakowi Kunst', Tartu Riiklik
Kunstimuuseum, Tartu, Estonia
'Le Dessin Polonais Contemporain',
Institut Polonais, Paris
1990 'Konst fran Krakow', Kulturcentrum,
Ronneby, Sweden
Paintings, Zimny Gallery, Krakow
1992 The Anniversary Salon of Painting,
Polish Artists Union, BWA Gallery,
Krakow
1993 SIAC, International exhibition, Palace
of Art, Krakow

Bibliography
J. Juszczyk, 'Debiut w dramatycznym Kregu',
Gazeta Zachodnia, 20, 1980
J. Madeyski, 'Gryoekspresjonistyczne', *Sztuka*,
6, 1985
J. Madeyski, 'Galeria Czterdziestolecia "P"',
Przekroj 14, 4, 1985

A. Matynia, 'Polaski Rysunek Wspolczesny',
Projekt, 4, 1989

PAWEL CHAWINSKI
1955 Born in Krakow
1979–85 Assistant Lecturer, Academy of Fine
Arts, Krakow
Lives and works in Krakow
Education and Awards
1974–79 Studied at the Higher School of Art
and Design, Poznan; graduated with a
diploma from the studio of Professor
Tadeusz Brzozowski
1988 Schwann-Stabilo Prize, 4th
International Drawing Triennale,
Kunsthalle, Nurnberg, Germany
Solo Exhibitions
1978 Diploma show (with two other
artists), Nowa Gallery, Poznan
1980 Kramy Dominanskie Gallery, Krakow
1984 Drawings and Paintings, Arts
Workshop, Newbury, England
1986 The Fabiarnia Gallery, Krakow
1990 'Stones, Sticks, Papers, Canvases',
installation, Zimny Gallery, Krakow
1991 'Papers off Stones, Stones of Paper',
installation, Zderzak Gallery, Krakow
1992 BWA Arsenal Gallery, Bialystok
Baltyka Gallery, BWA Slupsk, Ustka
1993 Labirynt II Gallery, BWA Lublin,
installation, Lublin
1994 'Harmony of Events, Path of
Geometry', installation, BWA Gallery,
Czestochowa
St Nicholas' Priory, installation,
Exeter, England
Group Exhibitions
1980 'Presentations II', MCK Gallery,
Krakow
'Absolwenci III', Pryzmat Gallery,
Krakow
1981 'Tadeusz Brzozowski – friends –
disciples', BWA Gallery, Poznan
1982 Exhibition of the 112 M Group,
private space, Krakow
1983 'The Importance of Drawing', West
Surrey College of Art and Design,
Farnham, England

1984 35th Salon de Jeune Peinture, Grand
Palais, Paris
Drawing exhibition, Fabiarnia Gallery,
Krakow
1986 'Poland Painting', Ashley Gallery,
Epsom, England
'Polish Contemporary Painting',
Richard Demarco Gallery, Edinburgh
1st International Drawing Triennale,
Kalisz
1988 4th International Drawing Triennale,
Kunsthalle, Nurnberg, Germany
1991 'Dotyk/Touch: Iconography of the
Eighties', BWA Gallery, Palace of Art,
Krakow
International Print Triennale, BWA
Gallery, Krakow
1992 'Intergrafia '92', BWA Gallery,
Katowice
'International Drawing Triennale',
Wroclaw
'Fainesthai', BWA Gallery, Krakow;
BWA Gallery, Wroclaw
'Consument Art', Nurnberg, Germany
'10th Norwegian International Print
Triennale', Fredrikstadt, Norway
'Neue Kunst aus dem Alte Krakau',
Staatstheater, Darmstadt, Germany
1993 'Krakow–Cork Exchange', Crawford
Municipal Art Gallery, Cork; City Art
Centre, Dublin, Ireland
'Erschlossene raum' (Opening up
Spaces), International Art Workshop,
Weimar, Germany
'Fort of Art', St Benedict's Fort,
Krakow
1994 'Sacrum': Triennale of Polish Visual
Art, BWA Gallery, Czestochowa
'Science, Technology, Art:
International Symposium', BWA
Gallery, Krakow

MARTA DESKUR
1962 Born in Krakow
1980–83 Worked in the theatre 'Teatr STU',
Krakow
1989–90 Drawing teacher, School of Fine Arts,
Aix-en-Provence, France

1992 Artist-in-residence, School of Design, Altos de Chavon, Dominican Republic

Education and Awards
1980–82 School of Fine Arts, Krakow
1983–88 School of Fine Arts, Aix-en-Provence, France
1986 Student exchange, School of Visual Arts, Bristol, England
1988 Diplome National Superieur d'Expression Plastique, School of Fine Arts, Aix-en-Provence, France

Solo Exhibitions
1991 Gallery Carolin Serero, Marseille, France
Gallery Dziekanka, Warsaw
Center of Contemporary Art, BWA Gallery, Szczecin
Center of Contemporary Art, Wroclaw
1993 Dom Polonii Gallery, Krakow
'Modus', Zderzak Gallery, Krakow
'Premonitions on the Road', Buclein Theater, Krakow (with Piotr Jaros)
1994 'Au dela de Marie-Madeleine', Zderzak Gallery, Krakow

Selected Group Exhibitions
1989 Foundation Vasarely, Aix-en-Provence, France
1990 FRAC, Marseille, France
1991 Usine St Gobain, Avignon, France
Center of Contemporary Art, Zacheta Gallery, Warsaw
'Abattoire 91', Marseille, France
1992 'Salon de Jeune Peinture', Grand Palais, Paris
Altos de Chavon Cultural Center Foundation, Dominican Republic
Szkic do Galerii Sztuki Wspolczesnej, permanent exhibition, National Museum, Warsaw
1993 'Zywioly', National Art Gallery, Lodz
'Dom Artsty Plastyka' Gallery, Warsaw
'Wspotrzedne' Mikolajska 1, Krakow
'My Home is Your Home', Construction in Process, Lodz
1994 'Ikonopress', Zamek Ksiazat Pomorskich, Szczecin

Public Collections
National Museum, Warsaw
Collection 'Vacance Bleue', Marseille, France
Altos de Chavon Cultural Center Foundation, Dominican Republic.
Also in private collections in France, Belgium and Poland

JAN DOBKOWSKI

1942 Born in Lomza
Paints, draws and engages in art-actions

Education and Awards
1968 Graduated from Academy of Arts, Warsaw in the studio of Jan Cybis
1971 Gold Medal, Grona wystawa , Zielona Gora
1972 Fundee, Kosciusko Foundation, New York
1978 C.K. Norwid Critics' Award
1992 Medal, 5th Miedzynarodowe Triennale Rysunku, Muzeum Architektury, Wroclaw

Selected Solo Exhibitions
1970 Galeria A, Gniezno
1972 Galeria Wspolczesna, Warsaw
Bodley Gallery, New York
Galeria 72, Chelm
Galeria BWA, Lublin
1973 William Hunter Gallery, Los Angeles
Galerie BWA, Bydgoszcz
1974 Galeria Wspolczesna, Warsaw
1975 Galeria Zapiecek, Warsaw
1977 Rathausdurchgang Galeria, Winterthur, Switzerland
1978 CBWA Zacheta, Warsaw
1979 Galeria Krytykow, Warsaw
1980 Galeria Piotra Nowickiego, Warsaw
1981 Galeria Mala ZPAF, Warsaw
1983 Galeria 72, Chelm
1984 Pennsylvania University, USA
Galeria Centrum Sztuki Studio, Warsaw
1985 Meissner Galerie, Hamburg, Germany
1986 Galeria Zapiecek, Warsaw
1988 Galeria Centrum Sztuki Studio, Warsaw
Galeria Awangarda, Wroclaw
1989 Muzeum Regionalne, Lomza

Helander Gallery, Helsinki, Finland
1990 Galeria Pokaz, Warsaw
1991 Muzeum Archidiecezjalne, Warsaw
1992 Galeria Zderzak, Krakow
1992 Galeria Centrum Sztuki Studio, Warsaw
1993 Galeria Centrum Sztuki Studio, Warsaw
Galeria Arsenal, Poznan
Galeria Ars Polona, Warsaw

Selected Group Exhibitions
1967 'Neo–Neo–Neo', Klub Medyka, Warsaw
1968 'Secesja–secesja?', Wspolczesna Gallery, Warsaw
1969 '1000 lat sztuki polskiej: zrodla i poszukiwania 1917–1969', Musee Galiera, Paris
1969–70 'Sztuka polska 1959–1969', National Museum, Berlin
1970 'Malarstwo w Polsce Ludowej', Muzeum Narodowe, Warsaw
'Polskie malarstwo i grafika', Galeria Illeany Popescu, Dusseldorf, Germany
1971 'Polska sztuki wspolczesna', Muzeum Sztuki, Lodz
'Nowe zjawiska w sztuce polskiej 1960–1970', 5th Sympozjum Zlotego Grona wystawa, Zielona Gora
11th Miedzynarodowe Biennale Sztuki, Sao Paulo, Brazil
'Wystawa polskiej sztuki wspolczesnej', Muzeum Narodowe, Goeteborg
1972 '7 malarzy polskich i amerykanskich', wystawa, Benson Gallery, New York
'Czlowiek i jego swiat', miedzynarodowa wystawa sztuki wspolczesnej, Pawilon EXPO, Montreal, Canada
1973 8th Biennale Mlodych, Muzeum Sztuki Wspolczesnej, Paris
Wystawa sztuki polskiej, National Museum, Malmo, Sweden
1974 'Nowa generacja', Muzeum Narodowe, Wroclaw
Reprezentacyjna wystawa polskiego malarstwa, Rathaus-Volkshalle,

Wieden
Wystawa polskiego malarstwa
wspolczesnego, Mall Gallery, London
1975 'Krytycy proponuja: 30 dziel na XXX-
lecie PRL', Galeria Zacheta, Warsaw
'Polskie malarstwo wspolczesne',
Muzeum Sztuki Wspolszesnej, Mexico
1976 'Sztuka polska 1900–1975 i jej
reminiscencje', Wiener Secesion
Museum, Wieden
'Polskie malarstwo wspolczesne',
Fundacao Calouste Gulbenkian,
Lisbon, Portugal
1977 'Malarstwo polskie', Muzeum
Narodowe, Teheran, Iran
'Malarstwo polskie', Muzeum Sztuki
Nowoczesnej, Bagdad, Iraq
'Polskie malarstwo wspolczesne',
Palacio de Velazquez, Madrid
1978 '28th Bayereuther Kunstaustellung',
Neues Schloss, Bayreuth, Germany
1980 'Miloszowi: artysci plastycy', Muzeum
Narodowe, Wroclaw
1981 16th Miedzynarodowe Biennale
Sztuki, Sao Paulo, Brazil
1983 'Polska sztuka wspolczesna', Muzeum
Narodowe, Wroclaw
'Znak Krzyza', Kosciol Milosierdzia
Bozego, Warsaw
1984 'Pamiec', Muzeum Archidiecezjalne,
Warsaw
1985 Miedzynarodowe Targi Sztuki,
Meissner Galerie, Bazylea
Miedzynarodowe Targi Sztuki,
Meissner Galerie, Kolonia
1986 Miedzynarodowe Biennale Sztuki
Azjatycko-Europejskiej, Ankara,
Turkey
40th Edinburgh International Festival,
Richard Demarco Gallery, Edinburgh
1987 'Realizm–Metafora–Geometria',
wystawa polskiego malarstwo, Palais
Palffy, Wieden
1989 'Polskie malarstwo wspolczesne',
Charlottenborg, Copenhagan,
Denmark
1991 Miedzynarodowe Biennale Sztuki
(nagroda krytyki), Cagnes-sur-Mer

1992 5th Miedzynarodowe Triennale
Rysunku, Muzeum Architektury,
Wroclaw
1993 'Sztuka polska XX wieku', Muzeum
Narodowe, Warsaw
'My dzisiaj', Galeria Arsenal, Poznan
1st Arts Biennial, Sharjah, United
Arab Emirates
Wystawa polskiej sztuki wspolczesnej,
Uniwersytet, Honolulu

Public and Private Collections
Muzeow Narodowych w Warszawie, Krakowie,
Wroclawiu, Poznaniu i Gdansku
Muzeum Sztuki, Lodzi
Muzeum im. L. Wyczolkowskiego, Bydgoszczy
Muzeum Pomorza Srodkowego, Slupsku
Muzeum Ziemi Mazowieckiej, Plocku
Muzeum Ziemi Lubuskiej, Zielonej Gorze
Centrum Sztuki Studio, Warsaw
Muzeow Okregowych w Chelmie Lubelskim,
Lomzy, Kielcach, Olsztynie, Lublin, Kalisz,
Koszalinie
Solomon R. Guggenheim Musuem, New York
Santa Barbara Museum, California, USA
Love Arts Museum, Miami, Florida, USA
Rose Museum of Art, Waltham, Massachussetts,
USA
Everson Museum of Art, New York
Center of Modern Art, Oklahoma, USA
Muzeum Miejskiego, Gandawie
Muzeum Archidiecezjalnego w Warszawie oraz
w innych kolekcjach panstwowych i prywatnych
w kraju i za granica.

Bibliography
E. Benezit, *Dictionnaire Critique et
Documentaire des Peintres, Sculpteurs,
Dessinateurs et Graveurs*, Librairie Grund
Francoise Laroche et Tristan Roux, *Les arts en
Europe*, Editions Christian Hals, Monte Carlo,
1974
Andrzej Banach, *Erotyzm po polsku*,
Wydawnictwa Artystyczne i Filmowe, Warsaw,
1974
Jerzy Zanozinski, *Wspolczesne malarstwo
polskie*, Wydawnictwo Arkady, Warsaw, 1974
Bozena Kowalska, *Polska awangarda malarska
1945–1970*, PWN, Warsaw, 1975
Aleksander Wojciechowski, *Mlode malarstwo

polskie 1944–1974*, Ossolineum, Wroclaw,
1975
Ireneusz J. Kaminski, *Sztuka w labiryncie*,
Wydawnictwo Lubelskie, Lublin, 1976
Aleksander Wokciechowski, *Polskie malarstwo
wspolczesne*, Wydawnictwo Interpress, Warsaw,
1977
Bozena Kowalska, *Tworcy-postawy*,
Wydawnictwo Literackie, Krakow, 1981
Alicja Kepinska, *Nowa sztuka: sztuka polska w
latach 1945–1978*, Wydawnictwa Artystyczne i
Filmowe, Warsaw, 1981
Wieslawa Wierzchowska, *Wspolczesny rysunek
polski*, Wydawnictwa Artystyczne i Filmowe,
Warsaw, 1982
Janusz Bogucki, *Sztuka Polski Ludowej*,
Wydawnictwa Artystyczne i Filmowe, Warsaw,
1983
Peter Betthausen, Thomas Hantzsche, Ulrike
Krenzlin, Detlef Rossler, *Europaische
Kunstgeschichte in Daten*, VEB Verlag der
Kunst, Dresden, 1984
Helmut Kajzar, *Z powierzchni … szkice o
teatrze*, Centralny Osrodek Upowszechniania
Kultury, Warsaw, 1984
Zbigniew Taranienko, *Rozmowy o malarstwie*,
Panstwowy Instytut Wydawniczy, Warsaw, 1987
Andrzej K. Olszewski, *Dzieje sztuki polskiej
1890–1980*, Wydanictwo Interpress, Warsaw,
1988
Janusz Bogucki, 'Od rozmow ekumenicznych do
LABIRYNTU', Centrum Sztuki Wspolczesnej
Zamek Ujazdowski, Warsaw, 1991
Aleksander Wojciechowski, *Czas smutku, czas
nadziei*, Wydawnictwa Artystyczne i Filmowe,
Warsaw, 1992
Ewa Hornowska, 'My: dzisiaj, o sztuce
pokolenia lat siedemdziesiatych', ZO ZPAP,
Poznan, 1993

EDWARD DWURNIK

1943 Born in Radzymin
Lives and works in Warsaw
Education
1963–70 Studied at Academy of Fine Arts,
Warsaw
1992 Coutts Contemporary Art Foundation
Award, Zurich, Switzerland

Selected Solo Exhibitions

1971	Wspolczesna Gallery, Warsaw
1974	Studio Gallery, Warsaw
1977	Kordegarda Gallery, Warsaw
1980	Sciana Wschodnia Gallery, Warsaw
1983	Alvar Aalto Museum, Jyvaskyla, Finland
1985	Stedelijk van Abbemuseum, Eindhoven, Netherlands
1987	National Museum, Wroclaw
	Benjamin Rhodes Gallery, London
1989	Regional Museum, Bydgoszcz
1990	Center of Contemporary Art, Warsaw
1991	Benjamin Rhodes Gallery, London
1992	Arnolfini, Bristol
	Galeria Zderzak, Krakow
	Galeria Vorsetzen, Hamburg
1993	Benjamin Rhodes Gallery, London
	Galeria Zderzak, Krakow
	Galeria Vorsetzen, Hamburg

Selected Group Exhibitions

1982	'Documenta 7', Kassel, Germany
1984	5th Biennale, Sydney, Australia
1985	Nouvelle Biennale de Paris, Paris
1986	'Eye Level', van Abbemuseum, Eindhoven, Netherlands
	'America/Europa', Museum Ludvig, Cologne, Germany
1987	'Radical Realism: Concrete Abstraction', National Museum, Warsaw
1988	'Farbe Bekennen, Kunstmuseum,' Basel, Switzerland
1990	'Art of Martial Law: Winter 81/82', National Museum, Wroclaw
	'Lost Paradise,' Center of Contemporary Art, Warsaw
1991	'Emanuel Hoffmann-Stiftung 1980–90', Museum fur Gegenwartskunst, Basel, Switzerland
	'Zone D', Leipziger Galeria Fur Zeitgenossische Kunst, Leipzig, Germany
1992	'Standpunkte der Moderne', Deichtorhallen, Hamburg, Germany
1993	'Der zerbrochene Spiegel, Positionen zur Malerei', Museumsquartier, Messepalast, Kunsthalle Vien,

Diechtorhallen, Hamburg, Germany

STANISLAW FIJALKOWSKI

1922 Born in Zdolbunow [now Ukraine]
Professor, State Higher School of Fine Arts, Lodz
Painter and printmaker

Education and Awards

1946–51	Studied at the State Higher School of Fine Arts, Lodz, with masters Wladyslaw Strzeminski, Stefan Wegner and Ludwik Tyrowicz
1968	1st Prize, Triennial of Drawing, Wroclaw
	Special Prize, Print Biennale, Krakow
1970	Medal, Print Biennale, Krakow
1972	Prix ex aequo, 'Bianco e Nero', Lugano, Switzerland
	C.K. Norwid Critic's Award
1978	Scroll, 'Grafica Creativa', Jyvaskyla, Finland
	2nd Prize, Print Biennale, Frechen
1979	2nd Prize, Print Biennale, Heidelberg, Germany
	Grand Prix, Polish National Print Exhibition, Warsaw
1979	Prix ex aequo, 'Small Forms of Graphic Art', Lodz
1985	Prix ex aequo, 'Small Forms of Graphic Art', Lodz
1986	Special Prize, Festival International de la Peinture, Cagnes-sur-Mer
1990	Jan Cybis Award [Artists Union]
1993	Grand Prix, Xylon 12, Winterthur, Switzerland

Professional Associations

Vice-President, International Society of Wood Engravers Xylon, Winterthur, Switzerland
President, Polish National Section of Xylon
Academia Scientiarum et Artium Europea, Salzburg, Austria
Academie Royale des Sciences, des Lettres et des Beaux Arts de Belgique, Belgium

Solo Exhibitions

1965	Galerie Lambert, Paris
1966	Galeria Wspolczesna, Warsaw
1967	Galerie Od Nowa, Poznan
	Artistic Society's Club, Wroclaw
1970	Galerie beim Minoritensaal, Graz,

	Austria
1973	Galeria Krzysztofory, Krakow
	Galeria Kordegarda, Warsaw
1974	Galerie Prisma I, Stockholm
	Galerie Elisabeth Henning, Hamburg, Germany
	Galeria Pawilon, Krakow
1977	Kunsthalle Wilhelmshaven, Germany
	St Annen Museum, Lubeck
	Kulturgeschichtliches Museum, Osnabruck, Germany
1978	Kunstlerhaus, Hannover, Germany
1981	Univesity of Alberta, Edmonton, USA
1982	Kleine Graphik-Galerie, Bremen, Germany
	Centre de la Gravure et de l'Image Imprimee, La Louviere, Belgium
1984	Institut Polonais, Paris
1987	Galerie Marina Dinkler, Berlin
1988	Exhibition Office, Lodz
	Justus-Liebig-University, Giessen, Germany
1989	Uniwersitats-museum fur Kunst und Kulturgeschichte, Marburg/Lahn, Germany
	Xylon Werkstatten und Museum, Schwetzingen, Germany
	Zentrum fur Interdisziplinare Forschung, Bielefeld, Germany
1990	Polish Cultural Institute, London
	Galeria Studio, Warsaw
1991	Exhibition Office, Lublin
1992	Galeria 'Gest', Lodz
1993	Galeria no Pietrze, Koszalin
	Galeria 'Gest', Lodz

Group Exhibitions

1966–78	Print Biennale, Krakow
1967	Print Biennale, Ljubljana, Slovenia
1968	Print Biennale, Tokyo
1968–69	International Graphic Art Exhibition, Florence
1969	Biennial, Sao Paulo, Brazil
	Woodcut Triennial, Carpi, Italy
1969–93	5th–12th International Xylon Exhibitions
1970	International Plein-Air Meeting, Palais Esterhazy, Eisenstadt
	Miro Competition, Barcelona

1970–74 Print Biennial, Bradford, UK
1971 Print Biennale, Ljubljana, Slovenia
Aspetti della Grafica Europea,
Ca'Pesaro, Museo d'Arte Moderna,
Venice
Miro Competition, Barcelona
1971 Premio Biella, Italy
1972 Biennale, Venice
Grafica d'Oggi, Ca-Pesaro, Museo
d'Arte Moderna, Venice
Woodcut Triennial, Carpi, Italy
Biennale de Menton, France
International Drawing Exhibition,
Rijeka, Croatia
1973–75 Miro Competition, Barcelona
1974 First International Graphik Art
Exhibition, All-India Fine Arts and
Crafts Society, New Delhi, India
Biennale de Menton, France
1975 Eastern European Printmakers,
Cincinnati Art Museum, USA
Triennial, New Delhi, India
1975–76 Art Basel, Switzerland
1975–79 Print Biennale, Ljubljana, Slovenia
1976 Print Biennale, Bonsecours
Arte Fiera, Bologna, Italy
Premio Biella, Italy
Print Biennale, Frechen, Germany
1978 Biennale, Fredrikstad, Norway
Print Biennale, Frechen, Germany
1978–84 Triennale 'Grafica Creativa', Jyvaskyla,
Finland
1979 Wash Art, Washington, USA
United Nations, New York
Print Biennial Woodcut, Heidelberg,
Germany
Print Biennial, Bradford, England
1979–91 'Small Forms of Graphic Art', Lodz
1980 2nd Canadian Biennial of Prints and
Drawings, Edmonton, Canada
1981 Impact Art Festival, Kyoto, Japan
1982 Internationaler Holzschnitt,
Kunstlerhaus, Vienna
1983 Biennale, Cul-des-Sarts/Couvin
Iere Triennale Internationale de
Gravure 'Dialogue Grave', Spa,
Belgium
1984 Print Biennale, Krakow

Print Biennial, Bradford, England
International Drawing Exhibition,
Rijeka, Croatia
1985 Salon Internationale de la Gravure,
Association les Amis de l'Art, Nantes,
France
1986 Biennale Internationale de la Gravure
sur Bois 'Bois Pluriel 2', Evry, France
1987 'Graphica Atlantica', Reykjavik,
Iceland
'Surrealismi-Surrealism', Retretti Art
Centre, Punkaharju
1988 RIPOPEE 1, La Louviere, Belgium
1990 Art Hamburg, Germany
Premio Biella, Italy
Impact Art Festival, Kyoto, Japan

Public Collections

National Museums in Krakow, Poznan, Szczecin,
Warsaw
Art Museums in Bydgoszcz, Chelm, Koszalin,
Lodz, Radom, Torun and Zielona Gora
Museum, Bochum, Germany
Museo della Xilografia 'Ugo da Carpi', Italy
Kupferstich Kabinett, Dresden, Germany
Graphothek, Erlangen, Germany
Kunsthalle, Hamburg, Germany
Kunsthalle, Hannover, Germany
Centre de la Gravure et de l'Image Imprimee, La
Louviere, Belgium
Tate Gallery, London
St Annen Museum, Lubeck
Museo Civico di Belle Art, Lugano, Switzerland
National Museum, Prague
Tretjakov Gallery, Moscow
Museum of Modern Art, New York
Galerie Vytvarnego Umeni, Roundnice n/L
Museum of Contemporary Art, Skopje
Graphische Sammlung Albertina, Vienna
Museum of 20th Century, Vienna
Gewerbemuseum, Winterthur
Print Collection of the Academy of Sciences and
Arts, Zagreb
Also in many private collections

STEFAN GIEROWSKI

1925 Born in Czestochowa
Lives and works in Warsaw

Education
1948 Graduated, having studied painting at
Academy of Fine Art, Krakow and art
history at the Jagiellonian University
1965 Gold Medal, 5th Biennale di San
Marino
1967 Minister of Art and Culture Award,
Zacheta Gallery, Warsaw
1968 Award, 1st Triennale of World Art,
New Delhi, India
1980 Jan Cybis Award

Selected Solo Exhibitions
1955 Gallery of Polish Architects'
Association, Warsaw
1957–64 Galeria Krzywe Kolo, Warsaw, six
exhibitions
1970 Galeria Wspolczesna, Warsaw
Galeria Przymat, Krakow
1973 Galeria Zderzak, Krakow
1974 Galeria BWA, Lublin
1976 Galerie Numaga, Auvernier-
Neuchatel, Switzerland
1985 Galerie Numaga, Aubernier-
Neuchatel, Switzerland
Gallery of the Polish Architects'
Association, Warsaw
1986 Galeria SHS, Warsaw
1993 Zacheta Gallery, Warsaw

Selected Group Exhibitions
1959 Mostra di Pittura Polacca
Contemporanea, Venice
1st Biennale de Sao Paulo, Brazil
1960 'Confrontations', Galeria Krzywe
Kolo, Warsaw
1961 'Douze Peintres Polonaises', Galerie
Lacloche, Paris
1962 'Metaphors', Sopot
1965 'Profile IV', Bochum and Kassel,
Germany
'37 Contemporary Polish Artists', Tel
Aviv, Israel
5th Biennale di San Marino
1967 Zacheta Gallery, Warsaw
1968 24th Biennale di Venezia
1st Triennale of World Art, New
Delhi, India
Galerie Numaga, Auvernier-
Neuchatel, Switzerland

1983	'The Sign of the Cross', the Church on Zytnia Street, Warsaw
1985	'A New Heaven and A New Earth', the Church on Zytnia Street, Warsaw
1986	'Freiraum', Kunststation, Kleinassen
1989	'Vision and Unity', Van Reekum Museum, Apeldoorn, Netherlands

ZBIGNIEW GOSTOMSKI

Solo Exhibitions

1960	Klub Studenta 'Od Nowa', malarstwo, Torun
1964	Galeria Krzywe Kolo, malarstwo, Warsaw
1966	Galeria Wspolczesna (z Wl. Hasiorem), Warsaw
1967	Galeria Foksal, environment, Warsaw
1968	'System II', Galeria Foksal, Warsaw
1970	'Zaczyna sie we Wroclawiu', nagroda krytyki im. C.K. Norwida, Galeria Foksal, Warsaw
	'Ulisses James Joyce'a', Galeria Foksal, Warsaw
	Galeria Krzysztofory /j.w./, Krakow
1971	'System III', Galeria Foksal, Warsaw Sonja Henie Niels Onstad Foundations, Oslo
1972	Galeria Foksal, konstrukcja, Warsaw
1973	'Trojkat Pascala', Galeria Foksal, Warsaw
1974	'1,2,3,4,5,6,7,8,9,0 (10)', Galeria Foksal, Warsaw
1975	Galeria Foksal, tkanina, Warsaw
1976	'Z powodu odczytu o niczym' John Cage'a, Galeria Foksal, Warsaw
1980	Galeria A.i.E. Dluzniewskich, Warsaw
1981	Galeria Foksal, draperie malowane, Warsaw
1984	'Trzy Krzyze', Galeria Foksal, Warsaw
1988	'Toter Baum' instalacja, Galeria Foksal, Warsaw
	'Wie grun sind deine Blatter', Galeria Foksal, Warsaw
1991	'Utrwalacze wladzy', fotografie, Galeria Foksal, Warsaw

Selected Group Exhibitions

| 1963 | Konfrontacje 1963, Galeria Krzwe Kolo, Warsaw |

1964	'Two Worlds', Grabowski Gallery, London
1965	'Arte Actual de Polonia', Centro di Artes Visuales del Instituto 'Torquato di Tella', Buenos Aires
	'17 Polish Painters', Washington, USA 8th Biennale de Sao Paulo, Sao Paulo, Brazil
	'Wystawa polskiej sztuki wspolczesnej', Muzeum, Tel Aviv, Israel
1966	'Pierwsza wystawa Galeria Foksal' (z E.Krasinskim, R. Owidzkim, H. Stazewskim, J. Ziemskim), Galeria Foksal, Warsaw
	'Wystawa malarstwa polskiego', Svea Gallery, Stockholm
1967	'Exposicion de Arte Polaco', pinturas, grabados, dibujos, tapiceria, Palac Sztuk Peiknych, Havana; Santiago de Cuba
	'Modern Polsk Malerkunst', Galeria Charlottenborg, Copenhagen
1968	100th Exhibition Grabowski Gallery, Grabowski Gallery, London
1969	'Peintre Moderne Polonaise: Sources et Recherches', Musee Galliera, Paris
1970	Elektra 70, New York
	'1000 Years of Art in Poland', Royal Academy of Arts, London
1971	Swiatlo geometrii, miedzynarodowa, Muzeum Sztuki, Lodz
1972	'Atelier 72', Edinburgh International Festival, Richard Demarco Gallery, Edinburgh
1975	'Polonia en Mexico', Museo del Arte Moderno, Mexico
	'Wystawa polskich konstruktywistow', Everson Museum of Art, Syracuse, USA
1976	Biennale di Venezia, 'International Events 72–76', Wenecja
1977	'The Poetry of Vision', ROSC, Dublin
1979	3rd Biennale of Sydney 1979: European Dialogue, Sydney
1981	'Contemporary Painting in Eastern Europe and Japan', Kanagawa, Japan Prefectural Gallery, Yokohama; Osaka

	National Museum of Art
1982	'Echange entre artistes 1931–1982: Pologne–USA', Musee d'Art Moderne de la Ville de Paris, Paris
1983	'Presences Polonaise: l'Art vivant autour de Musee Lodz', Centre George Pompidou, Paris
1985	'Dialog: Zbigniew Gostomski invites Barry Flanagan', Moderna Museet, Stockholm
1986	Festival sztuki, Richard Demarco Gallery, Edinburgh
1988	'Wspolczesna szuka polska', ASP, New Delhi; Hyderabad, India
1989	'Dialog', Moderna Museet, Stockholm 'Vision and Unity', Muzeum Sztuki Lodz; Van Reekum Museum, Apeldoorn, Netherlands
1991	Kolekcja sztuki XX w.w. Muzeum Sztuki w Lodzi, Galeria Zacheta, Warsaw
1992	'Muzeum Sztuki w. Lodzi 1931–1992: Collection–Documentation–Actualite', Musee d'Art Contemporain, Lyon, France
	'Polnische Avangarde 1930–1990', Kunsthalle, Berlin

RYSZARD GREGORCZYK

| 1958 | Born in Scinawka Srednia |
| 1987–89 | Worked as an assistant in the Painting Studio of the Conservation Department, Academy of Fine Arts, Krakow |

Education and Awards

| 1981–86 | Studied at the Painting Department, Academy of Fine Arts, Krakow, in the studio of Professor Juliusz Joniak |
| 1986 | Graduated, receiving the Academy of Fine Arts Rector's Medal and Ministry of Culture and Art Scholarship |

Exhibitions

| 1987 | 'Dyplom '86', exhibition of the best diploma works from 1986, The Fabric Museum, Lodz |
| | 'Ateliereinblicke', Stadtmuseum, Bad Oyenhausen; Norishalle, Nurnberg, Germany |

1988	'Painting is Colour', KAW Gallery, Krakow
1989	'Painting Environment from Krakow', Plastyka Gallery, Warsaw
1990	'Pro-Art', Galerie Anne Lettree, Lyon; St Etienne, France
	'New Art in Palace', Palace of Art, Krakow
1991	'Friends', Piano Nobile Gallery, Krakow
1992	'Salon', painting exhibition on the occasion of 80 years of ZPAP, BWA Gallery, Krakow
1994	Europ'Art, Palexpo, Geneva, Switzerland
	'Sacrum–Faith–Art', All-Polish Triennial of Painting, BWA Gallery, Czestochowa

WLADYSLAW HASIOR

| 1928 | Born in Nowy Sacz |
| 1957– | Teacher at the State Secondary School of Plastic Techniques, Zakopane |

Education and Awards

1947–52	Studied at the State Secondary School of Plastic Techniques, Zakopane in the studio of Professor Antoni Kenar
1952–58	Studied at the Academy of Fine Arts, Warsaw in the studio of Professor Marian Wnuk
1959–60	Scholarship of the French Ministry of Culture
1959–60	Studied in the studio of Professor Ossip Zadkine, Paris
1963	Honorary Award, International Competition for F.D. Roosevelt Mauzoleum
1971	Ministry of Culture and Art Award

Solo Exhibitions

1961	Exhibition of assemblages, Jewish Theatre, Warsaw
1963	Krzysztofory Gallery, Krakow
1966	Zacheta Gallery, Warsaw
1968	Moderna Museet, Stockholm, Sweden
1969	Galeri F 15, Moos, Norway
1970	35th Biennial, Venice
1971	Bochum Museum, Bochum, Germany

1972	Muzeum Louisiana, Copenhagen
1973	Galeri F 15, Moos, Norway
1974	The King's Castle, Warsaw
1976	Kunstmuseum, Goteborg, Sweden
	Kunsthall, Malmo, Sweden
1977	Royal Festival Hall, London
	The Cathedral, Coventry, England
1978	Amos Andersonin taidemuseo, Helsinki, Finland
	Kunstlerhaus, Vienna, Austria
1982	Tatrzanskie Museum, Zakopane
1984	Institute of Polish Culture, London
	Opening of W. Hasior Gallery, Zakopane
1987–88	Musee A. Aalto, Jywaskyla, Finland
1988	Galeria Trietiakowska, Moscow, Soviet Union
1989	Lengel tajekozatato es kulturalis kozpont kiallitasi hivatal, Budapest Culture Centre, Tallin, Estonia
1990	Kunsthalle, Darmstadt, Germany
	Musee Bochum, Bochum, Germany
1991	Palace of Exhibitions, Budapest
	BWA 'Arsenal', Poznan
	Aleksander Puszkin's Museum, Moscow
1994	Retrospective exhibition, Contemporary Art Gallery, BWA , Czestochowa
	Retrospective exhibition, BWA Gallery, Slupsk
	Retrospective exhibition, BWA Gallery, Bielsko Biala
	Retrospective exhibition, Gallery Ostroleka, Ostroleka
	Retrospective exhibition, District Museum, Radom
	Retrospective exhibition, National Museum, Gdansk
	Retrospective exhibition, BWA, Olsztyn

Selected Group Exhibitions

1959	First monument 'For them, who go in the mountains'
1960	First sculptures of cement cast, in the form dug out of the earth, for example 'Sebastian'
1961	2nd All-Polish Exhibition of Religious

	Art, Krakow
1963	International Competition for F.D. Roosevelt Mauzoleum
1964	'Polish Art', Paris, France; Bucharest, Romania; Prague, Czech Republic; Bochum, Germany
	'Memory of the executed guerillas', monument, Kuznice, Zakopane
1965	8th Biennial, Sao Paulo, Brazil
	'Dream in the Polish Art', Stedelijk Museum, Amsterdam
	First projects of the glass monument 'For them, who are in the sea'
1967	'Art Polonais Contemporain: Sources et Recherches', Musee des Beaux Arts, La Chaux-de-Fonds, France
	'Puolan nkrymaalausta Polskt nutidsmaleri', Bergens Kunstforening, Bergen, Norway
	'Moderne Polsk Malerkunst', Charlottenborg, Denmark
1969	'Peinture Polonaise Contemporaine: Sources et Recherches', Musee Galliera, Paris
	1st International Biennial of Plein-air Sculpture, 'Golgota', Montevideo, Uruguay
	Institute of Contemporary Arts, plein-air sculpture 'Exhumed', Buenos Aires
1970	'1000 Years of Art in Poland', Royal Academy of Art, London
1971	11th Biennial, Sao Paulo, Brazil
1972	'Atelier 72', 26th Edinburgh International Festival, Richard Demarco Gallery, Edinburgh
1974	10th Biennale Internationale d'Art, Palais de l'Europe, Menton, France
	'Polska tapiserie 1945–1974' The King's Castle, Prague
1975	'Romantyzm i romantycznosc', Zacheta Gallery, Warsaw
	'Polonia en Mexico', Festival de la formas de pintura contemporance, Museo de Arte Moderno, Mexico
	'Art contemporain polonais', Foire International de Paris, Paris
1977	'Le Romantisme et l'esprit romantique dans l'art polonais des XIX et XX

siecle', Grand Palais, Paris, France
ROSC 77, Dublin, Ireland
1979 'Peinture contemporaine polonaise'
The Polish Institute, Paris
1980 'In the circle of surrealism',
Eindhoven, Netherlands
'El realismo magico en et arte polaco',
Barcelona; Madrid
'Burning Birds', monument, Szczecin
'For them, who fight for freedom of
Pomorze', Koszalin
1983 'Presences polonaises', Beabourg;
Paris
1985 'Polish Art', Pekin; Sian Czengdu,
China
1986 World's Exhibition of Surrealism,
Retretti, Finland
1987 'Artists from Middle Europe', Musee
du XXe Siecle, Vienna
'Expressiv', Washington, USA
1988 'Zarliwe sztandary' (Burning Banners)
, plein-air show, Nowy Sacz
1992 On the occasion of 700 years of Nowy
Sacz 'Burning Banners', Nowy Sacz
1994 'Avanguard of 20th century',
Museum Kunsthalle, Bonn, Germany

Public Collections
Amos Andersons Konstmuseum, Helsinki,
Finland
Ateneum Konstmuseum, Helsinki, Finland
Galerie Lambert, Paris
Institute of Polish Culture, Stockholm, Sweden
Kunstmuseum, Pori
Kunstnernes Hus, Oslo
Museo de Arte Moderna, Sao Paulo, Brazil
Museo de Arte Moderna, Roma
Museo de Arte Moderna, Milano, Italy
Aleksander Puszkin's Museum, Moscow
National Gallery, Edinburgh
National Gallery, Budapest
Stadt Museum, Bochum, Germany
Stadt Museum, Disburg, Germany
Stedeljik Museum, Amsterdam
BWA, Gorzow Wielkopolski
Central Museum of Fabrics, Lodz
Gornoslaskie Museum, Bytom
National Museum, Krakow
National Museum, Poznan

National Museum, Szczecin
National Museum, Warsaw
National Museum, Wroclaw
Regional Museum, Bydgoszcz
Regional Museum, Lublin
Regional Museum, Nowy Sacz
Museum of Art, Lodz
Tatra Museum, Zakopane
Also in private collections in Poland and aboard

KOJI KAMOJI

1935 Born in Japan
Has lived in Poland since 1959
Education and Awards
1958 Graduated from Musashino Academy
of Fine Arts, Tokyo
1966 Graduated from Academy of Fine Arts
in Warsaw
1975 C.K. Norwid Prize for 'Hole', 'Line',
'Mirror', 'Draught', installations,
Foksal Gallery, Warsaw
Solo Exhibitions
1965 Painting (with Leszek Walicki),
Krzysztofory Gallery, Krakow
1967 Reliefs, spatial works, Foksal Gallery,
Warsaw
1969 Reliefs, Wspolczesna (Contemporary)
Gallery, Warsaw
1970 Reliefs, Mona Lisa Gallery, Wroclaw
1972 'Two Poles', painting, installation,
Foksal Gallery, Warsaw
'Distance from the Lines', installation,
A. Partum's Poetry Office, Warsaw
'Air, Interior, Space', installation,
Foksal Gallery, Warsaw
1973 'Flagstone, Metal Rod and the Sky',
installation, Foksal Gallery, Warsaw
1975 Four shows: 'Hole', 'Line', 'Mirror',
'Draught', installations, Foksal
Gallery, Warsaw
1977 Painting, Pi Gallery, Krakow
1978 'Site', installation, DESA Gallery,
Nowa Huta
1980 Intermedia installation (with
Wlodzimierz Borowski), MDM Gallery,
Warsaw
1980 'Body', installation, Piwna 20/26
Gallery, Warsaw

1983 'Beginning a Sentence', installation,
RR Gallery, Warsaw
1984 'Man', installation, Foksal Gallery,
Warsaw
1985 'Cry', installation, RR Gallery, Warsaw
'Moments', painting, Studio Art
Centre, Warsaw
1986 'The Middle Ages', painting, Foksal
Gallery, Warsaw
'In Peace', four installations, Galeria
Dzialan (Gallery of Actions), Warsaw
Painting, Gallery 72, Chelm
1988 'Basho', performance (with
Wlodzimierz Borowski), Galeria
Rzezby (Sculpture Gallery), Warsaw
'Child in the summer',
performance–installation, Okuninka
'Auschwitz Stone',
performance–installation, Galeria
Rzezby (Sculpture Gallery), Warsaw
1989 'Closed Area',
performance–installation, Galeria
Rzezby (Sculpture Gallery), Warsaw
1991 'The Lake in a Pyramid', installation,
Galeria Foksal, Warsaw
1992 'Night', painting, Galeria Foksal,
Warsaw
1992 'Showing Bugs (insects)', painting,
Galeria, Biblioteka, Legionowo
1993 Haiku 'Rain', painting, installation,
Galeria, Biblioteka, Legionowo
1994 Haiku 'Water', installation, Galeria,
Biblioteka, Legionowo
Group Exhibitions
1970 2nd International Biennale of Prints,
Bradford, England
1972 'Atelier 72', Edinburgh International
Festival, Richard Demarco Gallery,
Edinburgh
1977 Winners of the C.K. Norwid Prize
1967–76, Artists' House, Warsaw
1979 'Wlodzimierz Borowski, Edward
Krasinski, Koji Kamoji, Henryk
Stazewski', painting, Artists' House,
Warsaw
1981 'Constructivist Tendencies', Artists'
House, Warsaw
'Contemporary Painting in Eastern

Europe and Japan', Kanagawa, Japan
Prefectural Gallery, Yokohama;
National Museum of Art, Osaka,
Japan
'Kreis und Wuadrat', Depolma, Ars
Polona Gallery, Dusseldorf, Germany

1982 'Echange entre les artistes:
Pologne–USA', Musee d'Art Moderne
de la Ville de Paris, Paris

1983 'Sign of the Cross', Church in Zytnia
Street, Warsaw

1984 'The Language of Geometry', Zacheta
Gallery, Warsaw

1985 'Apocalypse', St Cross Church,
Warsaw
'Die Ecke, the corner, le coin', Galerie
Hoffmann, Friedberg, Germany

1986 Group exhibition, St Christopher's
Church, Podkowa Lesna
'Henryk Stazewski, Edward Krasinski,
Koji Kamoji', Foksal Gallery, Warsaw
'Geometry and Expression', Parko
Eleftherias, Athens

1987 'Geometry and Order', Gallery 72,
Chelm

1988 'String', Galeria Dzialan (Gallery of
Actions), Warsaw

1990 'Work and Prayer', Diocese Museum,
Lublin'
'Homage to Henryk Stazewski', Studio
Art Centre, Warsaw

1991 The Collection of 20th Century Art,
Muzeum Sztuki, Lodz

1992 The Collection of 20th Century Art,
Muzeum Sztuki, Lodz; Museum, Lyon,
France

1993 'From Nooks and Crannies', Galeria
Rzezby, Warsaw

TADEUSZ KANTOR

1915 Born in Wielopole
1942 Founds Underground Theatre
1945 Sets up the Group of Young Artists,
Krakow
1948 Appointed as Professor, Academy of
Fine Arts, Krakow (dismissed the
following year)
1952 Establishes Cricot 2 Theatre

1968 Reappointed as Professor, Academy
of Fine Arts, Krakow (dismissed again
after a few months)

1990 Dies in Krakow on December 8

Awards

1967 Grand Prix in Painting, 9th Biennale,
Sao Paolo, Brazil

1969 Medal Premio Roma, Galleria
Nazionale d'Arte Moderna, Italy

1973 Scotsman Prize for Theatre for
'Lovelies and Dowdies' by Witkiewicz
(with Cricot 2 Theatre), Edinburgh
International Festival, Edinburgh

1975 Scotsman Prize for Theatre for 'The
Dead Class' (with the Cricot 2
Theatre), Edinburgh International
Festival, Edinburgh

1977 Medal of the City of Gdansk
Theatre Critics' Prize Commemorating
Tadeusz Boy-Zelenski

1978 Cyprian Norwid Artistic Critics' Prize
Rembrandt Award from the Goethe
Foundation in Basel
Mayor's Medal, Commune di Roma

1979 Mayor's Medal, Commune di Milano

1980 Mayor's Medal, Ville de Lyon
Mayor's Gold Medal, Commune di
Firenze

Exhibitions and Theatre Pieces

1945 Group of Young Artists, Krakow
1946 Group of Young Artists, Krakow
1948 Polish Exhibition of Modern Art,
Krakow (co-organiser)
1955 Joint exhibition, Krakow artists
including Tadeusz Brzozowski, Jerzy
Nowosielski, Maria Jarema, Erna
Rosenstein and Jonasz Stern
1956 'Po Prostu', joint exhibition with
Maria Jarema, Warsaw Salon
'The Cuttle Fish' by Stanislaw Ignacy
Witkiewicz, premiere
1957 Solo exhibition, Krzysztofory Gallery,
Krakow
1959 Documenta 2, Kassel
1960 30th Biennale, Venice
1961 'The Art of Assemblage', Museum of
Modern Art, New York
'15 Polish Painters', Museum of

Modern Art, New York
1963 Krzysztofory Gallery, Warsaw
(organiser)
1965 'Cricotage', happening, Society of
Friends of Fine Arts, Krakow
1966 'Division Line', happening, Society of
Art Historians, Krakow
'Le Grand Emballage', happening,
Gallery Handschin, Basel, Switzerland
1967 'A Letter', happening, Foksal Gallery,
Warsaw
'Panoramic Sea Happening', Osieki
'The Water Hen' by Witkiewicfz
(Happening Theatre)
9th Biennale, Sao Paolo, Brazil
1968 'An Antomy Lesson According to
Rembrandt', happening, Kunsthalle,
Nurnberg, Germany
'Hommage a Maria Jarema',
happening, Krzysztofory Gallery,
Krakow
1969 'Assemblage d'Hiver', Foksal Gallery,
Warsaw
1970 'Multipart I', Foksal Gallery, Warsaw
'Happening und Fluxus', Kunsthalle,
Koln, Germany
1971 'Multipart II', Foksal Gallery, Warsaw
1972 'The Shoemakers' by Witkiewicz (with
a group of French actors), Theatre 71,
Malakoff
'The Water Hen' by Witkiewicz (with
Cricot 2 Theatre), 'Atelier 72',
Edinburgh International Festival,
Richard Demarco Gallery, Edinburgh
1973 'Precieuses and Green Monkeys'
(Theatre of the Impossible)
'Everything is Hanging by a Slender
Thread', Foksal Gallery, Warsaw
'Lovelies and Dowdies' by Witkiewicz
(with Cricot 2 Theatre), Edinburgh
International Festival, Richard
Demarco Gallery, Edinburgh
1974 Creates designs for 'Balladyna' at the
Bagatela Theatre in Krakow.
1975 'Emballages', Muzeum Sztuki, Lodz
'The Dead Class' (with the Cricot 2
Theatre) premieres: world tour,
including Edinburgh International

Festival
1979 'Where Have All the Former Snows Gone?', cricotage
1980 'Wielopole, Wielopole', premieres with the Cricot 2 Theatre: world tour in 1980–81
'The Ideas of the Cricot 2 Theatre', exhibition, Circoteka, Krakow
1982 'Metamorphoses', Galerie de France, Paris
1983 'Presences Polonaises', Centre Georges Pompidou, Paris
1985 'Let The Artists Perish' premiere with the Cricot 2 Theatre, Nurnberg, Germany
1986 'The Wedding', cricotage, Milan, Italy
1987 'Death and Love Machine' at Documenta 8, Kassel, Germany
1988 'I Will Never Come Back Here' premieres with the Cricot 2 Theatre, Milan, Italy
1989 Cricot 2 Theatre Festival, Theatre Chaillot in Paris
'Kantor, l'artiste au fin du Xxieme Siecle', international symposium, Centre Georges Pompidou, Paris
'Plus Loin Rien', Galerie de France, Paris
1990 'Today is My Birthday' premieres with Cricot 2 Theatre, prepared for international symposium, Krakow to commemorate Kantor's 75th birthday

Between 1965 and 1990 the Cricot 2 Theatre presented works conceived and directed by Tadeusz Kantor with the company in many places, including: Rome, Modena, Bologna, Paris, Edinburgh, Glasgow, Nancy, Essen, Cardiff, London, Amsterdam, Nurnberg, Belgrade, Bruxelles, Lille, Milan, Florence, Adelaide, Sydney, Zurich, Geneva, Caracas, Berlin, Stuttgard, New York, Mexico, Stockholm, as well as in Krakow, Warsaw and Gdansk

Public Collections

Paintings and drawings by Tadeusz Kantor are included in all the major Polish national collections and in many public and private collections throughout the world

ANDRZEJ KAPUSTA

1956 Born in Skawina
1982 Began working in the Department of Painting, Academy of Fine Arts, Krakow

Education and Selected Awards

1981 Completed Diploma of Fine Arts (with distinction), Academy of Fine Arts, Krakow
Award of the President of the City of Krakow
1986 Scholarship of the Foundation France Liberte, Paris
1987 First Prize, The Survey of Young Artist's Painting, Krakow
1990 Scholarship of the British Council, London
1991 Award of The Polish Culture Foundation

Solo Exhibitions

1979 Gallery of Jagiellonian University, Krakow
1983 Gallery of Academy of Fine Arts, Krakow
1985 Gallery of Contemporary Art, Krakow
1986 Museum Nienburg, Germany
1987 Gallery Inny Swiat, Krakow
1989 Gallery Plastyka, Krakow
1990 Gallery Gil, Krakow
Gallery of Academy of Fine Arts, Krakow
1991 'Great Picture', STU Theatre, Krakow Historical Museum, Krakow
National Philharmonic, Gologorski & Rostworowski Gallery, Krakow
1992 Gallery Plastyka, Krakow
1994 Dominik Rostworowski Gallery, Krakow
Gallery ks. Pasierb, Warsaw

Selected Group Exhibitions

1981 'Dyplom '81', Zacheta Gallery, Warsaw
1984 'Contemporary Polish Art', Stockholm
1985 'Contemporary Polish Art', Aalborg, Denmark
'Towards the Person', Dominican Abbey, Krakow
3rd International Triennale of

Drawing, Nurnberg, Germany; Linz, Austria
1986 'Exchange', Belfast, North Ireland
1987 'Passion Mystery', Museum of the Archdiocese of Warsaw
'Ateliereinblicke', Nurnberg, Germany
1988 4th International Triennale of Drawing, Wroclaw
'Plein–Air', Darmstadt, Germany; Gavorrano, Italy
'Szancenbach and his Students', Warsaw, Sopot; Vienna, Austria
1989 'Contemporary Polish Art', Darmstadt, Germany
1990 'Seis Artistas de Cracovia', Santiago de Compostella, Spain
'Art from Krakow', Ronneby, Sweden
1991 'What use is an Artist in Poor Times', Warsaw
'Dotyk/Touch: Iconography of the Eighties', BWA Gallery, Palace of Art, Krakow
1992 'Ten Years After', Radom; Krakow; Lodz
5th International Triennale of Drawing, Wroclaw
Expo '92, Seville
'Kunst aus Krakau', Darmstadt, Germany
'Art Contemporain Polonais', Toulon, France
1993 'Portret Ironiczny', Krakow, Lodz; Fejkiel Gallery, Amersfort, Netherlands
SIAC, International exhibition, Palace of Art, Krakow
'Coordinates 19° 57,6'E + 15° 3,9'N', Krakow
'The Artists from Krakow', Warsaw
1994 'Della Passione', Roma
'Four Elements', Fejkiel Gallery, Krakow
Krakow '94, Gandawa, Belgium

Public Collections

National Museum, Szczecin
National Museum, Katowice
National Museum, Bytom
Foundation France Liberte, Paris

LUKASZ KONIECZKO

1964 Born in Krakow
1990– Has worked as an assistant at the
 Academy of Fine Arts, Krakow in the
 Painting Studio of the Conservation
 Department

Education and Awards

1984–90 Studied at the Painting Department,
 Academy of Fine Arts, Krakow in the
 studio of Professor Zbigniew
 Grzybowski
1988 Scholarship training in the studio of
 Professor Werner Knaupp at the
 Akademie der Bildenden Kunste,
 Nurnberg, Germany
1988–89 Ministry of Culture and Art
 Scholarship
1990 Ministry of Culture and Art
 Scholarship
 Graduated, receiving a citation in the
 studio of Professor Zbigniew
 Grzybowski
1991 Main Prize and Honorary Award, All-
 Polish Review of Painting of Young
 Artists 'Promocje '90', BWA Gallery,
 Legnica
1992 Stays in Chicago, USA, as a part of
 artistic exchange organized by
 Stawski Gallery
 Honorary Prize, 'Third Salon of Young
 Artists Painting', Dom Poloni, Krakow

Solo Exhibitions

1988 'Three Pictures Gallery', Academy of
 Fine Arts, Krakow
1992 'Supporting the Sky', BWA Gallery,
 Legnica
1993 'Paintings', SDK, Sanok
1994 'Stawski Gallery', Krakow

Selected Group Exhibitions

1989 'Free City of Krakow', NORA Gallery,
 Krakow
1990 Diploma Exhibition, BWA Gallery,
 Krakow
 'New Art in Palace', Palace of Art,
 Krakow
1991 All-Polish Review of Painting of
 Young Artists 'Promocje '90', BWA
 Gallery, Legnica

 Triennial of Young Artists from the
 Baltic Countries 'Vilnius '90', Palace
 of Art, Vilnius, Lithuania
1992 'Chicago International Art Exposition',
 Chicago, USA
 'Permissible Decisions', 'Pryzmat'
 Gallery, Krakow
 'Best Diploma Works '90, '91', BWA
 Gallery, Gdansk
 'The Krakow Art Exhibition',
 Staatstheater, Darmstadt, Germany
 'Around the Coyote', Chicago, USA
 'Third Salon of Young Artists
 Painting', Dom Poloni, Krakow
1993 'Stawski Gallery', Palace of Art, Krakow
1994 'New Perspective', Ukrainian Institute
 of Modern Art, Chicago, USA
 Europ'Art, Palexpo, Geneva,
 Switzerland

WOJCIECH KOPCZYNSKI

1955 Born in Krakow

Education and Awards

1975–82 Studied at the Graphic Art
 Department, Academy of Fine Arts,
 Krakow; diploma in: Designing
 Advertising Forms, Professor Witold
 Skullicz; Lithography, Professor
 Wlodzimierz Kunz; Painting, Professor
 Jan Swiderski
1984 Ministry of Culture and Art
 Scholarship
1986 Mayor of Krakow Scholarship

Group Exhibitions

1978 Exhibition together with 'Grupa
 Luzna'
1980 Exhibition together with 'Grupa
 Luzna'
1982 'Diploma Works '82', Poznan
1984 '10th International Biennial of
 Graphic Art', Krakow
 'Krakau und Welt', Kassel, Germany
1985 Kunsthalle, Nurnberg, Germany
1986 'Scholarship holders', Krakow
1990 'Art in Palace', Krakow
1991 'Polish Art Festival', Polish Museum,
 Chicago, USA
1992 'Decouvertes '92', Grand Palais, Paris

 'Stawski Gallery', Palace of Art, Krakow

Solo Exhibitions

1987 Il Trangolo Gallery, Cosenza, Italy
1989 Volksbank, Lemgo, Germany
1991 Stawski Gallery, Krakow
1992 'Escape Goya', Bordeaux, France
 Le Monde Des Arts, Paris, France
1993 The Polish Institute, Paris, France

Public Collections

National Museum, Kielce
Espace Goya, Bordeaux, France
Also in private collections in Poland and aboard

EDWARD KRASINKSI

Individual Exhibitions

1966 Galeria Foksal, Warsaw
1968 Galeria Foksal, Warsaw
1969 Galeria Krzysztofory, Krakow
1970 Musee d'Art Moderne de la Ville de
 Paris, Blue 'Scotch' Line in the
 courtyard and in the windows of 50
 galleries on the Right Bank
1974 Galeria Repassage, Warsaw
1975 Galerie 28, Paris
 Galerie Alfred Hempel, Dusseldorf,
 Germany
1976 Galeria Pawilion, Krakow
 Galeria Zapiecek, Warsaw
1978 Galeria Pawilion, Krakow
1981 Exhibitions in various places outside
 galleries, including cafes, apartments,
 lift cages etc.
1982 Galeria 72, Chelm
1984 Galeria Foksal, Warsaw
1985 Galeria Foksal, Warsaw
1986 Galeria Foksal, Warsaw
1987 Galeria Foksal, Warsaw
1988 Galeria Foksal, Warsaw
 Galerie Donguy, Paris
1989 'Homage to Henryk Stazewski',
 Galeria Foksal, Warsaw
1990 Galeria Foksal, Warsaw
1991 Major retrospective, Muzeum Sztuki,
 Lodz
1994 Galeria Foksal, Warsaw

Group Exhibitions

1962 'Argumenty 62', Galeria Krzywe Kolo,
 Warsaw

1963 'Five Polish Painters', Grabowski
Gallery, London
1964 'Konfrontacje 64', Galeria Sztuki
Nowoczesnej, Warsaw
1965 'Konfrontacje 65', Galeria El, Elblag
1st Biennale Form Przestrzennych,
Elblag
1st Happening, cricotage Tadeusza
Kantora, Warsaw
1966 Wystawa Pieciu Malarzy, Galeria
Foksal, Warsaw
1st Sympozyum Plastykow i
Naukowcow, Pulawy
1967 'List', happening, Tadeusza Kantora,
Warsaw
'Panoramiczny Happening Morski',
Tadeusza Kantora, Osieki
Galeria Foksal, Warsaw
5th Guggenheim International
Exhibition, Guggenheim Museum,
New York
1968 'Assemblage d'Hiver', Galeria Foksal,
Warsaw
1969 'Intermedia', Heidelberg, Germany
'Peinture Moderne Polonaise: Sources
et Récherches', Musee Galeria, Paris
1970 10th Tokyo Biennale, Tokyo
Metropolitan Museum; Kyoto
Municipal Art Museum, and Aicki
Prefectural Art Museum, Nagaya, Japan
3rd Salon des Galeries Pilotes, Palais
des Beaux Arts, Lausanne; Musee
d'Art Moderne de la Ville de Paris,
Paris
1972 'Atelier 72', Edinburgh International
Festival, Richard Demarco Gallery,
Edinburgh
'10 Polish Artists', Benxon Gallery,
Long Island, New York
1974 'Doswiadczenia I Poszukiwania',
Muzeum Sztuki w Lodz
1976 '17 Contemporary Painters from
Poland', Albright-Know Museum,
Buffalo, New York
1977 '22 Polnisch Kunstler aus dem Besitz
des Muzeum Sztuki w Lodzi',
Kolnische Kunstverein, Koln, Germany
1978 43rd Biennale, Venice, Italy

'Sculpture Polonaise', Musee d'Art
Moderne de la Ville de Paris, Paris
'16 Contemporary Polish Artists',
Aldrich Museum of Contemporary
Art, Connecticut, USA
1979 'L'Avanguardia Polacca 1919–1978',
Palazzo delle Esposizioni, Rome
'Ten Polish Contemporary Artists from
the Collection of the Muzeum Sztuki
w Lodzi', Richard Demarco Gallery,
Gladstone Court, Edinburgh
'Borowski–Kamoji–Krasinski–
Stazewski', Dom Artsty Plastyka,
Warsaw
1981 'Contemporary Painting in Eastern
Europe and Japan', Kanagawa, Japan
Prefectural Gallery, Yokohama;
National Museum of Art, Osaka,
Japan
1982 'Echange entre Artistes: 1931–1982,
Pologne–USA', Musee d'Art Moderne
de la Ville de Paris; Ulster Museum,
Belfast; Douglas Hyde Art Gallery,
Trinity College, Dublin
1985 'Dialog', Moderna Museet, Stockholm
1986 'Kamoji–Krasinski–Stazewski', Galeria
Foksal, Warsaw
1989 'Fonds National d'Art
Contemporia–Acquisitions 1988',
CNAP, Paris
1990 'Polsk Kunst', Galeri Kram Art-On,
Halmstad
1991 'Kolekcja Sztuki XX w.w. Muzeum
Sztuki w Lodzi', Galeria Zacheta,
Warsaw

Public Collections
Centre Georges Pompidou, Paris
National Museums of Krakow, Warsaw and
Wroclaw
Muzeum Sztuki w Lodzi
National Museum, Prague
Also in many private collections

JAROSLAW KAWIORSKI
Born in 1955
Painter, drawer and printmaker
Education and Awards
1980 Completed Diploma, Academy of Fine

Arts, Krakow
1987 Prize of the Polish Contemporary Art
Foundation, 2nd Young Art Biennale,
Wroclaw
Prize of the Chancelor, Academy of
Fine Arts, Krakow
1988 Schwan–Stabilo Prize, 4th
International Triennale of Drawing,
Kunsthalle, Nurnberg, Germany
1989 Silver Griffin, 13th Triennale of Baltic
Countries, Rostock, Germany
Solo Exhibitions
1979 BWA Gallery, Nowy Sacz
1985 Contemporary Art Gallery, Krakow
1986 Farbiarnia Gallery, Krakow
Inny Swiat Gallery, Krakow
1989 Gil Gallery, Krakow
M. Gologorski & D. Rostworowski
Contemporary Art Gallery, Krakow
1993 Dominik Rostworowski Gallery,
Krakow
BWA Gallery, Czestochowa
BWA Gallery, Kielce
Selected Group Exhibitions
1987 5th Miniprint International, Cadaques
International Exhibition of Small
Prints, Lodz
Ateliereinblicke, Kunsthale, Nurnberg,
Germany
'The Way and the Truth', 2nd Young
Art Biennale, Wroclaw
3rd International Triennale of Portrait,
Radom
Interart '89, Poznan
1988 'Young Krakow Painting', Polish
Institut, Paris
'The Dream Print', Polish Institut,
Lipsk; Berlin; Stockholm
4th International Triennale of
Drawing, Kunsthalle, Nurnberg,
Germany
1989 13th Triennale of Baltic Countries,
Rostock, Germany
'Taisaxe Remota, Paisaxe Futura',
Trinta Galeria, Santiago de
Compostella, Spain
'Young Krakow Printmakers', BWA
Gallery, Lodz

1990 'Seis artistas de Cracovia', Trinta
Galeria, Santiago de Compostella,
Spain
ARCO '90, Trinta Galeria, Madrid
4th Miniprint International, Cadaques
15th Festival of Polish Contemporary
Painting, Szczecin
'Krakow Painting', Ronneby, Sweden
'Konsument Art '90', Kunsthalle,
Nurnberg, Germany
Interart '90, Zimny Gallery, Poznan
Summer show, National Museum,
Krakow
'Who Needs an Artist in these
Wretched Times: Independent Art of
the Eighties', Zacheta, Warsaw

1991 'Who Needs an Artist in these
Wretched Times: Independent Art of
the Eighties', National Museum,
Krakow
'Dotyk/Touch: Iconography of the
Eighties', BWA Gallery, Palace of Art,
Krakow
'Zeitgenossische Malerei aus Polen',
Galerie zur Alten Deutschen Schule,
Thun, Switzerland.

1992 '10 Years Later', exposition of
drawings, Contemporary Art Gallery,
Regional Museum, Radom; BWA
Gallery, Krakow; BWA Gallery,
Czestochowa; BWA Gallery, Slupsk
'Art from Crakow, Bednarski,
Brincken, Kawiorski', Galerie zur
Alten Deutschen Schule, Thun,
Switzerland
Exhibition of Krakow Art, Staatstheater
Galerie, Darmstadt, Germany
'From Galicia to Galicia', Painting,
prints, drawing, BWA Gallery, Krosno

1993 'From Galicia to Galicia', Painting,
prints, drawing, Dominik
Rostworowski Gallery, Krakow
'Generations', prints, drawings, BWA
Gallery, Wloclawek; BWA Gallery,
Opole
'Krakow Spleen', DAP Gallery, Warsaw
SIAC, International exhibition, Palace
of Art, Krakow

Public Collections
Silesian Museum, Katowice
National Museum, Krakow
Museum, Bydgoszcz
Art Museum, Bytom
Regional Museum, Nowy Sacz
Old Theater Museum, Krakow

ZYGMUNT MAGNER

1937 Born in Katowice

Education and Awards
1967 Graduated from the Academy of Fine
Arts, Warsaw
1974 First Prize and Gold Medal, 5th
Festival of Art, Warsaw
1982 Award, 6th International Biennale of
Painting, Koszyce

Selected Solo Exhibitions
1970 Painting exhibition, Modern Art
Gallery, Warsaw
1973 Painting, graphic and drawing
exhibition, DAP Gallery, Warsaw
1974 Graphic and drawing exhibition, De
Kromme Gallery, Delft, Netherlands
1975 Graphic and drawing exhibition,
Kriterion Gallery, Amsterdam
1976 Painting and graphic exhibition, BWA
Arsenal Gallery, Bialystok
1977 Painting, graphic and drawing
exhibition, 1st Deutsche Bank,
Ludwigshafen, Germany
1979 Painting and graphic exhibition,
Kordegarda, Warsaw
1981 Painting and drawing exhibition, BWA
Gallery, Katowice
1983–86 Test Gallery, Warsaw
1988 Painting exhibition, BWA Gallery,
Czestochowa
Painting exhibition, Arkady Gallery,
Krakow
1989 Painting and drawing exhibition,
Slaski Muzeum, Katowice
1990 Painting exhibition in Historics of Art
Gallery, Krakow
1991 Painting, graphic and drawing
exhibition, Hartmanstrasse 45 Gallery,
Ludwigshafen, Germany

Selected Group Exhibitions
1968 2nd Festival of Art, Warsaw
4th Festival of Painting, Szczecin
1969 4th Polish Exhibition of Graphic Art,
Warsaw
Exhibition of Polish Graphic Art,
Skopje, Macedonia; Sarajevo, Bosnia-
Herzegovina
1970 3rd Festival of Art, Sopot
1971 3rd Triennale of Drawing, Wroclaw
5th Polish Exhibition of Graphic Art,
Poznan
1972 4th Festival of Art, Warsaw
1973 Exhibition of Polish Art, Mannheim,
Germany
Exhibition of Polish Graphic Art,
Algiers, Algeria
1974 5th Festival of Art, Warsaw
Exhibition of Polish Graphic Art,
Rabat, Tunis
1975 'Romantyzm I Romantycznoscw
Sztuce Polskiej XIX i XX wieku',
Warsaw; Katowice
1976 Exhibition of Polish Graphic Art, Tunis
7th Polish Graphic Art Exhibition,
Warsaw
'W Kregu Metafory', Warsaw
6th Festival of Art, Warsaw
6th International Graphic Biennale,
Krakow
1977 Exhibition of Polish Graphic Art,
Rotenburg, Germany
Exhibition of Polish Graphic Art,
Clermont-Ferrand, France
1978 7th Festival of Art, Warsaw
'Prawda Czlowieka Prawda Artysy',
Wroclaw
5th International Triennale of
Drawing, Wroclaw
1979 18th International Joan Miro Drawing
Competition, Barcelona
Exhibition of Polish Graphic Art, Oslo
Exhibition of Polish Graphic Art,
Ludwigshafen, Germany
'Rysunek dzielo spelnione', Warsaw
1980 19th International Joan Miro Drawing
Competition, Barcelona
'Druk Plaski', Warsaw

1981 Exhibition of Polish Graphic Art,
 Osaka, Japan
 Exhibition of Polish Graphic Art,
 Lisbon
 Exhibition of Polish Graphic Art,
 Cairo, Egypt
 Exhibition of Polish Graphic Art,
 Algiers
 9th Polish Exhibition of Graphic Art,
 Warsaw
 Festival of Art, Warsaw
1982 6th International Biennale of Painting,
 Koszyce
 Exhibition of Polish Art, Budapest
 'Granica Marzen I Wyobrazni', Sofia,
 Bulgaria
1983 Exhibition of Polish Art, Prague
 Exhibition of Polish Painting,
 Varrelbusch, Germany
1985 Exhibition of Polish Art, Gent,
 Belgium
 Exhibition of Polish Modern Painting,
 Beijing; Xian; Czenage, China
1988 Exhibition of Polish Art, Berlin
1991 'Memory and its Differents Aspects',
 Bruxelles
1992 Polish Graphic Art exhibition,
 Istanbul, Turkey
 'Warsaws' Akademy Artists',
 Ludwigshafen, Germany
1994 'W kregu Nowej Figuracji', Warsaw

Public Collections
National Museum, Warsaw
Slaski Museum, Katowice
City Museum, Katowice
National Museums, Gdansk and Przemysl
Art Centre 'Studio', Warsaw
National Library, Warsaw
National Gallery, Washington, USA
Lincoln University Museum, Nebraska, USA
Also in private collections in Poland and aboard

DOROTA MARTINI
Born in Krakow
1981–92 Art teacher
1992– Working in Cultural Centre
Education
1975–80 Studied at Academy of Fine Arts,
 Krakow

Solo Exhibitions
1981 Gil Gallery, Krakow
 DESA Gallery, Krakow
1985 Piwnica pod Baranami Gallery,
 Krakow
1986 Studio wiznalne KONTAKT, Poznan
1987 Rotunda Gallery, Krakow
 KMPiK Gallery, Zielona Gora
 University of Tubingen, Germany
1988 Cafe 'La Boheme', Tubingen,
 Germany

Selected Group Exhibitions
1981 'Krakow '81', Warsaw
1984 Art sans Frontieres Gallery,
 Strasbourg, France
1985 Biennale of Young Art, Church of the
 Holy Cross, Warsaw
1987 Biennale of Young Art, Church of the
 Holy Cross, Warsaw
 'Art as Freedom', Koszalin
1988 'Original Graphics', Nurnberg,
 Germany
 'Six Artists from Krakow', Krakow
1990 ARCO, Madrid
1991 'Dotyk/Touch: Iconography of the
 Eighties', BWA Gallery, Palace of Art,
 Krakow
1992 'Neue Kunst aus dem Alten Krakau',
 Darmstadt, Germany
 'Six Artists from Krakow', Krosno;
 Krakow
1993 'Krakow–Cork Exchange', Crawford
 Municipal Art Gallery, Cork; City Art
 Centre, Dublin, Ireland
 'Small Pictures', Krakow
 'Art for the Place of Self-Discovery',
 SIAC, International exhibition, Palace
 of Art, Krakow
 'Consument Art', Nurnberg, Germany
 'Spleen of Krakow', Warsaw

JADWIGA MAZIARSKA
1913 Born in Sosnowiec
1944–49 'Group of Young Artists' member
 (Grupa Mlodych Plastykow)
1957– 'Krakow Group' member (Grupa
 Krakowska)

Lives and works in Krakow
Education
1933 Studied painting at the Alfred Terlucki
 School
1934–39 Studied at the Academy of Fine Arts,
 Krakow in the studio of Professor
 Ignacy Pienkowski

Solo Exhibitions
1957 Dom Plastykow, Krakow
 Galeria Kordegarda, Warsaw
1964 Galeria Krzywe Kolo, Warsaw
1976 Galeria Pawilon DESA, Nowa Huta,
 Crakow
1984 Galeria Krzsztofory, Krakow
1984 Galeria Studio, Warsaw
1988 Galeria Studio, Warsaw
1991 Palac Sztuki, Krakow
1994 Zderzak Gallery, Krakow

Group Exhibitions
1945 Wystawa Mlodych Plastykow, w
 Zwiazku Literatow, Krakow
 Wystawa Malarstwa i Rzezby ZZPAP,
 Tow. Przyjacol Sztuk Pieknych,
 Krakow
 Wystawa Krakowskiego ZZPAP,
 Miejskia Galeria Sztuk Plastycznych,
 Lodz
1945–46 Wystawa Niezaleznych (Gwiazdkowa),
 TPSP, Krakow
1946 Wystawa Mlodych Plastykow, Palac
 Sztuki, Krakow
1947 Ogolnopolski Salon Zimowy, Palac
 Sztuki, Krakow
 Malarstwo, rzezba, grafika, 3rd
 Ogolnopolski Salon, Poznan
1948–49 Polish Exhibition of Modern Art, Palac
 Sztuki, Krakow
1949 Wystawa Okregu Krakowskiego ZPAP,
 Palac Sztuki, Krakow
1953 Doroczna wystawa Krakowskiego
 Okregu ZPAP, Palac Sztuki, Krakow
1955 Wystawa 9 malarzy, Dom Plastykow,
 Krakow
 Okregowa jesienna wystawa ZPAP
 1945–56, Palac Sztuki, Krakow
1956–57 Wystawa Mlodej Plastyki Okregu
 Krakowskiego, Palac Sztuki, Krakow
1957 Wystawa Prac Plastykow Zaglebia,

Dom Gornika Sosnowiec, BWA Katowice, Czestochowa, Gliwice, Bytom
2nd Polish Exhibition of Modern Art, CBWA Galeria Zacheta, Warsaw
Wystawa Mlodej Plastyki Okregu Krakowskiego, CBWA, Wroclaw
Wystawa malarstwa Grupy Krakowskiej z II Wystawa Sztuki Nowoczernej, Szczecin

1958 Wystawa 3 malarzy: Jadwiga Mazearska, Erna Rosenstein, Tadeusz Romanowski, CBWA, Lublin
Wystawa wspolczesnych malarzy polskich, Klub MPiK, Nowa Huta, Krakow

1959 3rd Polish Exhibition of Modern Art, CBWA Galeria Zacheta, Warsaw

1960 Wystawa Krakowskiego Okregu ZPAP 1945–56, Palac Sztuki, Krakow

1961 Wystawa Jubileuszowa 50-lecia ZPAP Okregu Krakowskiego, Palac Sztuki, Krakow

1962 Polskie dzielo plastyczne w XV-leciu PRL, Muzeum Narodowe, Warsaw

1962–63 Salon TPSP, Palac Sztuki, Krakow

1963 Konfrontacje 1963, Galeria Sztuki Nowoczesnej (Krzywe Kolo), Warsaw

1964 Wystawa malarstwa i rzezby, Palac Sztuki, Krakow

1965 'Konfrontacje 65', Galeria, 'EL', Elblag
Porownania, BWA, Sopot
Ogolnopolska Wystawa Jesienne Konfrontacje, Rzeszow

1967 Porownania, Wroclaw
X-lecie Grupy Zaglebie, Sosnowiec, Katowice

1969 'Espaces abstraits', Galleria d'Arte Cortina, Mediolan
Malarstwo i malowanie od romantyzmu do taszyzmu: Wystawa obrozow malarzy polskich z XIX i XX wieku, Palac Sztuki, Krakow

1974 Krakowskie malarstwo i rzezba w XXX-leciu PRL, BWA, Palac Sztuki, Krakow

1978 15 Polnische Kunstler, Rathaus, Augsburg, Germany

1979 Malarstwo Polskie 1944–79, Muzeum Okregowe, Bydgoszcz
W kregu wystawy Sztuki Nowoczesnej, Krakow 1948, Museum Okregowe, Radomiu

1980 35 lat malarstwa w Polsce Ludowej, Muzeum Narodowe, Poznan

1981 Polskie malarstwo wspolczesne ze zbiorow Muzeum Narodowego w Poznaniu, BWA w Jeleniej Gorze

1985 Krakowscy malarze, rzezbiarze i graficy w 40-lecie Polski Ludowej, BWA, Palac Sztuki
63 Kunstler aus Krakau, Staatstheater, Darmstadt, Germany
'Four Women Artists from Eastern Europe', Battersea Art Centre, London

1986 Polsk nutidskunst, Kunstpavillon, Aalborg, Denmark

1988 'Geometria es Metafora', Budapest Galeria, Budapest
'Polnische Malerei seit 1945', Galerie der Stadt Esslingen, Villa Merkel, Esslingen, Wilhelmshaven, Germany
Polskie Malarstwo Wspolczesne, Lwowska Galeria Obrazow, Lwow

1990 Galeria Krzywe Kolo: Wystawa Retrospektywna, Muzeum Narodowe, Warsaw

1991 Artystki Polskie, Muzeum Narodowe, Warsaw

1991 Kolekcja Sztuki XX wieku w Muzeum Sztuki w Lodz, Galeria Zacheta, Warsaw; Lyon, France

1992 Kolekcja Galerii Starmach, Miejska Galeria sztuki Extravagance, Sosnowiec, Lublin

1992 29th Ogolnopolska Wystawa Malarstwa, Bielska Jesien '92, Bielsko-Biala

1993 Artysci z Krakowa, Galeria Zacheta, Warsaw

Collections
1965 Muzeum Slaskie, Wroclaw
1967 Muzeum Slaskie, Wroclaw
1973 BWA, Wroclaw
1981 BWA, Lublin

1984 Pecsi Galeria, Pecs
1988 Muzeum Okregowe, Nowy Sacz
BWA, Rzeszow

HANNA MICHALSKA
1963 Born in Torun
1988– Member of Polish Artists' Society
Member of the art group TE7EM
Painting, printmaking and book illustration

Education and Awards
1983–88 Studied at the Academy of Fine Arts, Krakow, Graphic Faculty
1988 Diploma in Professor A. Pietsch's studio of etching and in Professor R. Banaszewski's studio of typography and book design
1991 Grand Prix, 'Galizien', The Historical Museum Gallery, Krakow
1992 Grand Prix, 3rd Review of Young Painters, Plastyka Gallery, Krakow
1993 Grand Prix, May, Print of the Month, Krakow

Solo Exhibition
1988 PSP Gallery, Torun

Group Exhibitions
1989 'Three Printmakers from Krakow', Drent Gallery, Leuvaarden, Netherlands
'Tumult Torunski', Town Hall, Torun

1990 'Best Diplomas 1988–89', Esken Palace, Torun
'Print of the Year', ASP Gallery, Krakow
'The Youngest Printmakers in Krakow', 'Nr 4' Gallery, Krakow; Leipzig, Germany

1991 Galizien (Grand Prix), Historical Museum Gallery, Krakow; Parliament House, Vienna; Salzburg, Austria
'Szara Kamienica–Objects, Paintings', Krakow
'Young Graphics Review', Plastyka Gallery, Krakow
1st Triennale of Polish Graphics, BWA Gallery, Katowice
Young Artists' Art Triennale of the Baltic Countries, Art Palace, Vilnius, Lithuania

1992 'Neue Kunst aus dem Alten Krakau',
Darmstadt, Germany
Grand Jubilee Open Painting Salon,
BWA Gallery, Krakow
3rd Review of Young Painters,
Plastyka Gallery, Krakow
'Pobyt Czasowy' (with Art Group
TE7EM), Miriam Gallery, Tychy
12th Polish Graphic Competition,
BWA Gallery, Lodz
'W sierpniu' (with Art Group TE7EM),
Gole Niebo Gallery, Krakow
'Pieklo–Niebo' (with Art Group
TE7EM), Plastyka Gallery, Krakow
29th Polish Exhibition of Painting,
BWA Gallery, Bielsko-Biala
1993 'Krakow–Cork Exchange', Crawford
Municipal Art Gallery, Cork; City Art
Centre, Dublin, Ireland
'Artists from Krakow', Zacheta
Gallery, Warsaw
1st International Triennale of Prints,
Maastricht, Netherlands
Print of the Month, Krakow
'Generations—Krakow Graphics
Exhibition', BWA Gallery, Krakow
'Coordinates 19˚ 57,6'E + 15˚ 3,9'N',
Krakow
International Print Portfolio,
Geographic (organiser), Austrian
Consulate Gallery, Krakow

JAROSLAW MODZELEWSKI

1955 Born in Warsaw
Lives and works in Warsaw
Education
1975–80 Studied at the Academy of Fine Arts,
Warsaw in the studio of Professor S.
Gierowski
Solo Exhibitions
1981 Gallery of Contemporary Art, Warsaw
1983 'Some Sketches and Pictures',
Dziekanka Studio, Warsaw
Private Studio, Warsaw
1986 'The Chosen Aspects of Easel Painting
in View of the Author's Own Work',
Dziekanka Studio, Warsaw

1987 'I am 32 and I Live in Warsaw', SARP,
Warsaw
1988 Gallery of Young Artists, Warsaw;
1989 'Daddy! Little Hands are Little People!
Daddy! Little Hands are Little
Cannons!', Zderzak Gallery, Krakow;
1991 'My Paintings in Bialystok', Gallery of
Contemporary Art, City Museum,
Bialystok
1992 New Paintings, Zderzak Gallery,
Krakow
1994 Centre for Contemporary Art, Zamek
Ujazdowski, Warsaw
Selected Group Exhibitions
1982–91 Numerous exhibitions as a member of
GRUPPA group
1985 1st Biennial of Young Artists,
Wroclaw
1986 'Expression of the '80s', BWA, Sopot
'Polish Painting', Edinburgh
International Festival, Richard
Demarco Gallery, Edinburgh
1987 'Whats Going On', former Norblin
Factory, Warsaw
2nd Biennial of Young Artists,
Wroclaw
1988 'Radical Realism: Concrete
Abstraction', National Museum,
Warsaw
1989 Copenhagen
Berlin
Contemporary Polish Drawing, John
Hansard Gallery, Southampton, UK
1990 'Bakunin in Dresden', Kunstmuseum,
Dusseldorf
'Polen Zeit Kunst', Sankt Augustin;
Mainz; Berlin, Germany; Zacheta
Gallery, Warsaw
1991 'Accrochage 2', Zderzak Gallery,
Krakow
'Kunstlandschaft Europa', Bonn,
Germany
1992 4th Biennale 'Balticum '92', Rauma,
Finland

EUGENIUSZ MUCHA

1927 Born in Niewodna
Easel and wall painter

Education
1945–55 Studied at the Krakow Academy of
Fine Arts, Faculty of Painting; gained
his Diploma in the class of Tadeusz
Lakomski
Selected Solo Exhibitions
1966 Nowa Huta Culture Centre, Krakow
1970 Nowa Huta Rytm Gallery, Krakow
BWA Gallery, Lublin
BWA Gallery, Rzeszow
1972 Artist Association Club, Opole
1973 DESA Gallery, Krakow
1974 BWA Gallery (together with W. Hasior
& R. Kwiecien), Krakow
Pegaz Gallery and Dom Turysty Hotel,
Zakopane
1976 Stomil Works Gallery, Krakow
1977 BWA Gallery, Sopot
1981 Komunale Galerie Sohle, Bergkamen;
Darmstadt, Germany
1982 Level Taide Oy Gallery (with A.
Bodganowicz), Seinajoki
1983 Schloss Galerie, Bonn
1986 Gologorski & Rostworowski Gallery,
Krakow
1988 Galeria Plastyka, Krakow
Selected Group Exhibitions
1956 'Young Artists of Krakow Region',
Palace of Art, Krakow
1959 'Young Polish Artists', Messepalast,
Vienna
1961 'Spring Exhibition of Krakow', Palace
of Art, Krakow
'First Exhibition of Nowa Huta Artists',
TPSP Nowa Huta Gallery, Krakow
1964 'Krakow Painters', Bratislava
1966 Nowa Huta Culture Centre and Palace
of Arts, Krakow
1968 'Review of Krakow Artists' Works',
Pryzmat Gallery, Krakow
1971 'Young Krakow Painters', Kordegarda
Gallery, Warsaw
1972 'Myths, Cults and Beliefs as
Inspiration', Pryzmat Gallery, Krakow
1973 'The Connoisseur in Poland', BWA
Gallery, Krakow
'Picture of Human Being', Pryzmat
Gallery, Krakow

1974	'Artist and Civilization', Studio Gallery, Warsaw
	'Polish Modern Art Exhibition', Stockholm
1975	'Comparisons 6', BWA Gallery, Sopot
1976	'Contart '76', Lidzbark Warminski
1977	STU Theatre Gallery, Krakow
1979	'Polish Painting 1944-79', Regional Museum, Bydgoszcz
1980	'Art from Krakow', Staatstheater, Darmstadt; Bonn, Germany
1982	'Six Artists from Poland', Galerie Swetec, Dusseldorf, Germany
1984	'Art from Krakow', Kunstlerhaus Graz, Graz, Austria
1986	'Mystery of the Passion, Death and Resurrection of Jesus', Church of OO Pijarow, Krakow; Warsaw
1988	'Trends of Krakow Painters', Berlin
1989	'As His Picture and Resemblance', Norblin Works, Warsaw
1989	'What Can the Artist Be For in Bad Times?', Zacheta Gallery, Warsaw; Krakow
1991	'Dotyk/Touch: Iconography of the Eighties', BWA Gallery, Palace of Art, Krakow
1991	'Painting in Poland', Galerie zur alten detschen schule, Thun, Switzerland
1993	'Art as the Place of Recovering Ourselves', International Secretariat of Christian Artists, Krakow
1994	'Ars Erotica', National Museum, Warsaw

Collections

Some of his polychrome works can be found in several churches: Niewodna, Catholic University of Lublin, Letownia near Lezajak, Lutcza, Lubliniec Stary near Cieszanow, Niechobrz, Oleszyce, Polok Jaworowski, Zapalow.

HENRYK MUSIALOWICZ

Awards

1980	Zloty medal na Wystawie Czionkow Accademia Italia delle Arti e del Lavoro, Parma
1984	Nagroda European Banner of the Arts, Stowarzyszenia
	Accademia Europea, Wlochy
1985	Nagroda Gold Flame przyznana przez, Parlament Swiata (World Parliament), USA
1988	Nagroda Centauro d'Oro za rok
1988	Wloskiej Akademii Sztuki

Selected Solo Exhibitions

1944	Pokaz malarstwa w ramach tajnych spotkan kulturalnych, Warsaw mieszkanie prywatne przy ul. Rybaki 27
1959	Umietnicki Paviljon, Sarajevo, Bosnia-Herzegovina
	Tribina Mladih, Nowy Sad
1960	Galeria Cepelia, New York
	Highland Gallery, Cincinnati, USA
	Zacheta Gallery, Warsaw
1963	Musee Rath, Geneva, Switzerland
	Galerie Alirc Pauli, Lozanna
1964	Galerie Lambert, Paris
1965	Internationales Kultur und Austausch Zentrum, Frankfurt, Germany
	Haus der Begtegnung, Hamburg, Germany
	Galerie Numaga, Auvernier, Switzerland
1966	Galeria Prisma, Copenhagen
	Galerie Rathauset, Brandbern
	Dom Artysty Plastyka, Warsaw
1967	Galerie im Hailing, Goppingen
	Gallery Younge, Toronto
	Gallerie Numaga, Auvernier, Switzerland
1968	Galerie Bel Etage, Berlin Zachodni
1970	Kleine Galerie im Elisabethenbad, Bad Waldsee
	Galerie Numaga, Auvernier, Switzerland
	Galerie Moebius, Beaune, France
	Galerie Aurora, Geneva, Switzerland
1971	Umietnicki Paviljon, Sarajevo, Bosnia-Herzegovina
	Zydler Gallery, London
	Galerie Verleger Otton Muller, Frankfurt, Germany
1972	Ortas Galerie, Giessen, Germany
	Galerie Lometsch, Kassel, Germany
	Galerie im Hailing, Goppingen
1973	Art Gallery Museum, Niagara Falls, USA
1974	Gallerie Martello, Mediolan
1975	Gallerie Artes, First National City Bank, Mediolan
1977	Im Allgau Schlosshofgalerie, Kisslegg
1979	Galerie der Dresdner Bank, Frankurt, Germany
	Galeria CBWA, Zacheta Gallery, Warsaw
	Galerie Moderne, Bad Zwischenahn, Germany
1980	Galeria BWA, Zamek Ksiazat Pomorskich, Szczecin
	Galerie L.K. Garel, Varrelbusch, Germany
	Galerie C.C. Paul, Monachium
	Galerie Heland, Stockholm
1981	Galeria BWA, Jelenia Gora
	Galerie L.K. Cloppenburg
1985	Galerie Klostermuehle, Hude
1986	Galerie Bremenhaven, Bremen, Germany
1989	Galerie BWA, Bialystok

Selected Group Exhibitions

1964	Exposition Nationale d'Art Contemporain, Paris
1965	Exposition de Noel, Lozanna
1966	'Expressions et Rencontres', Neuchatel, Switzerland
1967	'Le Visage de l'Homme dans l'Art contemporain', Geneva, Switzerland
1972	Internationaler Markt fur aktuelle Kunst, Dusseldorf, Germany
1974	Summer Festival, Baltimore, USA
1976	Le Salon International d'Art, Basel, Switzerland
1977	Internationaler Markt fur aktuelle Kunst, Dusseldorf, Germany
	Washington Art '77, Washington, USA
1978	Miedzynarodowe Targi Sztuki, Washington, USA
1980	Miedzynarodowa Wystawa Czionkow Accademia Italia delle Arte e del Lavoro, Parma, Italy
1981	Miedzynarodowe Targi Sztuk, Toronto
1983	Art Centre Gallery, Tokyo
1984	Miedzynarodow Wystawa Sztuki, Salsomaggiore

1986 'Masters of Contemporary Art in Poland', Herbert F. Johnson Museum of Art, Cornell University, Ithaca, USA

1988 Edith Barrett Art Gallery, Utica College, Syracuse University, Syracuse, USA

Public Collections

Muzeow Narodowych, Warsaw, Krakow, Wroclawiu, Szczecin, Poznan
Musee d'Art et d'Histoire, Geneva, Switzerland
Musee des Beaux-Arts, Neuchatel, Switzerland
Stadliche Kunstahalle, Mannheim, Germany
Herbert F. Johnson Museum of Art, Cornell University, Ithaca, USA
Galleria Martello, Mediolan
Galerie Numaga, Auvernier, Switzerland
Galerie Lometsch, Kassel, Germany
Galerie Lambert, Paris

EDWARD NARKIEWICZ

1938 Born in Troki
Lives and works in Warsaw

Education

Graduated from the Academy of Fine Arts, Warsaw

Selected Solo Exhibitions

1967 Salon Debiutow, Warsaw
1968 Galeria Foksal, Warsaw
1977 Galeria Zapiecek, Warsaw
1985 Galeria Foksal, Warsaw
1987 Galeria Zapiecek, Warsaw
1989 Galerie Johanna Ricard, Nurnberg, Germany
 Galerie Usakowska-Wolff, Herford, Germany
 Gallery NDA, Sapporo, Japan
1990 Galeria Fresk, Krakow
1992 Galeria BWA, Zamosc
 Galeria Rzezby, Warsaw
1993 Galeria Biblioteka, Legionowo
1993 Galeria Domu Artysty Plastyka, Warsaw
1994 Galeria Danuty Ziemskiej, Lublin

JERZY NOWOSIELSKI

Selected Solo Exhibitions

1955 ZPAP, Lodz
1960 Krzysztofory Gallery, Krakow

1963 Zacheta Gallery, Warsaw
 Cassel Gallery, London
1966 Galerie in der Biberstrasse, Vienna
1969 Wspolczesna Gallery, Warsaw
1972 Krzysztofory Gallery, Krakow
1974 Contemporary Art Gallery, Zapiecek, Warsaw
1976 Gallery 72, Regional Museum, Chelm
1977 Contemporary Art Gallery, Zapiecek, Warsaw
1983 Polish Institute, Paris
1985 Warsaw Archdiocese Museum, Warsaw
1987 Polish Culture Institute, London
1988 Inny Swiat Gallery, Krakow
1989 Inny Swiat Gallery, Krakow
1990 Starmach Gallery, Krakow
 Lvov Gallery of Paintings, Lvov
 Polish Institute, Paris
1991 Inny Swiat Gallery, Krakow
 Nyreghasa Museum, Nyreghasa, Hungary
1993–94 Major Retrospective, National Museum, Poznan
 National Museum, Wroclaw
 Zacheta Gallery, Warsaw
 BWA Gallery, Krakow

Selected Group Exhibitions

1943 Exhibition of Young Artists' Group, Ewa Siedlecka's apartment, Krakow
1946 Young Artists' Exhibition, Palace of Art, Krakow
1948 Contemporary Art Exhibition, Palace of Art, Krakow
1955 Exhibition of paintings: Tadeusz Brzozowski, Maria Jarema, Tadeusz Kantor, Jadwiga Maziarska, Kazimierz Mikulski, Jerzy Nowosielski, Erna Rosenstein, Jerzy Skarzynski, Jonasz Stern, Artists' House, Krakow
1956 28th Biennale, Venice
1957 2nd Contemporary Art Exhibition, Zacheta Gallery, Warsaw
1959 3rd Contemporary Art Exhibition, Zacheta Gallery, Warsaw
 5th Biennale, Sao Paulo, Brazil
 'Poolse schilderkunst van nu', Stedelijk Museum, Amsterdam

 'Pologne: 50 ans de peinture', Musee d'Art et d'Histoire, Geneva, Switzerland
1961 'Young Painters: Brzozowski, Dominik, Kowalski, Nowosielski, Pagowska, Ziemski', Contemporary Art Gallery, Chicago, USA
 '15 Polish Painters', Museum of Modern Art, New York
 Polsk Malerei, nasjonalgalleriet, Oslo
1965 'Profile IV: Polnische Kunst heute', Stadlische Kunstgalerie, Bochum, Germany
 'Eibisch, Gierowski, Jackiewicz, Jaskierski, Nowosielski, Ziemski', Washington Gallery of Art, Washington, USA
 '37 artistes polonais contemporains', Musee Tel Aviv, Pavillon Helena Rubinstein, Tel Aviv, Israel
1966 '100 Malingar av Polska Konstonarer', Sweagalleriet, Stockholm
1966–67 '17 Polish Painters', D'Arcy Galleries, New York
 Polnische Malerei der Gegenwart, Neue Berliner Galerie, Berlin
1972 'Atelier 72', Edinburgh International Festival, Richard Demarco Gallery, Edinburgh
1974 Pintura Polaca Contemporanea, Museo de Bellas Artes, Caracas, Venezuela
1975–76 'Romanticism and Romanticity', Zacheta Gallery, Warsaw; BWA Gallery, Katowice
1977 'L'esprit romantique dans l'art polonais XIXe-XXe siecle', Grand Palais, Paris
1978 'Color in Polish Painting of the 19th and 20th Centuries', National Museum, Poznan
1979 '25 Artistes Polonais Contemporains', Centre d'Echanges de Perrache, Lyon, France
1983 'Reality and Imagination', Zacheta Gallery, Warsaw
 'Sign of the Cross', Church of Divine Mercy, Warsaw

1986 'Pittura Contemporanea Polaca', Centro Studi di Arte e Cultura di Napoli, Naples, Italy
1988 Art at the Edge, Museum of Modern Art, Oxford, England
1991 'Dotyk/Touch: Iconography of the Eighties', BWA Gallery, Palace of Art, Krakow
1992 'Beres–Brzozowski–Nowosielski– Sawka–Starowieyski', Exposicion de Polonia, Pabellon de las Artes, EXPO'92, Seville, Spain
'Lodz/Lyon—Muzeum Sztuki w Lodzi 1931–92: Collection–Documentation– Actualite', Musee d'Art Contemporain, Lyon, France

WLODZIMIERZ PAWLAK

1957 Born in Korytow
Lives in Korytow
Education
1985 Graduated from the Academy of Fine Arts, Warsaw
Selected Solo Exhibitions
1984 'Sticks, Pigs, Flies' , Academy of Fine Arts, Warsaw
1986 'Compass and Line of Artistic Measure', Dziekanka Studio, Warsaw
1987 'Recital', Teatr-Gallery Mandala, Krakow
1989 'Diary 1988-1989', Youngs Gallery, Warsaw
1990 'Didactic Table', SARP Gallery, Warsaw
1992 'Introduction to Whiteness', Zacheta Gallery, Warsaw
Selected Group Exhibitions
1986 'Art from Poland', Gallery Nouvelles Images, Hague, Netherlands
1988 'Graz 1988', Graz Museum, Austria
1988 'Polish Realities', Third Eye Centre, Glasgow, Scotland
1989 'Dialogue', Wilhelm-Lehbruck Museum, Duisburg, Germany
1990 Peter Pakesch Gallery
1991 'Europe Unknown', Palace of Art, Krakow
1992 Frontiera 1 92, Bolzano, Gruppa 1982–1992, Zacheta Gallery, Warsaw

1993 'Consequence of Time', Gallery Appendix, Warsaw

IRENEUSZ PIERZGALSKI

1929 Born in Lodz
1955–76 Lectured at the Higher Film School in Lodz
1976– Professor, Graphic Faculty, State Higher School of Fine, Lodz
Practices painting, graphic art and photography. Also experiments with audio-visual media
Education
1955 Graduated from the State Higher School of Fine Arts, Lodz
Solo Exhibitions
1972–74 Photographic and audio-visual works, Muzeum Sztuki, Lodz
1976 Photographic and audio-visual works, Muzeum Sztuki, Lodz
1987 'Ireneusz Pierzgalski: Painting', BWA Gallery, Lodz
Selected Group Exhibitions
1958– Participated in numerous major collective exhibitions of painting in Poland and abroad
Participated in International Biennales of Graphic Art in Krakow, Ljubljana, Tokyo
1972 'Atelier 72', Edinburgh International Festival, Richard Demarco Gallery, Edinburgh
1972 'L'avanguardia Polacca 1910–1978', Rome
1983 'Presences Polonaises', Georges Pompidou Centre, Paris
1986 'Poland Painting: Twelve Contemporary Polish Artists', Ashley Gallery, Epsom, England
1988 'Le Dessin Contemporain Polonais', Paris
1992 'Between Realism and Abstraction', Galerie Miejskie, Lodz
Public Collections
Muzeum Sztuki, Lodz
National Museum, Warsaw
National Museum, Poznan
Also in private collections in Poland, Canada, France, Finland, Italy, Japan, Sweden and USA

TOMASZ PSUJA

1956 Born in Poznan
1981–1 Teaches at Faculty of Painting and Graphic Art, State College of Fine Arts, Poznan
Education
1976–81 Studied at Faculty of Painting and Graphic Art, State College of Fine Arts, Poznan
1981 Graduated from Professor Eugeniusz Markowski's painting studio
Exhibitions
1981 Institut fuer Weltwirtschaft, Kiel, Germany
1983 Kleine Kellergalerie, Trappenkamp
1984 Galeria On, Poznan
1985 Kleine Kellergalerie, Trappenkamp
1986 Galeria Krzysztofory, Krakow
BWA Gallery, Poznan
Ateliergemeinschaft Wassermuehle, Steinfurt bei Kiel, Germany
Galerie Kubus, Hannover, Germany
1989 Galerie Wielka, Poznan
Galerie Grodzka BWA, Lublin
Galerie New Space, Fulda
3rd Biennale of New Arts, Zielona Gora
Galeria Labirynt, Lublin
1989/90 'Potatoes', BWA, Poznan
1990 SARP Gallery, Warsaw
Zacheta Gallery, Warsaw
1992 Galerie Artio, Athens
1993 Solo exhibition, Museum Bochum, Bochum, Germany
Kunstspeicher, Friedersdorf Schul, Bethaus, Altlangsow

JANUSZ PRZYBYLSKI

Born in 1937
Professor at the Academy of Fine Arts, Warsaw
Painting, graphic arts and drawing
Education and Awards
1963 Completed Diploma, Academy of Fine Arts, Warsaw
1967 1st Prize, Internationale Ausstellung Graphic, Vienna
1968 1st Prize, 1st All-Poland Contest for a work of Graphic Art, Lodz
1970 Silver Medal, Third Festival of Fine

Arts, Warsaw
1971 Gold Medal, 11th Biennale of Art, Sao Paulo
1972 Grand Prix, 6th Festival of Contemporary Painting, Szczecin
1973 Gold Medal, Fourth Festival of Fine Arts, Warsaw
Ministry of Culture and Art Award, 1st Triennale of Painting and Graphic Arts, Lodz
1976 1st Prize, Section 'Woman', 7th All-Poland Exhibition of Graphic Arts, Warsaw
1985 'Apollo '85' Medal, Talla, Italy
1986 Ministry of Culture and Art Award, 2nd degree
1987 Grand Prix, 'Miniature '87', Bydgoszcz

Selected Solo Exhibitions
1970 Zacheta Gallery, Warsaw
1973 Sculpture Gallery, Warsaw
Malmo, Sweden
1974 Wartheim Gallery, Berlin
1975 Dusseldorf, Germany
1977 Dusseldorf, Germany
1978 Zacheta Gallery, Warsaw
BWA Gallery, Lodz
1980 Studio Art Gallery, Warsaw
Cologne, Germany
1985 Studio Art Gallery, Warsaw
1986 BWA Gallery, Lodz
1987 Test Gallery, Warsaw
Kordegarda Gallery, Warsaw
Dusseldorf, Germany

Group Exhibitions
Participated in many international and overseas exhibitions:
1st, 2nd, 3rd and 6th International Biennale of Graphic Art, Krakow
Moderne Polask Maleri, Norway; Finland; Denmark
Biennale of the Young, Paris
'Contemporary Polish Graphic Arts', Havana, Cuba
International Biennale of Graphic Art in Bradford, Heidelberg, Frechen, Ljubljana and Liege

Collections
National Museum, Warsaw

National Library, Warsaw
Cabinet of Prints, Albertina, Vienna
Bibliotheque Nationale, Paris
Tate Gallery, London
Also in private collections in Poland and abroad

ALINA RACZKIEWICZ-BEC

1958 Born in Tomaszow Lubelski

Education and Awards
1980–86 Studied at Department of Painting, Academy of Fine Arts, Krakow
1986 Diploma from studio of Professor J. Nowosielski
1989 Grand Prix, 2nd Review of Young Painters, Plastyka Gallery, Krakow

Solo Exhibitions
1989 National Gallery 'Plastyka', Krakow
1990 National Gallery 'Maly Rynek', Krakow
1993 Gallery Frank, Tulln, Austria

Selected Group Exhibitions
1986 Exhibition of the Best Graduations Works from Art Academies in Poland in 1986, National Gallery, Lodz
1989 2nd Review of Young Painters, Plastyka Gallery, Krakow
Inter Art, Poznan
5th Contemporary Portrait Triennale, National Gallery, Radom
1990 1st International Art Meetings and Workshop, Przemusl Krasiczyn
1991 'Dotuk: Art from the Eighties', National Gallery, Krakow
2nd International Art Meetings and Workshop, Krasiczyn Plener; Small Gallery, Nowy Sacz
'Kunst Fran Krakow', Ronneby, Sweden
1992 Big Open 100th Anniversary of Krakow's Artist Union Exhibition, National Gallery, Krakow
1993 'Krakow–Cork Exchange', Crawford Municipal Art Gallery, Cork; City Art Centre, Dublin, Ireland
'Artists from Krakow', Zacheta Gallery, Warsaw
'Artists from Krakow', Market Art '93, Nurnberg, Germany

JADWIGA SAWICKA

Born 14 January 1959

Education and Awards
1979–84 Academy of Fine Arts, Krakow
1985 Ministry of Culture and Art Award
1992 Pollock-Krasner Foundation Grant, New York

Solo Exhibitions
1990 Fresk Gallery, Krakow
BWA Gallery, Prezemysl
1991 BWA Gallery, Prezemysl
1993 BWA Gallery, Prezemysl

Group Exhibitions
1985 Nurnberg, Germany
1985 Wroclaw
1986 Wroclaw
1987 Przemysl
1989 Przemysl
1991 Oxford, England
International Artists Workshops 'Krasiczyn Plener', Poland
Artweek International Artist Plener
1992 Przemysl
Krakow
International Artists Workshops 'Krasiczyn Plener', Poland
1993 Przemysl
Krakow
International Artists Workshops 'Krasiczyn Plener', Poland
Sutton Courtenay Abbey, England
Shave Farm Artists Workshops, England

LUKASZ SKAPSKI

1958 Born in Katowice
1988 Guest Artist, Ecole de Beaux Arts, Aix-en-Provence, France
1989–91 Lived in China

Education and Awards
1977–82 Studied at Academy of Fine Arts, Krakow in studio of Tadensz Brozozowski
1985 Scholarship at Artists Home, Boswill, Switzerland
1987 Award, Droga i Prawda, Biennale, Wroclaw

Selected Solo Exhibitions
1985 Klus Galerie, Zurich
1986 'Zolty VW plonie', Galeria Mandala, Krakow
'AN-24' Galeria Zderzak, Krakow
1988 'Zalatw dzisiaj', Galeria Zderzak, Krakow
1989 Galerie AF, Wiesbaden, Germany
'Pokaz prywatny', Frankfurt, Germany
'Wiazki', Beijing
1991 Ambasada RP, Beijing
'Wiazki, Galeria QQ, Krakow
'Szeregi', Galeria Zderzak, Krakow; Galeria Arsenal BWA, Bialystok
1991 'Installekty', Galeria Arsenal BWA, Bialystok
1993 Winter Welt festspiele fur Jugend und Studenten in Berlin, Galeria Zderzak, Krakow
Installacje, Galeria Miejska, Wroclaw
'Sztaby i Szczeliny', Centrum Sztuki, Bytom
'Caged Light', Galerie Unwahr, Berlin
Rysunki cieniem, Galeria BWA, Sandomierz
Zderzak Gallery, Krakow

Selected Group Exhibitions
1982 11m2, Group wystawa grupy, Krakow
1983 International Biennial of Drawing, Cleveland, USA
1984 Salon de Jeune Peinture, Paris
1985 Droga i prawda, Biennale, Wroclaw
'Namiot Szamana Sztuki', performance, Biennale Sztuki Nowej, Zielona Gora
1986 Performance meeting, Teatr Mandala, Krakow
Salon de Jeune Peinture, Paris
1987 Droga i Prawda, Biennale, Wroclaw
Exchange, wystawa objazdowa, Northern Ireland
1990 Galerie lat 80-tych, wystawa z Galeria Zderzak, Zacheta, Warsaw
1992 Zderzak goscinnie w Bytomiu, Centrum Sztuki, Bytom
Neue Kunst aus dem Alten Krakau, Darmstadt, Germany
1993 'Krakow–Cork Exchange', Crawford

Municipal Art Gallery, Cork; City Art Centre, Dublin, Ireland
'Coordinates 19° 57,6'E + 15° 3,9'N', Krakow
Fort Sztuki, Fort sw. Benedykta, Krakow
1993 AVE Festival, Arnhem, Netherlands ('Tropfen+Bable' audio-performance ze Stefanem Heidenreich'em)
'Tropfen+Bable', Tacheles, Berlin
Centrum Sztuki Wspolczesnej, Zamek Ujazdowski, Ogrod Sztuki, Warsaw
1994 'Trzech z Krakowa', Kunsthaus Raskolnikow, Dresden, Germany

JACEK SROKA

1957 Born in Krakow
1981–89 Worked at the Faculty of Printmaking, Academy of Fine Arts, Krakow

Education
1976–81 Studied at the Academy of Fine Arts, Krakow

Solo Exhibitions
1980 Galeria FAMA, Krakow
Lufthansa Stadtburo, Bonn, Germany
1981 Galeria BWA, Myslenice
1985 Galeria M. Gologorski & D. Rostworowski, Krakow
1986 L.K. Gallery, Varrelbusch, Germany
1987 Galeria M. Gologorski & D. Rostworowski, Krakow
Langbrok Gallery, Reykjavik, Iceland
Galeria Teatr STU, Krakow
1988 Iona Stichting Gallery, Amsterdam
W. Asperger Gallery, Knittligen, Germany
1989 Signe Gallery, Heerlen, Netherland
1990 CIAP Gallery, Hasselt, Belgium
1991 Galeria BWA, Miechow
W. Asperger Studio Gallery, Berlin
Galeria BWA, Zamosc
1992 Galeria BWA, Slupsk
Galeria GP, Warsaw
Muzeum Historyczene Miasta Krakow, Wieza Ratuszowa, Krakow
'Budowa swiata', Jan Fejkiel Gallery, Krakow
1993 Galeria Salustowicz, Bielefeld,

Germany
Galeria Denis Canteux, Valmorel, France

Group Exhibitions
1982 Old Warsaw Gallery, Alexandria, USA
1983 Kunsthalle, Nurnberg, Germany
1984 12th Festival of Polish Painting, Zamek Ksiazat Pomorskich, Szczecin
3rd Print Biennale, Vaasa, Finland
10th Print Biennale, Krakow
Galeria De La Marmita, Cordoba, Spain
1985 World Print Council, San Francisco, USA
Maii Art, The Young Artist Club, Budapest
1986 Kosciuszko Foundation, New York
Atrium Gallery, Storrs, USA
1987 La Mostra Internazionale Di Grafika, Catania, Italy
Grafica Atlantica, Kjarvais-Stadir Museum, Reykjavik, Iceland
17th Print Biennale, Ljubljana, Slovenia
'Four Artists from Krakow, Galeria Energoinvest, Sarajevo
1988 'Polish Painting Since 1945', Galerie der Stadt Esslingen, Kunsthalle Wilhelmshaven, Germany
'Angst: Art from Central Europe', University of Michigan, Ann Arbor, USA
1989 'Young Polish Artists', Polish Cultural Centre, Sofia, Bulgaria
'Rondije Poolse Kunst', Bollenhove, Netherlands
Artistic Studios Gallery, Moscow
1990 Art Fair, SAGA, Galerie de la Gare, Grand Palais, Paris
'The Expressive Struggle: Twenty-Six Contemporary Polish Artists', New Academy of Art, New York
1991 'Positionen Polen', Kunstlerhaus Bethanien, Berlin
Praha Graphic, Modry Pavilon, Prague
'The Struggle for Self Image', Boston Centre for the Arts, Boston, MA, USA
Jan Fejkiel Gallery Collection, Polish Cultural Institute, Stockholm

1992 'Polish Prints', Retretti Art Centre, Punkaharju, Finland
Jubilee Exhibition of the Artists' Union, Galeria BWA, Krakow

1993 'Polnische Graphic in der Albertina', Albertina, Vienna
'Artists from Krakow', Galeria Zacheta, Warsaw
Art Fair LINEART, Post & Salamon Contemporary Art, Gent, Belgium

JONASZ STERN

Solo Exhibitions
1958 11th Festival of Plastic Arts, BWA Galeria, Sopot
1972 National Museum, Warsaw
1976 Exhibitions in Bialystok, Swidwin, Koszalin, Kolobrzeg
1977 Muzeum Mikolaja Kopernika, Frombork
Dom Srodowisk, Tworczyk
1978 Galeria 72, Chelm
BWA Galeria, Wroclaw
1979 Galeria Zapiecek, Warsaw
BWA Salon, Slupsk
Klub Literatow, Krakow
1980 BWA Galeria, Lublin
1982 Galeria Krzysztofory, Krakow
1983 CBWA Galeria Zacheta, Warsaw
BWA Galeria, Poznan
BWA Galeria, Lodz
1984 BWA Galeria Awangarda, Wroclaw
Galeria Sztuki Wspolczesnej, Olsztyn
Klub Kuznica, Krakow
1985 Jonasz Stern Jubilee Exhibition, Palac Sztuki, Krakow
1988 Works from 1964–88, Muzeum Okregowe, Synagoga, Nowy Sacz
1989 Galeria Sztuki Wspolczesnej, Katowice
Jonasz Stern, Galeria Krzysztofory, Krakow
1993 Galeria Studio, Warsaw
'The Lvov Ghetto', Museo della Comunita Ebraica di Roma, Italy

Selected Group Exhibitions
1933–58 More than 25 important exhibitions throughout Poland as well as in
Moscow, Belgrade, Ljubljana and Skopje
1958-59 Various exhibitions of Polish contemporary art in Cairo, Alexandria, Damascus, Belgrade, Brno, Geneva, Lugano, Zurich, Stockholm, Reykjavik, Venice, Amsterdam and Copenhagen as well as in Poland
1960 The Krakow Group, Galeria Krzysztofory, Krakow
'Polish Contempory Graphics 1900–1960', Muzeum Narodowe, Warsaw
1962 The Krakow Group, Galeria Krzysztofory, Krakow
1st Festival of Polish Contemporary Painting, Szczecin
1963 The Krakow Group, Galeria Krzysztofory, Krakow
1964 'Polish Contemporary Art', Bratislava, Slovakia
1965 The Krakow Group, Galeria Krzysztofory, Krakow
Krakow Pavilion, Muzeum Slaskie, Wroclaw
'37 Contemporary Polish Artists', Muzeum-Pavilion Helena Rubinstein, Tel Aviv, Israel
1966 The Krakow Group, Galeria Krzysztofory, Krakow
1967 'Polish Contemporary Painting', Prague
1979 'The Art of the Krakow Group 1932-37', Palac Sztuki, Krakow
'Polish Contemporary Painting', Sarajevo, Skopje, Titograd; Dijon and Lyon, France
1979 'Krakow Art from Young Poland to the Present', Muzeum Narodowe, Krakow; Muzeum, Gniezno
1980 'Expressionism in Polish Art', Muzeum Norodowe, Wroclaw; Galeria Zacheta, Warsaw
1982 'Abstraction': Works from the collection of the Museum Narodowe, Poznan; Arsenal Gallery, Poznan
1983/5 The Krakow Group Collection, Galeria Krzysztofory, Krakow
1986 'Poland Painting', Ashley Gallery, Epsom, England
1987 The Krakow Group, Galeria Krzysztofory, Krakow
1991 'Dotyk/Touch: Iconography of the Eighties', BWA Gallery, Palace of Art, Krakow
1992 'Collection–Documentation–Actualite', Musee d'Art Contemporain, Lyon, France; Muzeum Sztuki, Lodz
1993 'Identity Today: Contemporary Polish, Hungarian, Czech and Slovak Art', Bruxelles
1994 'Artists from Krakow', Galeria Zacheta, Warsaw
'Europe, Europa': Das Jahrhundert der Avangarde in Mittel und Osteuropa, Bonn, Germany

Public Collections
All major galleries and national museums in Poland
Also in private collections in Poland and in Belgium, Denmark, Spain, Netherlands, Japan, Portugal, Germany, Switzerland, the USA, Great Britain and elsewhere

ANDRZEJ SZEWCZYK

Selected Exhibitions
1969 Assemblages and events in various studios, flats and on the streets
1971–72 Paintings on mirrors, Galeria Beanus, Sosnowiec
1973–74 'Painting is Visible', Uniwersytet Slaski, Cieszyn
1974–79 Unification of the painting of paintings with painting the walls
1977 Galeria pod Prasa, Katowice
1978 Westbeth Gallery, New York
'Paintings from Chlopy', Galeria Foksal, Warsaw
1979 'Four Books', Galeria Foksal, Warsaw
Painting, Galeria Foksal, Warsaw
1980 11th Biennale des Jeunes Artistes, Paris
1981 'Space is always the same, whether it extends or contracts ...', Galeria Foksal, Warsaw

'The Five Quarters of the Globe',
Galeria Foksal, Warsaw
Retrospective exhibition, Air Gallery,
London
Drawing Triennale, Wroclaw
16th Sao Paulo Biennale, Sao Paulo,
Brazil
1982 12th Biennale des Jeunes Artistes,
Paris
1984 'Monuments of F. Kafka's Letters to F.
Bauer', Galeria Foksal, Warsaw
'The Poet's House', Galeria Riviera-
Remont, Warsaw
'Objects Which Enable ...', Galeria
Riviera-Remont, Warsaw
1985 'Four Foksal Gallery Artists', Richard
Demarco Gallery, Edinburgh
1986 'Kunst uit Polen', Galeria Nouvelles
Images, The Hague, Netherlands
'Geometry and Expression', Parko
Eleftherias, Athens
Solo exhibition, Muzeum Okregowe,
Chelm
1987 'Basilica', Galeria Foksal, Warsaw
1988 Muzeum Sztuki, Lodz

JANUSZ TARABULA

1931 Born in Krakow
1961– Krakow Group member
Lives and works in Krakow
Education
1950–56 Studied at the Academy of Fine Arts,
Krakow in the studio of Professor
Czeslaw Rzepinski

Solo Exhibitions
1971 Galeria Krzysztofory, Krakow
1973 Galeria PI, Krakow
1974 Galeria Pawilon DESA, Nowa Huta,
Krakow
1977 Galeria Studio, Warsaw
1978 Galeria ZPAP 'ART', Florianska 34,
Krakow
1984 Galerie des Arcenaulx, Marsylia
1985 Galeria Krzysztofory, Krakow
1986 BWA, Kielce
1989 Galeria ZPAP, Florianska 34, Krakow
1990 Galeria Uniwersytecka, Cieszyn
Galerie Krzysztofory, Krakow

Group Exhibitions
1956 Wystawa Mlodej Plastyki Krakowskiej,
Palac Sztuki, Krakow
1958 Wystawa Malarstwa Krakowskiego,
Bergen; Oslo
1959 3rd Polish Exhibition of Modern Art,
Galeria Zacheta, Warsaw
1960 Galeria Krzysztofory, Krakow
Wystawa z okazji zjazdu AIAC, Nowa
Huta, Krakow
1961 3rd Wsytawa Grupowa, Galeria
Krzysztofory, Krakow
1961–74 Udzial w corocznych wystawach
Grupy Krakowskiej
1962 Wystawa siedmiu malarzy polskich,
Grabowski Gallery, London
1962–63 Wystawa objazdowa Grupy
Krakowskiej, USA
1963 Wspolpraca w realizacji pomnika
Zydow Lubelskich
1965 Sympozjum Zlote Grono, Zielona Gora
1969 'Przeciw wojnie', wystawa, Muzeum
na Majdanku, Lublin
1972 Wystawa Sztuki Polskiej, 'Atelier 72',
Edinburgh International Festival,
Richard Demarco Gallery, Edinburgh
1973 30-lecie Wojska Polskiego, Galeria
Zacheta, Warsaw
1975 30-lecie grafiki krakowskiej, Muzeum
Narodowe, Krakow
1976 5th Miedzynarodowa Wystawa
Rysunku, Rieka, Jugoslavia
1977 Salon TPSP, Palac Sztuki, Krakow
1980 Wystawa Malarstwa Krakowskiego,
Darmstadt; Bonn, Germany
1981 BWA Spotkania Krakowskie, Krakow
1983 Artysci z. Krakowa, Galeria Zacheta,
Warsaw
1994 Wystawa Grupy Krakowskiej, Galeria
Zacheta, Warsaw

LEON TARASEWICZ

1957 Born in Stacja Walily
Education
1979–84 Studied at the Academy of Fine Arts,
Warsaw, Faculty of Painting
Solo Exhibitions
1984 pracownia dziekanka, Warsaw

Byelorussian Cultural Society, Warsaw
Foksal Gallery, Warsaw
1985 pracownia dziekanka, Warsaw
Foksal Gallery, Warsaw
Biala Gallery, Lublin
1986 Galerie Nordenhake, Malmo, Sweden
Galleria del Cavallino, Venice
Riverside Studios, London
Boibrino Gallery, Stockholm
Galerie Nordenhake, Stockholm
1987 Edward Thorp Gallery, New York
Damon Brandt Gallery, New York
Gallery BWA Arsenal, Bialystok
1988 National Museum, Wroclaw
Foksal Gallery, Warsaw
Exhibition Hall, Grodno
Palace of Art, Minsk
1989 Galerie Nordenhake, Stockholm
Nigel Greenwood Gallery, London
Galleria del Cavallino, Venice
1990 Galerie Fahnemann, Berlin
1991 Krzysztofory Gallery, Krakow
Okregowe Museum, Bialystok
Galerie Nordenhake, Stockholm
Foksal Gallery, Warsaw

Group Exhibitions
1985 Diploma '84, BWA Gallery, Wroclaw
'40 Years of LSP in Suprasl', BWA
Arsenal Gallery, Bialystok
'Ex Oriente Lux', pracownia
dziekanka, Warsaw
'Four Foksal Gallery Artists', Richard
Demarco Gallery, Edinburgh
'Dialog', Moderna Museet, Stockholm
1986 'Poland Painting', Ashley Gallery,
Epsom, England
'Overland', Ikon Gallery, Birmingham,
England
'The Forest', Arnolfini Gallery, Bristol,
England
'Art from Poland', Galerie Nouvelles
Images, The Hague, Netherlands
1987 19th Biennale, Sao Paulo, Brazil
'What's Going On', former Norblin
Factory, Warsaw
'Radical Realism, Concrete
Abstraction', National Museum,
Warsaw 'Locus Solus', Galerie

1988 Nordenhake, Stockholm
'Aperto 88', Biennale, Venice
'Olympiad of Art', National Museum of Contemporary Art, Seoul
Triennal of Young Art, Palace of Art, Vilnius, Lithuania
'Art at the Edge', Museum of Modern Art, Oxford, England
'Polish Realities', Third Eye Centre, Glasgow, Scotland
1989 'Vision and Unity, Van Reekum Museum, Apeldoorn, Netherlands
L'Occhio della Galleria, Venice
'Wurzeln Treiben', Kutscheraus, Berlin
'Dialog', Kunstmuseum, Dusseldorf; Centre for Contemporary Art, Warsaw
Sala Uno, Rome
1990 'Polen Zeit Kunst', Sankt Augustin; Berlin; Mainz, Germany; Warsaw
Festival of Contemporary Art, Cagnes-sur-Mer
Biennale Balticum, Rauma, Finland
1991 'Tre giovani artisti e un maestro di serigrafia', Galleria del Cavallino, Venice
'Positionen Polen', Kunstlerhaus Bethanien, Berlin
'Europe Unknown', Palace of Art TPSP, Krakow
'Kunst, Europa', Bonner Kunstferein, Bonn, Germany
'Sculpture–Nash, Painting–Tarasewicz', Centre for Contemporary Art, Ujazdowski Castle, Warsaw

Public Collections
Moderna Museet, Stockholm
Minnesota Museum of Art, Saint Paul, USA
National Museum of Contemporary Art, Seoul
Museum Sztuki, Lodz
National Museum, Warsaw
National Museum, Wroclaw
National Museum, Bydgoszcz
National Museum, Poznan
Foksal Gallery Collection, Warsaw
Per Mattson Collection, Warsaw
George Costakis Collection, Varnanas, Greece

George Costakis Collection, Athens
Arthur Sackler Collection, New York
Fredrik Roos Collection, Malmo, Sweden
Egit Foundation, Warsaw

JAN TARASIN
1926 Born in Kalisz
Lives and works in Warsaw
Education
1951 Graduated from Academy of Fine Arts, Krakow
Selected Solo Exhibitions
1959 Galeria Krzysztofory, Krakow
1960 Galeria Krzywe Kolo, Warsaw
1962 Galeria Lambert, Paris
1965 Konstalongen Cavaletten, Uppsala, Sweden
1968 Zacheta Gallery, Warsaw
1971 Ado Gallery, Mechelen, Belgium
1977 Galerie Zapiecek, Warsaw
1980 Galeria Krzsysztofory, Krakow
1984 Studio Gallery, Warsaw
1985 Zero Gallery, Tokyo
1988 Galeria BWA, Olsztyn
1990 Salustowicz Gallery and ZIF, Bielefeld, Germany
Selected Group Exhibitions
1958 Berne, Reykjavik, Cairo, Damascus, Baghdad
1959 1st Biennale des Jeunes, Paris
1961 4th International Biennale of Graphics, Ljubljana, Slovenia
1962 3rd International of Print Graphics, Tokyo
1963 5th International Biennale of Graphics, Ljubljana, Slovenia
1964 'Profile IV—Polish Art Today', Bochum, Kassel, Germany
1965 8th Biennale, Sao Paolo, Brazil
5th International Biennale, San Marino
1966 '100 Polish Painters', Stockholm
Exhibition of the International Union of Established Artists (AIAP), Tokyo
'Contemporary Polish Art', Lubeck, Germany
1969 Biennale of Painting, Cagnes-sur-Mer
1974 'Polish Paintings', Vienna

1975–76 'Polish Paintings', Cologne; Dortmund; Essen, Germany; Basel, Switzerland, Bologna, Italy
1978–79 Augsburg, Germany
1979 Herzog Anton Ulrich Museum, Braunschweig; Budapest; Bratislava; Prague; London; Vienna; Barcelona
1980 Dusseldorf; Barcelona
1981 Oslo
1983 Mailand
1986 Naples; Cannes; Edinburgh
1988 'Polish Painting since 1945', Esslingen and Wilhelmshaven, Germany
1989 'The Open Door: Contemporary Polish Art', Copenhagen
1991 'Positionen Polen', Kuntslerhaus Bethanien, Berlin

TOMASZ TATARCZY.K
1947 Born in Katowice
1980–86 Assistant to the Chair of Painting, Academy of Fine Arts, Warsaw
Education and Awards
1966–72 Studied at the Polytechnic Institute, Warsaw
1976–81 Studied at the Academy of Fine Arts, Warsaw; diploma in Painting in studio of Professor Jan Tarasin
1987–88 Scholarship, Kosciuszko Foundation, New York
Solo Exhibitions
1984 Foksal Gallery, Warsaw
1985 Studio Gallery, Warsaw
1986 Lang Gallery, Malmo, Sweden
1987 Foksal Gallery, Warsaw
1988 Frank Bustamante Gallery, New York
Foksal Gallery, Warsaw
Lang Gallery, Malmo, Sweden
1989 Summer Gallery of the Nadwislanskie Museum, Kazimierz Dolny
1991 Castle of the Princes of Pomerania, Stettin
Spicchi dell'Est Gallery, Rome
1992 Adelgatan 5 Gallery, Malmo, Sweden
Foksal Gallery, Warsaw
ART-ON Gallery, Halmstad, Sweden
1993 Old Gallery, Lublin
1994 Sculpture Gallery, Warsaw

Selected Group Exhibitions

1984 'Artists of the Foksal Gallery', Foksal Gallery, Warsaw
Painters of the Cricot 2 Theatre and of Foksal Gallery, Stodola Gallery, Warsaw

1985 'Four Foksal Gallery Artists', Richard Demarco Gallery, Edinburgh
'Dialog', Moderna Museet, Stockholm

1986 'Poland Painting', Ashley Gallery, Epsom, England
'Kunst uit Polen', Nouvelles Images Galerie, The Hague, Netherlands

1988 Gallery Artists, Frank Bustamante Gallery, New York
'Polnische Malerei seit 1945', Galerie der Stadt Esslingen Villa Merkel; Kunsthalle, Wilhelmshaven, Germany
'New Talents', Everson Museum of Art, Syracuse, USA

1989 New Acquisitions, Aldrich Museum of Contemporary Art, Ridgefield, Ct., USA

1990 'The Expressive Struggle', Everson Museum of Art, Syracuse, USA

1991 'The Epitaph and Seven Spaces', Zacheta Gallery, Warsaw
Selected works from the Collection, Anderson Gallery, Buffalo, New York
4th Biennial of New Art, Zielona Gora

1992 'The Expressive Struggle', Anderson Gallery, Buffalo, New York
Foksal Gallery Artists, Foksal Gallery, Warsaw
'10 Years Later', Museum of Contemporary Art, Radom

1993 Frank Bustamante Gallery, New York

Collections

Museum of Art, Lodz
National Museum, Poznan
National Museum, Warsaw
Foksal Gallery, Warsaw
Moderna Museet, Stockholm, Sweden
Everson Museum of Art, Syracuse, USA
Glynn Vivian Art Gallery and Museum, Swansea, Wales, Britain
Aldrich Museum of Contemporary Art, Ridgefield, Ct/. USA
Arthur Sackler Collection, USA

David Anderson Collection, Buffalo, USA
Konrad Adenauer Foundation, Sankt Augustin, Germany

Bibliography

Vito Apuleo, 'Scultura e pittura polacchi in mostra', *Il Messagero*, 22 July 1991
Marek Bartelik, 'Widziane z Manhattanu', *Nowy Dziennik, Polish Magazine*, New York, 4 February 1988
Wieslaw Borowski, text in the catalogue of the exhibition 'Dialog', Moderna Museet, Stockholm, 1985
Mario de Candia, text in the catalogue of the solo exhibition in the Spicchi dell'Est Gallery, Rome, 1991
Stanislaw Cichowicz, 'In viaggio', text in the catalogue of the solo exhibition in the Sculpture Gallery, Warsaw, 1994
Jaromir Jedlinski, 'In Seclusion', text in the catalogue of the solo exhibition at the Spicchi dell'Est Gallery, Rome, 1991
Krzysztof Klopotowski, 'Wole pracowac w Polsce', an interview with Tomasz Tatarczyk, *Nowy Dziennik, Polish Magazine*, New York, 21 January 1988
Richard Noyce, 'Poland', *Art Line International Art News*, London, 1985
Tomasz Rudomino, 'Mountains, Forests, Trees', *Projekt*, no. 5, 1989
Barnaby Ruhe, 'Tatarczyk's Funeral Pyre', *Art World*, New York, vol. 12, no.4, 1988
Irma Schagheck, 'Polen: Aufbruch aus dem Untergrund', *Art, Das Kunstmagazin*, Styczen, January 1991

JACEK WALTOS

Selected Solo Exhibitions

1990 'Dr Freud ...', Horn Gallery, Poznan
1991 'Dr Freud ...', Kordegarda Gallery, Warsaw
1993 'Eleven Pictures', City of Krakow Museum of History, Town Hall Tower, Krakow

Selected Group Exhibitions

1990 'Aus der Metapher Heraus' (From the metaphor and back), Darmstadt, Germany
1991 'Dotyk/Touch: Iconography of the Eighties', BWA Gallery, Palace of Art, Krakow
1992 'Ten Years Later', drawing exhibition, Contemporary Art Museum, Radom
The Polish National Fund, auction of contemporary Polish paintings, New York
1993 'To Show the Invisible', Jesuit's Gallery, Poznan
'The Krakow Spleen', The Union of Polish Artists Gallery, Warsaw
1994 'Ars Erotica', Pro Arte Foundation & National Museum, Warsaw
'The Bible in Contemporary Artists' Intuition', National Museum, Gdansk
'44 Artists against Jan Matejko', National Museum, Krakow
'Della Passione' (On the Passion), Polish Institute of Culture, Rome

ANDRZEJ WELMINSKI

1952 Born in Krakow

Solo Exhibitions

1990 Foksal Gallery, Warsaw
1990 Krzysztofory Gallery, Krakow
1991 'Votive Tablets', Starmach Gallery, Krakow
1992 University Gallery, Cieszyn

Selected Group Exhibitions

1970 'Morning Happening or The Yellow Suitcase'
1971 'Anonymous Exhibition', A. Welminski & R. Siwulak joint exhibition, Foksal Gallery PSP, Warsaw
1972 '2nd Anonymous Exhibition', A. Welminski & R. Siwulak joint exhibition, Foksal Gallery PSP, Warsaw
1973 8th Biennale de Paris
1976 'Behind The Wardrobe', joint work of A. Welminski & Roman Siwulak, Foksal Gallery, Warsaw
1979 'The Painters of Cricot 2 Theatre', Palazzo delle Espositioni, Rome and Palazzo Reale, Milan
1985 'Artists of Foksal Gallery', Warsaw
1991 Homage to Tadeusz Kantor, with members of Cricot 2 Theatre troupe
1993 'Ruins', drawings, Solvay, Krakow